CANVASSING

CANVASSING

Recollections by
six Victorian women artists

Edited and introduced by
Pamela Gerrish Nunn

Series editor 'Women on Art'
Frances Borzello

CAMDEN PRESS

Published in 1986 by
Camden Press Ltd
43 Camden Passage, London N1 8EB, England

Introduction, selection and notes
© Pamela Gerrish Nunn 1986

Designed by Sue Lacey

Set in 11 on 12½ pt Imprint
by Inforum Ltd, Portsmouth
and printed and bound by
A. Wheaton & Co. Ltd, Exeter, Devon

British Library CIP Data
Canvassing : an anthology of Victorian woman artists'
autobiographical writings. – (Women on art)
1. Women artists – Great Britain – Biography
2. Art, Victorian – Great Britain
I. Nunn, Pamela Gerrish II. Series
709'.2'2 N6796
ISBN 0–948491–01–9

The Publishers gratefully acknowledge permission to
reprint material from Round About Three Palace Green
by Estella Canziani, Methuen & Co.

ACKNOWLEDGEMENTS

My thanks are due to Frances Borzello, whose initial enthusiasm brought this book into being and whose commitment helped bring it to fruition. I am also grateful to other women working in art-historical fields – galleries, libraries, museums, academic departments – whose cooperation and support have facilitated and enriched my own work. Likewise I am glad to acknowledge all the women participating in the current 'women and art movement' in this country, of which this book means to be a part. Finally, I deeply appreciate the encouragement and forebearance of the women who, as my friends and relatives, have helped me and my work along over the days, weeks, months and years.

*For my sisters, my mothers
and my aunts*

CONTENTS

List of illustrations xi

Introduction 1

Anna Mary Howitt
An Art Student in Munich (1853) 19

Anna Lea Merritt
Recollections from *Art Criticism and Romance* by Henry
Merritt (1897) 45

Elizabeth Thompson Butler
An Autobiography (1922) and *From Sketchbook and
Diary* (1909) 70

Henrietta Ward
Memories of Ninety Years (1924) 113

Louise Jopling
Twenty Years of my Life (1925) 139

Estella Starr Canziani
Round About Three Palace Green (1939) 163

Index 193

ILLUSTRATIONS

Page 21 Anna Mary Howitt, *The Sensitive Plant (The
 Lady)*, 1855, oil on canvas, private collection.
 Photo courtesy Julian Hartnoll Gallery.

Page 35 Anna Mary Howitt, *The School of Life*, 1853,
 engraving, *The Illustrated Magazine of Art*. Photo
 the author.

Page 47 Anna Lea Merritt, *Love Locked Out*, 1889, oil on
 canvas, 45in × 21in, Tate Gallery London. Photo
 courtesy the Tate Gallery.

Page 50 Anna Lea Merritt, *War*, 1883, oil on canvas,
 41½in × 56½in. Bury Art Gallery and Museum.
 Photo courtesy Bury Art Gallery.

Page 71 Elizabeth Thompson, Lady Butler, *The Visita-
 tion*, 1872, engraving after oil, *Art Journal 1882*
 (whereabouts of original unknown). Photo the
 author.

Page 74 Elizabeth Thompson, Lady Butler, *Calling the
 Roll after an Engagement, Crimea (The Roll
 Call)*, 1874, oil on canvas, 36in × 72in, Royal
 Collection England. Photo courtesy the Royal
 Collection.

Page 76 Elizabeth Thompson, Lady Butler, photo-
 graphed in 1874 by Fradelle and Marshall, Lon-
 don (albumen print). Mass collection.

Page 115 Henrietta Ward photographed in 1866, photo-
 grapher unknown, published in *Memories of Nine-
 ty Years*, 1924.

Page 118 Henrietta Ward, *Palissy the Potter*, 1866, oil on
 canvas, 43in × 53in, Leicestershire Museums and
 Art Gallery. Photo courtesy the Gallery.

Page 129 Henrietta Ward, *Queen Victoria*, n.d., oil on canvas, 57¾ × 38½in, Forbes Magazine Collection N.Y. Photo courtesy Forbes.

Page 141 Louise Jopling, *Self-Portrait*, 1877, oil on panel, 8in × 5¾in, Manchester City Art Gallery. Photo courtesy the Gallery.

Page 151 James McNeill Whistler, *Portrait of Louise Jopling*, 1888, oil on canvas, 19in × 99in, Hunterian Museum, Glasgow. Photo courtesy of the University of Glasgow.

Page 164 Estella Canziani, *The Piper of Dreams*, watercolour, The Medici Society, London. Photo courtesy the Society.

Page 167 Louisa Starr Canziani, *Brian Hodgson*, 1872, oil on canvas, 29in × 24½in, National Portrait Gallery, London. Photo courtesy NPG.

Page 179 Louisa Starr Canziani, *Sintram*, 1872, oil on canvas, Walker Art Gallery, Liverpool. Photo courtesy the Gallery.

Page 182 Louisa Starr Canziani, *The Alien*, 1906, oil on canvas, 44in × 31in, Aberdeen Art Gallery. Photo courtesy the Gallery.

The publishers would like to thank Jane Jopling, Louise Grattan and John Jopling for allowing us to reproduce Louise Jopling's Self Portrait *on the cover.*

INTRODUCTION

'WHY compare the differing genius of women and men? There
is room in the garden of art for flowers of every kind and for
butterflies and birds of every species; and why should anyone
complain because a daisy is not a rose, or because nightingales
and thrushes, despite their family resemblance, have voices of
their own, dissimilar in compass and in quality?' Thus wrote
Walter Shaw Sparrow in 1905, prefacing a book called *Women
Painters of the World* which promised its readers an account
stretching 'from the time of Caterina Vigri to Rosa Bonheur
and the Present Day'. Who of us now knows anything of
Caterina Vigri? Of Rosa Bonheur, how much? Yet Sparrow
knew that his readers would not only be eager to learn of this
Renaissance gem, but that they would also already have heard
of the French painter, heroine of their mothers' time. For
Sparrow was writing after half a century of debate about
women and the arts which had had the British art scene itching
and scratching since the 1850s.

The questions raised were enormous and fundamental:
'Are we entitled, at the present stage, to conclude that women
have another work in life, and that Nature (in the vast majority
of cases) is against their eminence in Art?' . . . 'What is
genius? Is it not both masculine and feminine?' . . . 'The
question is, what are the functions of women in art?' . . .
'What is essentially unwomanly and what are the only rightful
functions of true womanliness?' . . . 'Why a Society of Female
Artists? Why this exclusive exhibition of art – this petticoat
republic?' The phraseology may be unfamiliar to us, but the
inquiries are the same as those which present-day feminism
has forced in the art centres of the western world and within

the discipline of art history: what is assumed by the words 'art' and 'artist'? How do the edifices which society constructs on gender manifest themselves in that area of human activity called Art?

In 1859, the writer on art Anna Jameson declared in *Sisters of Charity*:

However we may depreciate the idea, it cannot be denied that we are in the midst of a moral and social conflict which is disturbing the deepest elements of our moral and social life, compared to which all political and national conflicts are superficial and transient.

She meant the 'woman question', the backdrop to the debate on women artists, of which most people know only the late, suffragist stage but which arose in Britain at the middle of the century. Just as the 'woman question' was a major aspect of life in the latter half of nineteenth-century Britain which has been left out of many history books, so women artists (and thus questions such as the ones posed above) were a hot topic in the British art world from 1850 to the end of the century, though most conventional histories of the arts in the Victorian age seem reluctant to tell us so. They prefer to discourse on the importance of Preraphaelitism, the rise of photography, or the history of the Royal Academy – all subjects of some but not greater importance.

To pay attention to the history of women always calls into question the assumptions on which other histories are based, and the history of art is especially jealous of its traditional definitions, categories, and exclusions. In the western tradition, the history of art as an academic practice and in its popular form has largely consisted of male scholars and collectors attending to the work of male 'creators', all of them espousing or pursuing a doctrine of romantic individualism which is in itself born of a male experience of the world and a masculine sense of self, tacitly bound to perpetuate situations of snobbery, privilege, and inequality. You could say that the

'woman (and art) question' opened up these matters for questioning, and that in our own time we are trying out possible answers.

The question of women and art in nineteenth-century Britain should be seen as related to several other trends or events of the middle of the century. It can be related firstly to the tide of radicalism and agitation for change which emerged from oppressed groups throughout Europe in the 1840s, leading modern historians to call 1848 the year of revolutions. It has a strong relationship with the scandal of the so-called 'redundant' women: middle class women who could not (because of the smaller number of men in the population) or would not (because of changing ideas) marry and thereby knit themselves neatly into the social and economic fabric of mid-Victorian society. It was William Greg's essay of 1862, 'Why are Women redundant?', which coined the derogatory term for the newly plentiful ranks of single middle-class women who were making sudden uncomfortable demands on the employment market, but it was the fundamental character of Victorian society which saw vast numbers of husband-less middle-class women as unwelcome misfits.

There are other important issues relevant to the women and art question. One of these was the challenge to the established practice of the fine arts expressed by the Great Exhibition's initiative to beautify industrial manufactures. Another was the contradiction between types of Victorian womanhood: the exploited, impoverished needlewomen (symbolised for the concerned bourgeoisie by Thomas Hood's poem 'the Song of the Shirt', published in *Punch* in 1843) and the model of womanhood offered by the prevailing ideology (exemplified by Coventry Patmore's poem 'The Angel in the House', 1854 and 1856, and satirised by Elizabeth Barrett Browning's poem 'Aurora Leigh' in 1856).

Class was crucially entangled in this complex question of women and art. An ideal design worker was seen as a working-

class person whereas the ideal artist was assumed to be a member of the middle or upper classes. Neither artist nor artisan was thought of as female.

The relationship between gender and class came clearly to the surface on the point of art education, which many saw as the crux of the matter when the debate opened at mid-century. The *Art Journal*'s review of the second exhibition, in 1858, of the feminist-initiated Society of Female Artists showed its awareness of the limited art education available for women:

. . . that which we see at the Egyptian Hall is the result of assiduous self-tuition, for we have no school for the instruction of ladies in painting from the living model. Labouring under such disadvantages as the female student does, we are not disappointed to see here so many drawings of flowers, fruit, and still-life objects – we are only surprised into exaltation to see so much excellence in the higher departments of Art . . . There is now an end in female education to parti-coloured butterflies and favourite canaries: we are surrounded here by evidence of the severest study, and those ladies who wish to gain a shred of reputation must sit down patiently with their best instructress – Nature.

The training options open to creative women at the middle of the century were self-help, the private drawing master who visited one's home or whose house one visited for tuition, the Government Schools of Design, or private schools such as Sass's (later Cary's) or Leigh's (later Heatherly's). There was also the additional resort, if ambition, snobbery and/or wealth led them to it, of training on the Continent where, it was believed, there was less institutionalised prejudice against women making art (as opposed to serving it as models or muses).

In 1857 a campaign was mounted by women, including Anna Jameson, to oblige the Royal Academy School to admit female students. Though the Academy's ideology and exclusiveness were coming under attack from various quarters at

this time, it was the only source in England (there was a separate Scottish Academy) of a fine art education that commanded respect. The campaign was publicly supported by numerous women already active in fine art, such as Henrietta Ward, by others wishing that they were, and by yet others who were engaged in the general struggle for broader opportunity for women. The impetus for the campaign came from the recently formed women's groups that had sprung up in liberal and radical middle-class London circles in the 1850s. The Royal Academy responded with an insistence that women *were* eligible for admission but that none ever applied. (The two female founder members of the Royal Academy, Angelika Kauffmann and Mary Moser, had not been replaced at their deaths by other women.) When, however, in 1861, a woman was passed into the School on the merit of her work as L. Herford (rather than Laura Herford), the Academy's hypocrisy was displayed by the embarrassment it showed when her gender was revealed. From this time, women gained some access to a rigorous and informed fine art education albeit one whose outdated reliance on the classical tradition was attracting increasing challenge from modern minds. The Academicians' prejudice against the women they had never really wanted to admit within their precious precinct ensured, however, that women's numbers were kept down by various strategies, leaving their ideal pupil still the upper-middle-class male.

At the same time, in the Government Schools of Design, it was class prejudice which kept women out. The government wished to produce designers for industry, artisans rather than artists, so the middle-class woman, presumed to be engaged in a hobby since if the world were arranged aright she could not possibly be seeking a job or career, was made even more unwelcome than the working-class woman, who was herself typecast in certain lines of work according to notions of femininity (nimble fingers and the like). The Government

5

Schools system did include a specific institution for women, the Female School in London, but the education offered there was an uneasy mix of tasks which neither satisfied a woman's ambition to learn art nor met her need to get a decent job. On top of this the government put less effort and money into the Female School than it did into other branches of the system, pushing it from pillar to post until it became a royal charity in 1862, relieving the government of the need to show any responsibility for it, either actual or feigned.

The middle-class woman, then, was caught in a limbo between the tradition that she be an idle-seeming, house-bound showpiece of her husband or father with neither the wit nor the will to work seriously at anything creative or productive, and the actuality that she was increasingly often single and independent, economically needy, and ambitious for equal rights for her sex. The Government School did not want her since it assumed she was, and thought she should be, looking only for distraction; the Academy would not have her since it wished to retain the licence to create (and the status that went with it) for men. Working class women were viewed exclusively as artisans, with the result that their creative potential was stultified and 'art' was kept aloof from their ambitions. But great numbers of women were no longer willing nor able, especially in the middle class, to play the part demanded of them, and thus all the tacit prescriptions on which art education and practice were based were, like those in other areas of society, forced out into the open for discussion.

The connecting aspects of mid-Victorian Britain which affected the position of women and the position of art were constantly addressed by a huge range of commentators in the 1850s and 1860s, though not necessarily honestly nor directly. Much professional criticism of women's artwork was prejudiced, disingenuous and hypocritical, based on hearsay, editorial pressure and scant attendance at the shows they were

6

claiming to review. Reviews of the Society of Female Artists' annual exhibitions run the gamut of attitudes, from suspicion and anger at female autonomy, through patronising or amused tolerance, to a double-edged support for female segregation which amounted to banishment from other venues. The diverse positions adopted by critics, artists and patrons were not simply of the 'goody' or 'baddy' order and were often inconsistent and confused. A writer who objected in 1857 to the appearance of the SFA might in 1867 be urging women to ensure its continuance by their patronage. Women themselves took up very different stances on the women and art issue – as they might do on the general question of women's rights – which involved their class as a powerful second determinant in their art politics. For obvious (though not acceptable) reasons, it is upper and middle-class women's opinions we know most about.

That many women did manage during this period to think of themselves as artists, to produce art and write of themselves as artists – as this anthology testifies – might have revealed many traditional 'truths' about women and art to be convenient fictions, might have swept such patriarchal contrivance and manipulation away, and might have instituted a new egalitarian order, albeit with much egg on many, chiefly male, faces. But the self-serving prejudice by which men such as the Royal Academicians kept women's creativity pigeon-holed and repressed and maintained a very particular definition for the words 'art' and 'artist' was not – as we still find today – easily reformed, and it was even less easily dismantled. The result was that though women's cause in art did seem to move forward, and individual women managed particular successes, the picture overall was of one step forward and two steps back.

For example, Louisa Starr won the Academy School's highest student award, the Gold Medal for Historical Painting, in 1867; in 1874 Elizabeth Thompson became an over-night

success when her painting *The Roll Call* proved to be the sensation of that year's Academy exhibition; Ellen Clayton found two volumes worth of material for her book *English Female Artists*, published in London in 1876; Anna Mary Howitt confidently declared in the preface to the second edition of her youthful autobiography *An Art-Student in Munich*, which came out in 1880: 'The difficulties which the habits of society of that day (1853) placed in the way of a young woman seeking an independent career in Art, or, indeed, in any other direction, have now almost wholly passed away.' But in the very same year, Louise Jopling wrote to her son: 'Did I tell you that they talk of limiting the number of female students at the Royal Academy because they carry off all the prizes from the young men!!!' Liberal support of the 1860s was eclipsed in the 1880s by a weary impatience or an outright return to old prejudices.

The note struck consistently in conservative quarters in the eighties and nineties was that having had their spot of limelight, the women should just get on with things – in short, they should shut up or go away. Even the painter William Frith who imagined himself supportive of the women's cause, could write ingenuously in 1887 in his autobiography: 'Whether we shall have female Academicians or not depends upon the ladies themselves; all the honours the Academy can bestow are open to them'. The art press of the 1880s carried clear signs of a rearguard action to arrest, and in some cases to negate, the changes which had come about during the previous few decades, so loudly trumpeted at the time. Such unprecedented infringements of male privilege as the purchase by the Chantrey Bequest in 1890 of Anna Lea Merritt's painting *Love Locked Out* (p.47) for the Tate Gallery had to be paid for. The Arts and Crafts Movement proved a powerful decoy, tempting women away from challenging the male monopoly in fine art with their painting and sculpture and nudging them into traditionally womanly and less authoritative fields of

8

cultural production. These types of creative activity, such as sewing, were more 'comfortable' and less threatening to the company women kept. In 1879, promoting an exhibition of needlework, the *Art Journal* ran a feature entitled 'An Exhibition of Woman's Work', which claimed in tones of carefully calculated flattery and divisiveness:

If the position of the needle as the sole or the chief implement of the graceful industry of woman has been somewhat impaired by the attention which the ladies of our own day have given to the pencil, the chisel, and the brush; to music, to literature, or to a wide range of occupations once considered proper to the ruder sex; nonetheless does the needle continue to be, par excellence, the woman's implement.

Twenty years previously, the *Art Journal* had, under the same editorship, waxed heroic in its defence of women's right to demand a *fine* art education and vouchsafed its certainty that, once properly trained, women would prove themselves as painters and sculptors. *The Magazine of Art* was nastier yet in its attempted subversion, running in the 1880s insidious articles whose titles tell their own tale, like 'Artist and Wife' (1881) and 'The Love Affairs of Angelika Kauffmann' (1882).

The events and discussions of the 1850-1900 period are the backdrop against which the authors of the books presented here tell their stories. It is owing to the developments of that period that these books, telling the life-stories of women artists, were brought into existence. They can serve us now as an additional source of evidence to stand with the artists' paintings and drawings as testimonials to their aims and efforts. In fact, in some cases, written evidence serves as the only source because women's pictures and sculptures have disappeared without trace, undervalued by earlier generations.

The authors' engagement with an art world struck by feminism varied according to several factors, which though

not traditionally taken into account in considering an artist's life and work, are relevant and enlightening. Firstly, generation and age: Anna Mary Howitt (1824-1884) was a young woman at the time of the swelling of the tide, and was dead before the reaction had set in; Henrietta Ward (1832-1924) was one of the group of artists made figureheads at the start of the women artists' movement, though she survived into a very different climate; Elizabeth Thompson Butler (1846-1933), Louise Jopling (1843-1933), and Anna Lea Merritt (1844-1930) were among the beneficiaries of their elder sisters' efforts but were also vulnerable to the quietism that so often besets the generation which follows great change; Estella Starr Canziani (1887-1964) writes about another woman of this generation, her mother Lousia Starr (1845-1909), through whom she appreciates the long chain of which Estella herself is the most recent link considered here.

Secondly, class and social circle: all of the authors came from the middle classes, and benefitted from the liberalism of parents or family who surrounded themselves with an educated and articulate circle of friends. Howitt's and Lea Merritt's families were Quaker, Canziani's mother married into an Italian family, Thompson Butler became a converted Catholic: these, too, are factors which affect an artist's work as they affect her life, just as similar factors in the viewer and reader affect her reception of the picture or book to which she turns her attention.

All these artists travelled: Canziani's mother Louisa Starr was American, as was Lea Merritt; though they took up residence in Britain, they saw other parts of Europe as well. Howitt, Jopling, and Thompson Butler write of their sojourns abroad, making Ward who ventured out of Britain only for her honeymoon seem very much the stay-at-home. Though the different women's experience of the world varies with the circumstances of their voyage, they are all typical of the educated middle-class Victorian in their complacent interest

in the rest of the world. This was the age of imperialism and colonialism, in which Britain was a prime mover, the age of the railway and of photography; one could come to know the world much more than previous generations, but one did not necessarily come to know it better.

Marriage is another factor that affected these women's engagement with their times. Both Ward and Jopling, in the extracts presented here, discourse on the pros and cons of marriage as their experience reveals them; the former with little overt complaint, the latter with much. Ward was married once, very young and very happily, while Jopling had three husbands during her young and middle adulthood. Lea Merritt married twice, widowed in both cases after a short time, so her predominant experience of life is as a single woman, though it is a different sort of singleness from Canziani's who seems never to have anticipated marriage. Thompson's marriage cemented her career, whereas Howitt's seems to have provided a retreat from hers. Louisa Starr, Canziani tells us, negotiated a relationship between marriage and career which few women enjoyed in her generation, though they saw the passing into law of such initiatives to improve women' choices as the second Married Women's Property Act of 1870.

In addition to being a wife, whether or not she became a mother made a material, psychological and social difference to the life of any middle-class woman of this era. To one wishing to practise art, it affected the nature and scale of her creative work, the physical conditions under which she might work, and the consistency and duration of her practice. Ward, for instance, though mainly ambitious to paint history, produced a number of domestic anecdotes and nursery scenes. Critics tended to reproach her for this but her account of her early career offers an explanation: 'So far, as may be seen, I had not specialised – at least not to any great extent – in historical painting, confining myself instead to domestic subjects, which was surely natural, as all my leisure moments were of

necessity spent in looking after my children.' It was of Ward's painting *The Despair of Henrietta Maria at the Death of her Husband Charles* at the Royal Academy in 1862, that the *Art Journal*'s critic wrote, with unusual understanding:

As the work of a lady, it is really wonderful; for so much has been said about the restricted opportunities of women, – from inability to devote themselves entirely to one pursuit, when they are expected to be equally accomplished in many. Indeed, so numerous are the calls for employment of time in such phases of occupation as are indivisible from them in the capacity, whether it be of daughter, sister, wife, or mother, – that such extraordinary excellence can seldom reasonably be expected.

Pursuing this thought, one wonders how many female artists deliberately remained childless or single to achieve their artistic ambitions. Certainly both Ward and Jopling found their hands full: Jopling was left by her first husband with children to support and widowed of her second before the children were independent, while Ward was left at her husband's death with seven dependent children. The fact that both opened schools of art for fee-paying students is surely no coincidence in the light of these circumstances.

It is in an economic light, too, that we can see the women artists' adoption of the role of author. Many Victorian cultural figures had some form of autobiography published, and the general interest in public figures among the literate Victorian and Edwardian public was emphasised by the nineteenth-century weakness for heroes, or lions as they were called, (and, in a much more negotiated way, for heroines and lionesses, too). The fact that several such figures belonged to the women's social and political circles encouraged them to see themselves as authors.

Though there were a few models of women artists' auto-biographies for them to follow, notably the *Souvenirs* of the French eighteenth-century painter Elisabeth Vigée-Lebrun,

perhaps Elizabeth Gaskell's *Life of Charlotte Brontë*, and the notorious diaries of the Russian Marie Bashkirtseff, they were mainly influenced by the memoirs of their contemporaries, above all the standard one-volume book of middle-class memories which the Victorian period produced in such abundance. Its influence is most clear in Ward's, Jopling's and Thompson Butler's books: a plethora of detailed accounts of social occasions with self-conscious lists of the famous names in attendance, obligatory mentions of Charles Dickens, William Gladstone, and Queen Victoria, and a judicious balance between the sentimental and the serious.

Though tediously lacking in analysis, this tendency is justified: Ward's family mixed with well-known cultural figures, were gregarious, and loved the royal family. Jopling worked hard at the social obligations of the ambitious artist and was a popular figure on the artists' social scene. Her anecdotes demonstrate vividly that the female artist was never allowed to forget that she was a woman before she was an artist, and that the portrait painter in particular was doomed to a sort of social prostitution as the price of acceptance. One senses that the famous friends whose names she drops with familiar ease are her attempts to compensate readers for being a mere woman. Elizabeth Thompson Butler, on the other hand, side-steps such self-deprecation by ignoring the ramifications of being a woman, just as one could say her art shrugged off her gender.

All the authors presented here adopt to some degree a literary form which is usually defined as feminine: the epistolary or letter form. Thompson Butler's travel books were based directly and largely on her correspondence home and on diaries kept during her journeying. Jopling's book is confessedly drawn from letters rather than from her memory. Canziani, Howitt, Ward and Lea Merritt use letters to provide additional information, to sketch a character or to change the rhythm of the narrative. In Lea Merritt's case, the usage is

obviously appropriate: she is writing about her correspondent, and letters are commonly thought to reveal a person's character in a very particular way. But this shared stylistic trait, so easily disposed of as feminine, has a more thought-provoking explanation.

Despite the fact that all these women came from middle-class backgrounds with rich cultural landscapes, their reliance on sources other than their own verbal and imaginative repertoire reminds us of the partial and premeditatedly biased education of the middle-class Victorian woman. Since middle-class girls were required to learn nothing superfluous to winning a suitable husband, their directors and mentors favoured the elegant over the exciting and the artistic over the arduous. In a lady, acumen was unbecoming and ambition inconvenient, unless hers was an unconventional home. The fight for higher education for women was taking place as these women grew up. Though some, like Louisa Starr, believed in equal opportunity for women, it was only the rare girl like Thompson Butler who, thanks to 'advanced', indulgent and enterprising parents, received a consciously programmed education to fit her for a life outside the home. Furthermore, if any woman showed a talent for art when young, it is likely that verbal skills and general knowledge would have quickly taken a back seat. Both Ward and Thompson Butler tell of precocious talent encouraged by the family, while Canziani writes that her mother, who 'from a tiny child . . . loved drawing', expressed a wish that she would in turn become an artist when she was twelve years old.

One of the received wisdoms of the history of art is that great artists show talent when young, and that nothing can smother their 'natural gifts'. Such romanticism feeds the desire for heroes and heroines, which is not necessarily bad; more seriously, it mystifies the art-making process and mythologises the artist. For many Victorian artists of both sexes, art-making was a trade, often turned to soberly and

pragmatically as a feasible way of earning a living. Many Victorian women artists saw art not as a pleasure but as a job on which their lives depended. In contrast to Ward or Thompson Butler, Jopling and Lea Merritt point out strongly that practising art seriously was a strategy for survival before anything else. Their art derived its importance from their circumstances rather than from a romantic belief in vocation, and their writings show little interest in genius, that seed of greatness which will out despite everything.

In this they are typical of numerous 'redundant' middle-class women, misfits through singleness or widowhood, whose lives were given economic feasibility and individual meaning by their turning an item in the required wardrobe of femininity into a functional and fulfilling activity. Educated to dabble in something artistic in order to prove their attractions as potential wives, they channelled their creativity into bread-winning and independence. Anna Lea Merritt, in a later book than the one quoted from here, illustrates this attitude:

One of them proposed to confer upon me the honour of teaching her daughter to paint, and assumed a lofty air of patronage. 'Pupils were not in my line; but it was possible the young girl had great talent, and did she wish to support herself as an artist?' With great pride: 'Oh no; she does not have to work.' Then said I: 'I feel no interest in teaching her.'

Given that painting – female sculptors were fewer, and not one has left us an autobiography – was so central to the lives of these women, a glaring lack in their accounts is information about their practice and aesthetics. Given the tendency in art history to validate artists' importance by their theory, by the originality of their analysis of the painterly problem, by the independence of their thinking, this tends to make us doubt the women as artists. We may have their pictures, but where are their ideas, asks the doubting critic. Admittedly Howitt and Thompson Butler describe things from a painter's point

of view, that is, in terms of tone, colour, mass and picturesqueness. Butler, especially, comes over as the ever-eager eye, alert to the possibility of a good 'scene' anywhere she goes. Howitt lays before us her vision of the ideal artistic community, a women's college of creativity, in which she gives some idea of her understanding of the function of art and its practice. All the authors except Lea Merritt, who not being the ostensible subject of her narrative suppresses matters relating to herself, freely mention their paintings and all except Howitt illustrate some of them, though only Butler's books use colour. This certainly makes their art visible, but even so these books do not assert their authors' artistic credibility. Perhaps in their own day it was assumed, but a modern reader might need more convincing.

All the writers tend to give the reader the anecdote or melodrama surrounding the production of a painting rather than an exposition of the technical and theoretical decisions which produced the work. Why did Ward choose the figures from history which she painted? What was it about the past which attracted the artist, or the woman, she was? What were the principles taught by Jopling or by Ward in their schools? What sort of canvas, what extent of preparatory drawing, what photographic aids, did Butler employ? These questions are neither posed nor answered in the books. On the one hand, this silence seems a negative factor: the artists reveal little learning or analysis underpinning their work and they do not present it as part of a definable, conscious project. On the other hand, it could be seen as positive: the artists correct the romantic aggrandisement of art and its practitioners by bringing art-making down to earth and revealing it in its everyday context.

Perhaps even more to the point, the reader is forced to recognise the difference between women as artists and men as artists, between the description of art-making as written by women and as written by men. Putting aside questions of

whether these women wrote to the market rather than according to personal inclination, we see that these artists did not have the self-importance that most male artists and their hagiographers did and do. We see that their self-image is not one of remarkableness let alone uniqueness and that they were practised in modesty not arrogance. We see that, though their times told them of woman's right to chose and a woman's ability to achieve, their society discouraged them from analysing their choices and conditioned them to minimise their achievements.

All the authors except Howitt would have known the awful example of the creative woman who did *not* know her place: Marie Bashkirtseff, a young Russian who wanted to become a painter once it became clear she could not become an opera singer and who died young in 1884. Her diary was published in 1890, causing a vigorous reaction amongst its public in London, Paris and New York. Her self-absorption, her ambition, and her railing against the unfairness of women's position combined to outrage and confirm the conservative sensibilities of men and women who were equally fed up with the women's movement, women artists, and the licence of modern art. The opprobrium dropped on Bashkirtseff in her posthumous role of embodiment of all that was dreadful about women's rights, especially in the arts, must have alienated many creative women from their own ambition, if they were young, and from their own achievement, if they were older.

The seven books presented here are the work of individuals as well as the work of women. Though they are all rememberings, they are meant to be different sorts of book: Lea Merritt's is an elaborate obituary to her husband; Howitt's is a portrait of a foreign place and a sort of artistic manifesto; Butler's two books recount her experience of life; Ward's, Jopling's and Canziani's books are memorials to an era. All give us different sorts of knowledge. They tell of particular lives, they give information about Victorian women artists,

and they speak of their authors' diverse interests. Their ways of telling are in themselves informative, for they form part of a general construction of the Victorian age which was made at the beginning of the twentieth century, and they remind us of the ambiguous role played by the individual voice in telling the story of the past.

In reading these rich and valuable accounts, we are bound to reread other descriptions of the same subject-matter and to reassess the requirements we shall have of any future works of history we come across, especially if the 'history' is of art or of women. From an earlier battle-ground, these women's writings address the combatants in the present-day struggle, which occupies a similar site. These extracts are brought together to offer a neglected but invaluable resource: here is history of women and history by women for the enrichment of everyone's notion of the past and occupation of the present.

Pamela Gerrish Nunn

[All excerpts use the original punctuation and spelling]

ANNA MARY HOWITT

An Art Student in Munich
(1853)

THIS two-volume account of Howitt's search for art education in Germany was prompted by two family friends: the novelist Elizabeth Gaskell and Henry Chorley, editor of the *Ladies Companion*. It attracted good reviews, though its rapturous enthusiasm for early nineteenth-century German painting and in particular the work of Wilhelm Kaulbach limited its appeal. Even so, its relationship to the burgeoning women-and-art movement as well to the new Preraphaelitism must have found it many readers. A second edition was released in 1880, when Howitt's own career as an artist had long since ended.

She was the first child (b.1824) of William and Mary Howitt, noted Quaker litterateurs and social commentators. Anna's mother records 'a fine talent' evidenced by her daughter's juvenile drawings in her diary for January 1834, though there is no record of Anna Mary having any formal art education either in Nottingham, where she lived as a child, or at Esher, where the family dwelt from 1836.

In 1840 the Howitts journeyed to Germany, then a collection of separate states not to be unified until 1872, meeting such cultural figures as Anna Jameson and Moritz Retsch, the foremost German graphic artist of the time.

They returned to England in 1843, moving to London in 1848, where Anna Mary deepened her friendship with women and men from Nonconformist backgrounds who were interested equally in art and politics. Prominent among these were Barbara Leigh Smith (later Bodichon) and Eliza Fox, bent, like Anna Mary, on becoming artists.

Mrs. Mary Howitt's diary records that in 1850, 'My eldest daughter, who desired to devote herself to art, had never forgotten the profit and delight which she had derived from our visits to the German capitals and their works of art . . . Anna Mary felt that Munich and Kaulbach would afford her the most consonant instruction, and in May 1850 went thither . . .' At home, Anna Mary had had her own painting room and the instructive companionship of other aspiring female artists; in Munich, with her friend Jane Benham (later Mrs. Benham Hay), studying under Kaulbach, she developed both her artistic abilities and her art theory.

The extracts presented here include Howitt's vision of an artistic community of women, a parallel to the sisterhood which was growing up in London amongst the feminists with whom she moved. Either Howitt or her mother was probably the author of a story called 'Sisters in Art' featured anonymously in the *Illustrated Exhibitor* in 1852, which conjures up a similar utopia. A significant aspect of Howitt's ideal is that it embraces fine art and design, on equal footing; both she and Jane Benham put this ideal into practice, working as hard at their illustrations for the press as at their paintings for exhibitions, though little work by either woman remains.

When Howitt returned home in 1852, the family circle included members of the Preraphaelite movement and a vigorous anti-slavery connection through her mother, who was one of the Ladies Committee organised by the Duchess of Sutherland which collected 576,000 signatures in 1853 demanding the abolition of slavery. The impetus for her return was her father's decision to visit the goldfields of Australia in

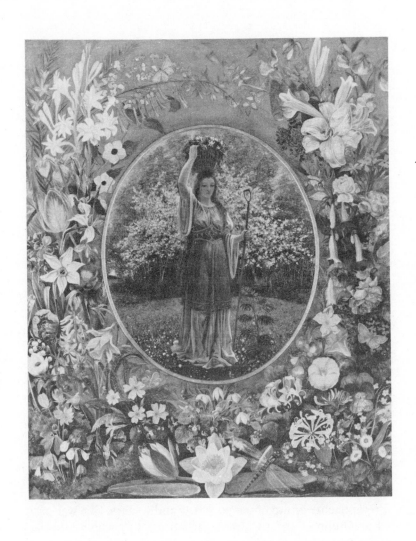

ANNA MARY HOWITT, *The Sensitive Plant (The Lady)*, 1855

C-C

search of a possible new life for the whole family, an idea later given up as impracticable.

Anna Mary Howitt's first appearance as an artist was with illustrations in the press during 1853; her paintings featured in the London exhibitions from 1854. Significantly, she chose to show her work at the National Institution (also known as the Free Exhibition), which had been set up some years previously as a democratic alternative to the Royal Academy and its imitators. Her exhibited paintings, still nearly all untraced, seem from their titles and descriptions to have indicated both her feminism and her earnest Germanism. *The Sensitive Plant* of 1855 (p.21) was reviewed by the *Spectator*: 'There is a warm grace in the lady's figure, and a tone of awe in the death scene – with a certain tinge, however, of German attitudinizing in both.' The Germanic influence was equated with English Preraphaelitism by some critics; the *Critic* dismissed *Faust's Margaret returning from the Fountain* (1854), the first work to bring her to the public's attention, as 'an attempt in the Millais school'. The *Spectator* critic F.G. Stephens, a member of the Preraphaelite circle, appraised this work in terms that placed her more carefully: 'There is none of that ultra-Germanism in the picture which one might have been disposed to predict from Miss Howitt's Munich studies and enthusiasms, but on the contrary an unmistakable adherence to the English Preraphaelite practice'.

It is not known whether she wished to be seen as belonging to a German school of art or to the Preraphaelite movement, but we do know that she was closely involved with the Preraphaelite group of young artists and writers. She was part of the Folio Club, a Preraphaelite project in which a folder passed around the members, each adding a piece of work to it as it came through their hands; in August 1854 Dante Gabriel Rossetti wrote to William Allingham that the Folio currently included a glen scene by Barbara Leigh Smith and a piece by Anna Mary 'called the Castaways, which is a rather strong-

minded subject, involving a dejected female, mud with lilies
lying in it, a dust-heap, and other details.' She was also
involved in the personal problems and concerns of the Pre-
raphaelites. Howitt and Barbara Leigh Smith provided com-
panionship and care for Elizabeth Siddal, the principal Pre-
raphaelite model and Rossetti's partner, during her illness and
Preraphaelites were often at Howitt family gatherings. It is
from a Preraphaelite source that we get a hint of the stress that
Howitt came under at this time, undoubtedly a situation
which foreshadowed the artist's decision to give up her profes-
sion within a few years: Rossetti reports in January 1855 that
Anna Mary had been seriously ill since her father's return, and
in December 1856 'he fear(s) Miss Howitt is anything but
well.'

By 1858 Howitt had made her last appearance in a London
gallery; when, in 1859, she married and became Mrs. Alaric
Watts, her chief interest was spiritualism. Her intense in-
volvement in the women's movement and in professional art
was wiped away. Her mother's diary gives one explanation:

Our daughter had, both by her pen and pencil, taken her place
amongst the successful artists and writers of the day, when, in the
spring of 1856, a severe private censure of one of her oil paintings by
a king amongst critics so crushed her sensitive nature as to make her
yield to her bias for the supernatural, and withdraw from the
ordinary arena of the fine arts.

The critic was John Ruskin, one of the mixed blessings of an
involvement with Preraphaelitism. Her interest in spiritual-
ism supplies another explanation. Though frequently ridi-
culed, spiritualism found an enthusiastic audience amongst
certain radicals, and remained a talking-point in middle-class
London circles for some time; in 1870, William Michael
Rossetti, brother of Dante Gabriel and a Civil Service col-
league of Howitt's husband, wrote in his diary that 'she does
not now pursue art, except under the form of Spirit Drawing.'

There must be more to it than this: Howitt acknowledged her own morbid nature and tendency to religiosity, and Ruskin could indeed be an intimidating man with erratic and tortuous attitudes to women and to women artists, but on the other hand she was surrounded by projects and opinions which should have reinforced her feminist and artistic aims. The Society of Female Artists, a product of the energy and visions of women like herself and Barbara Leigh Smith, was founded in 1857 and in 1858 Howitt exhibited with it. 1857 also saw the introduction to Parliament of attempts to reform marriage law and property law in women's favour, resulting in the passing of the Divorce Law. In 1858, the women's movement saw its own paper come into being, *The Englishwomen's Journal*, instigated by Barbara Leigh Smith and other friends of Howitt. Perhaps the key lies with Barbara Leigh-Smith who in 1856 met Eugène Bodichon, a French doctor, whom she married in 1857: the close and important friendship between Howitt and her sister-in-art must have been greatly altered by this new situation, and who knows how discouraging this was to the idealistic Howitt?

Anna Mary Howitt continued to sketch for her own pleasure, and the Howitts' circle still included many artists and radicals. In her preface and appendices to the second edition of *An Art Student in Munich*, 1880, Howitt neither regrets her decision of 1856 nor casts any light on it. In the extracts presented here, the author introduces two friends who, sharing her aspirations in 1850, pursued them long after Howitt altered her course: Clare is the pseudonym for Jane Benham (Hay) who came to prominence in the London exhibitions around 1850 and who later lived in Italy, as she and Howitt had in Munich, the life of a devotee to art; Justina is the name under which Barbara Bodichon appears. The two chapters come from the early part of the first volume, but the author's enthusiasm lasts until the very end of the books. The closing lines of *An Art Student in Munich* are: 'As hour after hour

removed the Art-Student from the beautiful Art-city of Munich, only the more noble did the Art there and the artist-life rise up before her, as if transfigured in her soul.'

PASSING SKETCHES

A T half-past six we breakfast, and then, as early as we can, set off to our work. It is a pleasant walk along the quaint old streets, now passing beneath the Falcon Tower, a heavy round mass of stone, which tells well from different points against the deep blue sky. All is bright and joyous: peasant-women, young and old, in their strange costumes, some with heavy round caps of black fur, some with black or gay-coloured handkerchiefs bound tightly across their brows, others with their little gold or silver *Riegel Hauben* (Munich caps) sparkling in the sun, others in Tyrolean hats, all are hurrying along with baskets to the market. Sentinels are standing on duty at almost every turn, their bayonets glittering in the sunshine. We see on our way numbers of beautiful groups and effects.[1]

The other morning, walking along our favourite path, one of the branches of the Isar, at a turn in the road just where the stream was crossed by a little wooden bridge, we came upon a peasant-woman with a reaping-hook in her hand. Behind her was a background of foliage, a magnificent tangle of vines; she had a sun-burnt, handsome, strong face, brawny brown arms, loose white chemise sleeves, a black handkerchief on her head, whilst over her breast was crossed an orange kerchief, on which the sunlight fell dazzlingly in its brilliancy. Such colouring I never saw before; and beyond, above the vines, was deep blue sky, which heightened the effect wonderfully. It was a study for Etty.[2] She looked like a bird, with a strange brilliant orange breast.

Having crossed this same wooden bridge, we come to a quaint little baker's shop, in which, half filling it and surrounded with heaps of pretty-looking bread, and in an atmosphere oppressive with aniseed, sits a very fat old woman, from whom we buy a pennyworth of bread, – enough and to spare for our drawing, and for ourselves.

And so, crossing another bridge, a stone-mason's yard, and another busy stream, we reach the gate close to the house where live the people who look after the studio. Here we are already recognised by the old dog as belonging to the place. If we are early we ascend the steps and ask for the keys of the studio, or perhaps a little brown-eyed girl, with her hair in a net, runs to meet us with them.

Two minutes more, and we unlock the heavy door and stand in our art-temple.[3] The high priest as yet is not there, and we have a quiet, earnest studying of his pictures, endeavouring through them to discover how he looks at nature – endeavouring to see only the beautiful, the strong, the tender. This union of the strong and the tender seems to me the great characteristic of his mind. But is not that the great and difficult union which we are all striving after, whether in life or in art? Is it not that glorious union, in its perfection, which we adore in Christ? Is it not this in our noblest poets – in the *In Memoriam*, for instance, – which so touches and ennobles us?[4]

We drew last week, as a refreshment when weary with harder work, a lovely branch of white lily, and became so enamoured of this study that we determined to make another. We resolved to group together the most beautiful flowers growing in the beloved wilderness-field in which the studio stands, and to keep them as memories of this beautiful place, and this no less beautiful passage in our lives. We began, therefore, the other afternoon; and to-day, being seized with a foreboding that as the field was now again covered with deep grass and flowers it would shortly be mown, we determined to draw flowers from morning till evening.

The change of occupation was in itself a pleasure, and with our usual insane enthusiasm for every new kind of work, we declared, and most firmly believed at the time that nothing in the shape of work could compare with the delight of drawing flowers, – the tracing their exquisite delicate lines, their infinite variation of form and character, the living in spirit,

like fairies as it were, among their bells and under their leaves.
Then, two or three times in the course of the day, we had to
make little expeditions into the field for specimens; and, as it
luckily happened, nobody was at the studio that morning, we
had the whole paradise to ourselves, and could go about freely
as if in our own garden. We sat among the flowers in the warm
grass, among bladder-campion and clover, lady's-bedstraw
and hare-bells, thyme and eye-bright. Above, the sky was
cloudless, and so intensely blue, that to talk of Italian skies
being bluer seemed to be absurd.

July 21st – How much time I have wasted in looking out of the
window and watching the blue-coated postmen, as the clocks
strike twelve, filing up the street from the Post-office, each
with a large packet of letters in his hand. Surely *one* among *all*
those letters must be for me!

A blue-coat turns in here! I wait and wait, and wait, but no
letter! No doubt it was only a letter he brought for one of the
hundred other inhabitants of this house, – for some student or
dressmaker who lives above, or for the master of the curiosity-
shop, or for some of his journeymen, or for Mr. Bürgermeis-
ter. Somebody, who lives on the floor beneath; for some one,
perhaps, at the Tailor's or, the Jeweller's, or the Bookseller's,
or perhaps for the Under Secretary Wagner, who has such
numbers of letters and official documents brought to him. At
all events, the letter is not for me! '*Paatience! paatience!
paatience*', as our friend L —— says. But how gay the street
looks! Such numbers of butterfly-ladies, in gay muslins and
light kid gloves, and with bright-coloured parasols; such
dandified young officers with their ridiculously small waists –
they lace themselves up as tightly as the silliest of girls; such
clean *Bürger-Leute;* such picturesque groups of students,
their hair so glossy from its Sunday brushing, their scarlet
caps set so jauntily on their heads, their gay corps-bands
displayed over their snowy shirt-fronts; such a pleasant sound

of voices and trampling of feet along the sunny pavements. I'm quite inspired to put on all my Sunday apparel and look as gay as the best: I quite long to descend into my unusual character of 'young lady,' and go abroad for a pleasant un-*exalté* afternoon; drink coffee with a gay party under green trees to the sound of music, and criticise all the faces and toilettes that pass before us. I wish Alfred were here to-day; we would for a few hours be as little in the clouds as he could wish![6]

I see some capital dinners going along the streets. I trust our capital dinner will soon appear; we are always ravenous about 12 o'clock. And, *à-propos* of dinners, we had anything but a ceremonious dinner the other day. We usually dine at the *Meyerischen Garten*, where they have orders when it is wet to send our dinners to the studio. Last Friday, therefore, the sky suddenly clouding over about eleven, after a most brilliant morning, when we had gone forth *sans* cloak, *sans* overshoes, *sans* everything necessary for a wet day, we awaited the advent of our first studio-meal with the intensest impatience, not unmingled with a slight uneasiness as to its appearance! The loud-ticking clock told quarter after quarter, till at length one o'clock arriving without the dinner, and the rain still pouring down in torrents, and we delighting in the consciousness of the thinnest of boots and muslin dresses, and a wet field of long grass to pass through before arriving at the region of *Braten* and *Mehlspeise*, were forced to summon all our philosophy, and cry, 'dinner go hang!' Dinner indeed! We working in the studio of a great master, and yet longing for our dinners! No, we would forget prosaic hunger, and satisfy our craving in the afternoon at home. Just having reached this point of heroism, there is a knock at the door, and enter a short, broad-built, merry brown woman, with a face not unlike a mulatto, the resemblance even increased by her wearing a bright-coloured handkerchief on her head. Ah! we know that welcome countenance – that countenance of our friend the kitchen-maid at the *Meyerischen Garten*. Beloved

kitchen-maid, with thy bare feet and thy big basket, well dost thou deserve to be celebrated in verse! Would that for thy sake I were Tennyson! then should the world long since have reverenced thee with a reverence equal to that inspired by the 'Waiter at the Cock!'

At once there was a sudden starting up from our easels; a flinging down of porte-crayons, a rushing up to the big basket, a delight and rejoicing in English and German over the contents it exhibited.

'Splendid goose!' cries Clare; '*Herrliche Mahlspeise*,' cries Anna. The magnificent kitchen-maid laughs and shows her white teeth; and we laugh and bustle about, and sweep off prints and books, boxes and flowers, from the little round table in the middle of the room. But plates! knives! spoons! Oh, thou celestial kitchen-maid, where are they? Forgotten, as mere sublunary trash! What is to be done? Oh, borrow plates, and knives and forks, from the *Hausmeisterin*. Away goes the kitchen-maid, and returns with a plate, a knife, and fork. That was all very well for the goose: – but when it came to the pudding! 'Eat it out of the dish,' suggests Clare; 'this is a pic-nic among the cartoons, instead of among trees, that's all!' And the pudding was eaten out of the dish with no lack of merriment: but most of all did our laughter increase when we came to drink our coffee, which, by the by, I ought to have said arrived on a little green tray, all flooded with rain; the coffee in one little white-lidded jug, the milk in another, the sugar safe and dry in the basket. But again there were neither coffee-cups nor spoons! Beloved kitchen-maid! thy wits of a truth had gone wool-gathering! But that was quite a minor discomfort – a difficulty which we speedily got rid of, simply by mixing coffee, milk, and sugar, in a china jar, which we keep at the studio for flowers; and then, having duly blended the ingredients, the delicious beverage was poured into the two jugs, and each drank her coffee with as much gravity as she could muster.

But why, instead of all this nonsense, have I not described last evening, with its beautiful walk down that lovely Ludwig Strasse; the long pause in the Ludwig *Kirche*, which affected us, seen in the twilight, as it never had affected us before, and our enjoyment of a glorious sunset, which we witnessed over the plain. The immensity of a plain affects one like the immensity of the ocean. Yes, I love this plain, as apparently I love everything connected with Munich! Everything, excepting the heat, the rain, the veal, and – the fleas! The greatest of all plagues! There was no plague in Egypt to compare to them! They fairly leap about the paper as I write. I have long since given up the sofa, convinced that it is stuffed with fleas instead of wool.[8]

JUSTINA'S VISIT –
A GROUP OF ART-SISTERS

September 2nd – How delicious was my meeting with Justina yesterday! At the moment when I was sitting at a solitary breakfast – for Clare was yet asleep – with my mind full of Justina, and after having arranged and dusted everything in our rooms, to be ready for her, I heard the outer door open. I said to myself, 'Justina!' The room door opened, and she entered.

Of course the first thing we did was to cry for joy, and then to gaze at each other, to see whether really she were Justina and I were Anna. It seemed strange, dream-like, impossible, that we two could be in Munich together.[9]

BEFORE long we set off to Kaulbach's studio – Justina, Clare, and I; but we could not resist going a little out of the way to walk down the beautiful Ludwig Strasse into the Ludwig Kirche. Many things struck her much: the rich colouring

31

introduced into the architecture, the pervading presence of one great artistic thought throughout the city. She was more impressed than I expected her to be. I had always imagined the German school of art would not find a response in her soul; but she declared that an entirely new class of beauty, a fresh field of delight and thought, had been opened to her.[10]

When we entered the Ludwig Kirche, I saw her form dilate with emotion. She seemed to grow taller and grander; a rich flush came over her face; and her eyes filled with tears.

'I do not feel this,' said she, 'to be the work of man, but of nature. The arched roof produces upon me the same thrill as the sky itself!'

Then we walked through the light and shadow of the English Garden – and I pointed out to her those particular spots that had always reminded me of her landscapes; [11] and across the timber-field and the bridge over the mill-stream, and along the side of the rushing water, till we came to the grey, wooden door opening into the studio-field, and so along the narrow path between the thick grass and flowers, in the pleasant sunshine across the field. But I was obliged to hold Justina's hand in mine, else nothing could have persuaded me that this was not one of my many dreams. We passed through the bushes; we stood under the vine; we opened the heavy grey door: we were in the little room.

The clock ticked as loudly as usual; there stood the two sister easels, and a sister painting-blouse hung on each; the casts, the books, the green jug with flowers, all looked so familiar, that to set to work at once and to fancy that I had only dreamed of Justina, seemed the most natural thing. But there she really stood in the body!

And having now seen what we were beginning, and having taken into her memory all the features of the beloved little room, so that she could picture our lives when she should have again vanished, we went into the other studio.

Thoroughly did she enter into the spirit of Kaulbach's

works; she is worthy to understand them. She thinks, with me, that for intellect, and dramatic power and poetry, he is superior to any living artist.

We three, as it happened, had the studio all to ourselves; and we stood and sat before those grand works, in the most perfect repose and silence, and drank in the whole spirit of the place.

Justina looked grandly beautiful, with that golden hair of hers crowning her as with a halo of glory, and her whole soul looking through her eyes and quivering on her lips as she gazed at the pictures. I longed for Kaulbach to quietly enter, and see her standing before them like a creature worthy to be immortalized by him, – an exception to the puny prosaic race of modern days, who are unworthy to live in art, – who only deserve to pass away and be forgotten.

But the sublimest intellectual emotion can, after all, last only for a time, seeing that we all, the most spiritual even, are possessed of a double nature, – body and soul. It was now half-past eleven o'clock, and we were grown very hungry, for our joy at meeting had prevented our eating much breakfast; we betook ourselves to the Meyerischen Garten, paying the *Hausmeisterin* a visit by the way, – so that Justina might have an idea of a German kitchen with all its picturesque characteristics; might have a glimpse of her poetical little sitting-room and bed-room, made beautiful by Kaulbach's prints and sketches; that she might see the *Hausmeisterin*; that I might have the joy of saying to the good woman, 'Here is my beloved friend out of England, the sister of my heart!'

What a pleasant dinner was ours at the Meyerischen Garten! What joy we had in all three going into the kitchen and ordering *three* portions! What a delight to see Justina's amusement at the odd look of every thing! What merriment in our bower over our dinner when it arrived! The flock of turkeys came round us as usual; all the eternal were the same, but the spirit was very unusual which reigned at our little

dinner-table. No more 'grinding'. *Flexors* and *extensors* were fogotten; such things as anatomy, or work, or fatigue, or home-sickness, no longer existed. All was the joyous, blessed present!

Justina entered thoroughly into the spirit of our life, laughing at the want of salt-spoons and such luxuries; wiping the forks for our second course, our *Mahlspeise,* on the table-cloth, and drinking the coffee with an indescribable relish.

After this dinner, which Justina enjoyed with all the keener relish, from the contrast it made to the life she was leading, – a life of the highest respectability, a life of first-class travelling, of couriers, of the grandest hotel, of English solemnity, and aristocratic propriety. She declared again and again that there never was such a delicious, free, poetical life as ours; and she was perfectly right. I fully believe that she will in a while spend a month with us; perhaps join us in our Tyrolean trip.[12]

Justina is gone! I am alone this evening, as Clare is out with some English friends.

Thank God that she has been here! We all agree that three such gay delightful days never before were spent by three such accordant spirits; days which we shall never forget, and out of which Justina declares that something great and good must come. She, the very embodiment of health, soul, and body, without a morbid or mean emotion ever having sullied her spirit – with freshness as of the morning, and strength as of a young oak – has had the most beneficial influence on both of us through her intense love of nature and art, through the same aims in life, yet we all three so different from each other. Clare, a thorough creature of genius, born to success whether she had devoted herself to music, the drama, or painting, – an artist in the true sense of the word, with a dramatic power of expression in everything she attempts, and of a self-absorbed character by nature. I, possessing an intense devotion and love of art, of a sensitive, poetical temperament, which at times

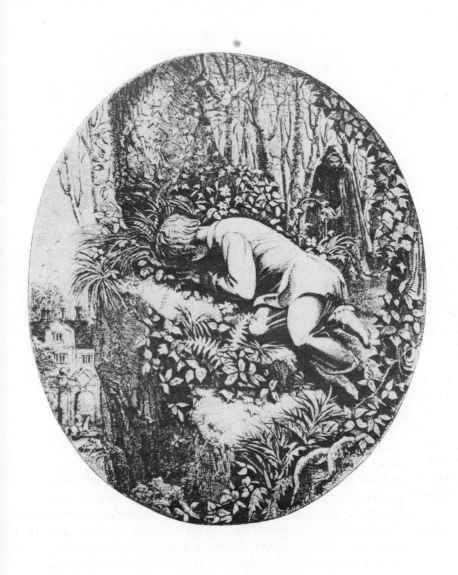

ANNA MARY HOWITT, *The School of Life*, 1853

35

becomes somewhat morbid, yet earnest, persevering, with a constant aspiration after the spiritual, and a firmer, much firmer faith in the unseen than either of the others.[13] Cannot you see how great must be our usefulness to each other, – our influence upon each other? We have been all three struck by this; we have felt our peculiar individualities come out in strongest contrast.

What schemes of life have not been worked out whilst we have been together! as though this, our meeting here, were to be the germ of a beautiful sisterhood in Art, of which we have all dreamed long, and by which association we might be enabled to do noble things.[14]

Justina, with her expansive views, and her strong feelings in favour of associated homes, talked now of an Associated Home, at some future day, for such 'sisters' as had no home of their own.[15] She had a large scheme of what she calls the Outer and Inner Sisterhood. The Inner, to consist of the Art-sisters bound together by their one object, and which she fears may never number many in their band; the Outer Sisterhood to consist of women, all workers, and all striving after a pure moral life, but belonging to any profession, any pursuit. All should be bound to help each other in such ways as were most accordant with their natures and characters. Among these would be needle-women, good Elizabeth —— s, whose real pleasure is needle-work, whose genius lies in shaping and sewing, and whose sewing never comes undone, – the good Elizabeth! how unspeakably useful would such an one as thou be to the poor Art-sisters, whose stockings must be mended!

Perhaps, too, there would be some one sister whose turn was preserving, and pickling, and cooking; she, too, would be a treasure every day, and very ornamental and agreeable would be her preparation of cakes and good things for the evening meetings once or twice a month. And what beautiful meetings those were to be, as we picture them in the different studios! In fact, all has been present so clearly to my imagina-

tion that I can hardly believe them mere castles in the air.[16]

Justina entered our rooms on the second day of her visit, – after coming, of course, through the pestilent passage, and exclaimed –

'You poor silly creatures! do you not know that you are killing yourselves as fast as you can by living in these close rooms and breathing this bad air?'

'Yes, we know it,' we replied.

'As for Anna,' continued the energetic Justina, 'I am angry with her; she who ought to know better, she who so thoroughly understands sanitary laws. What would the "Pater" say if he found you here? he would soon have you away. You will grow as pale as ghosts if you stay; and you can't help either of you growing morbid; you'll paint morbid pictures if you breathe this air! Don't think that I have only just perceived it; I felt it the moment I came near your door, and I've been thinking of it ever since; and I knew that it is my duty to drag you out of this place. If I saw a child with its head in a gutter or a drain I should drag it out, – and much more you.'

'Yes; but Justina, –' we began.

'If it is the money,' continued Justina, not listening to what we had to say, 'I'll pay your month's rent myself, and you shall move to-morrow. We will set out and hunt for rooms this very day; it will be capital fun. We'll move all your things to-morrow; pack them up here, and unpack them in the new rooms: I have a surfeit of churches, and pictures, and statues upon me. It will be a delightful change; I shall not be happy else; I can't think of your living here, I can't! I shall smell that smell in Milan – Venice – everywhere. I must see you in new rooms, and know how you will be in the winter; and I shall be connected with them in your thoughts if we move in this prompt, unique sort of way.'

'But, Justina,' we now argued, 'there are now no rooms to be had: all Munich moves four times a year; we can get nothing till the end of the quarter; we have tried already, but in vain.'

Justina, however, was resolute, and we set off on our expedition.

Having confided to Justina our desire for the winter to have rooms near the studio, we commenced our search in the St. Anna suburb. I think what we saw that day both astonished and amused Justina. First we went to Mrs. ——'s friend, the miller's wife, which was at the nearest of the mills; Mrs. —— accompanied us. After passing through a timber-yard, and then through a picturesque and really extensive garden, gay with sunflowers, we came to a long, low, white-washed house, covered with a vine. The miller's wife, instead of taking us into her house, pointed from the outside to two windows, which she said belonged to the rooms she had to let, – two southern windows, cheerful-looking from being draped with very clean white muslin curtains, and from being embowered with vine-leaves. Yes; very pleasant, they looked outside; but, – Could we see the inside?

After a good deal of hesitation and mysterious consultation in a low voice with another woman, and something being said about her father who was sick, we were told that we might see the rooms if we would excuse, etc., etc.!

We were accordingly taken up a narrow staircase, and along a narrow and apparently interminable passage; a door was opened, and behold a crowd of people busied in various occupations, – sewing, eating and heaven knows what beside; but all in a crowd and bustle, and breathing an atmosphere that took away our breath; and, seated on a bed – Oh, heavens! a sight which neither Justina, Clare, nor I, shall forget for many a day: we saw it but for an instant, but it was photographed for ever. An old man, nearly dead! They had propped him up, and were giving him some soup: the poor skeleton legs, bare from the knees, hung down the bedside, lank and horrible, and discoloured; whilst a wretched shirt barely covered his meagre shrunk chest and arms, and a wisp of a blue handkerchief was tied round his throat. One instant we

saw the vision; then turned away quite sick. Poor, unhappy, neglected old man! And this was one of the rooms which was to be let! The room in itself was not amiss, if it had been cleaned and had fresh furniture, and the second opening out of it was really pretty: but could we ever get over that horrible vision, or should we like to live with people who allowed life, much more death, to be so miserable and squalid?

Next we stopped at the house of a well-to-do carpenter, – but there was nothing; then to a very nice clean house, a *Wasser-Anstalt* (a Hydropathic Establishment).[17] Such a pretty place! with a sweet fresh garden. But the people of the place, – a stately elderly man, like a character in one of Kotzebue's plays, and his wife, who was dressed as gaily as a tulip, – would, however have nothing to do with us.[18] It was in vain that we mentioned the most respectable of our acquaintance, male and female; they knew nothing of them. But we were well known to the Baroness von ——: naming the most aristocratic of our acquaintance. Were we indeed! It might be so; but they had no rooms to let, – that is to say, they had none to let unless we came recommended by the physician of the establishment. But, in short, they had not any rooms which would suit us!

Mrs. —— and I laughed heartily as we returned from the door; and Justina and Clare, neither of them understanding German, thought, good souls! that this most respectable couple had been very polite to us.

I should think we went after this to a dozen other places; and what places we saw! places to make one hang oneself, or throw oneself into the mill-stream. Lastly, when standing in the twilight on the bridge, just opposite to the shop of our fat baker-woman, out she came, waddling towards us, to ask us if we wanted anything; and on our relating to her our bootless quest, she exclaimed, her whole face lighting up at once, that she had just what would suit us. Of course we went in to see the rooms through the hot little shop, through a still hotter

little room, – a very oven, – and then *the one* room presented itself which she had to offer: 'a beautiful room, a friendly room as ever was!' she declared, good fat soul! in a coarse rough voice, – 'a pretty, friendly room, which would just suit the dear young ladies!'

What a room it was! small almost as a coffin, underground almost, damp and hot at the same time, long and narrow; we should have died of the Munich fever in it before a month was out! But it would not have done to affront the old lady by telling her so; therefore we had a good excuse in requiring two rooms at least, and away we went.

Such was our expedition after lodgings. And when we returned home to our formerly despised abode, Justina was obliged to confess that it was, at all events, clean and wholesome, and a very palace, after what we had seen.

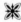

Notes

1 Munich was already known to British artists as a fount of the picturesque as well as a modern art capital. It had come to prominence among British art-lovers with Anna Jameson's book *Visits and Sketches at Home and Abroad* (1834), and this was reinforced by the project of decorating the new Palace of Westminster (the Houses of Parliament), which took as its exemplar the fresco work done in Munich by Cornelius, Kaulbach and others under the patronage of King Ludwig. See William Vaughan, *German Romanticism and English Art*, London 1979. An article called 'Art and Artists in Munich' in the *Art Journal*, January 1872, p.10, written by Mrs. Mary Howitt, testifies to the continuing popularity of this particular German city with British artists and *amateurs*.

2 William Etty (1787-1849) was a figure and epic painter of the

early Victorian style, later known for his female nudes which were seen as controversial in their sensuality.

3 The expression is consciously chosen: throughout these memoirs, and her life as a whole, Howitt maintained a quasi-religious attitude to art, though interestingly not to culture generally. She was, however, quite self-aware: she writes in the preface that it sems to her 'more graceful for a Student of Art to present herself in public as the chronicler of the deep emotions of joy and of admiration called forth in her soul by great works of imagination, . . . feeling that although each passage of life has its peculiar prose and its peculiar pain, that to dwell, in retrospect, upon this pain and upon this prose is not only unphilosophic in itself, but ungrateful towards that Spirit of Joy and of Beauty which is ever brooding over the world.' To complete the metaphor she begins with, Howitt indentifies Kaulbach as the reigning priest in the temple, and she herself as the earnest acolyte.

4 Alfred Tennyson's semi-autobiographical poem had just been published (1850), and he was considered the coming man in poetical literature. The following year he was named Poet Laureate.

5 This passage suggests what sympathies Howitt had with Pre-raphaelitism, insofar as faithful and devout study and depiction of nature took pride of place in Preraphaelite theory. It was an ethic inspired by the writings of John Ruskin, but whether or not Howitt had read any of his books is not clear.

6 Alfred Howitt, born 1830, was the author's younger brother. One supposes from this comment that he was in the habit of chiding his sister for her elevated approach to life.

7 This is presumably a figure from Tennyson's poetry, but if so it is an obscure reference.

8 Concern about the author's health and comfort does not figure at all in the echo of *An Art Student in Munich* which is provided by her mother's letters and diary, quoted in *Mary Howitt, an Autobiography*, London 1889, a valuable account which was

compiled by Anna Mary's sister Margaret. Political, social and cultural news is the staple diet of the correspondence.

9 Justina is Barbara Leigh Smith Bodichon (1827-1891), the author's great friend and fellow artist. The description of character given here accords with other contemporaries' accounts of the woman's vigourous affection and broad-mindedly philanthropic approach to other women, friends or strangers. She became known more than anything else for her tireless efforts in the cause of higher education and legal parity for women. See Hester Burton, *Barbara Bodichon*, London 1949 and John Crabbe, 'An Artist Divided', *Apollo*, May 1981, vol. 113.

10 Barbara Bodichon was more enthused by French art, choosing Charles Daubigny and Camille Corot as advisors for her own work, which showed a disdain for finish characteristic of modern French landscapists such as the Barbizon school, whom she greatly admired. Struck by the vigour of her work, French critics were known to call her 'the Rosa Bonheur of landscape'.

11 Bodichon's art work has been shamefully neglected by historians of the Victorian period. She painted in oils and watercolour, almost always taking landscape as her subject, and she recorded the environments in which she travelled and lived: Sussex, Kent, Algerian villages, the natural wonders of the United States, Wales, France. Although like Howitt she mixed socially with the Preraphaelites, her art shows no influence at all from that school. Rather, she employed a dashing, sketchy brush, emphasising effect rather than detail, often careless of physical fact and more interested in atmosphere and mood. Typical critical commentary on her much-exhibited work baulked at the boldness of her style: 'The drawings show enterprise and ambition, and more feeling for effect than the power to carry it out' . . . 'solemn and fine, though scarcely elaborated so far as to be true in matter of fact as well as in impression'. The critics were surely reacting against the 'unladylike' quality of

her work, though they were neither aware nor honest enough to say so. The biggest collection of Bodichon work is at Girton College, Cambridge; Hastings Art Gallery also owns a number of pictures by her.

12 This description of Bodichon's lifestyle is rather misleading, since although she did enjoy wealth and relative independence, she became seen quite clearly as a person who lived beyond herself, a dedicatee to the cause. Her father was thought to be dangerously 'advanced' in his views and his daughter was therefore freer to develop a radical application of middle-class privilege than were most of her contemporaries.

13 Howitt's religiosity, almost a mysticism, led her after spiritualism to Catholicism, despite her Quaker upbringing. Violet Hunt claims that already in the early 1850s, 'Anna Mary Howitt's room was crowded with Catholic emblems' (*The Wife of Rossetti*, London 1932).

14 Although the beginnings of the Society of Female Artists are obscure, it was the sort of ideas expressed here that lent energy to the establishment of the SFA in 1856-57. Also fuelled by the enthusiasm typified by this passage were the self-help gatherings of Howitt, Bodichon, Eliza Fox and other creative women of their circle for study from the model. Ellen Clayton reported on this initiative in her book *English Female Artists* (London 1876): 'In this class, Miss Fox did not profess to give instruction, and it was attended at different times by several of our best lady artists who like herself felt the necessity of this kind of practice. The class excited intense interest, with differing opinions, among lady artists and girl students.' (p.83, vol.2).

15 Such a scheme as that outlined here did not come to pass, though feminists such as Bodichon did engage in questions of housing and homelessness; Octavia Hill's is the name most associated with these initiatives (see E. Moberley Bell, *Octavia Hill*, London 1942). For an idea of the range of improvements to women's lot which the movement symbolised by Bodichon and Hill and Howitt (in her early days) could claim credit for,

see 'Three Decades of Progress', *Englishwoman's Review*, 15 August 1878.

16 Ironically, Munich was even more excluding of aspiring female artists – from an institutional point of view – than some other European centres: in her *Art Journal* article of 1872 (see above, note 1) Mary Howitt writes that 'the Art-city of Munich has done much for men but little for women. Unlike England, America or Russia, Bavaria had no Female School of Design until three years since.'

17 These were places for curing diseases of one sort or another concerning the joints or the muscles. British people might go to German establishments of this sort when they would not have bothered with an English spa.

18 August von Kotzebue (1761-1819) wrote sentimental dramas which had influenced English theatre in the Regency era.

ANNA LEA
MERRITT

'Recollections'
from *Art Criticism and Romance*
by Henry Merritt (1879)

THOUGH Anna Lea Merritt became a popular professional painter and noted etcher in the last two decades of the nineteenth century, the only published account of her life appeared as a preamble to the collected writings of the picture-restorer Henry Merritt, whom she idolised and eventually married in 1877. This two-volume publication was illustrated with twenty-three etchings by Anna Lea Merritt, some of which were after sketches by her late husband. The editor of the book, Basil Champneys, presented Anna Lea Merritt's sixty-five pages of text thus:

Of the author himself it is not my province to say much. This has been done with perfect tact and most graphic fidelity by the one who is most entitled and most competent to speak of him.

That this piece, called *Recollections*, gives the reader a fascinating account of Anna Lea, as well, is quite ignored!

Anna Lea was American, born in 1844 to a Quaker family which had settled in the USA in the seventeenth century.

She married young and was widowed after a year. This unhappy turn of events took the Lea family to Europe in 1865 on a journey of distraction which lasted four years, and during this time Anna Lea obtained a rich and varied, though

uneven, art training. She copied in the Uffizi in Florence, she had private lessons in Dresden and she studied in Paris under Leon Cogniet. The outbreak of the Franco-Prussian War in 1870 prompted her to flee to London, while the rest of the family apparently returned to Philadelphia. One of the people she records meeting during this phase of her life was Harriet Hosmer, the American sculptor who was a conspicuous and controversial figure in the artistic community of Rome, where she worked, and in the British and American art world generally. Presented as the type of the modern creative woman in the writings of both critics and supporters, it was perhaps Hosmer's example of independence from traditional expectations of female behaviour and her dedication to art which instigated this comment of Lea's, recorded from 1869: 'How I longed to be a man freed from the tiresome conventions of young ladyhood!'

Once in London, Lea took up her training through copying, encouraged by the erstwhile Preraphaelite John Everett Millais, to whom she had an introduction. She writes, mistakenly, that in 1871 there were no art schools in London for women. In fact the Slade School opened in 1871 with equal opportunity for women as one of its declared attractions. She took some private lessons with Alphonse Legros who within a few years was to become the head of this institution at which Lea, could, as a woman, have legitimately sought a rigorous fine art training. The lessons did not last long. She had met her neighbour Henry Merritt and become fascinated by him. He quickly replaced any other adviser she might have had, sought, or intended, as she vividly records in her *Recollections*. Henry Merritt wished Anna Lea to look only to him for opportunity and approval, and by giving the young woman advice for no payment could expect the loyalty of obligation. He advised her to concentrate on portraiture and leave subject pictures alone, although it was as a painter of figure subjects that, under the name Anna Lea Merritt, she eventually

46

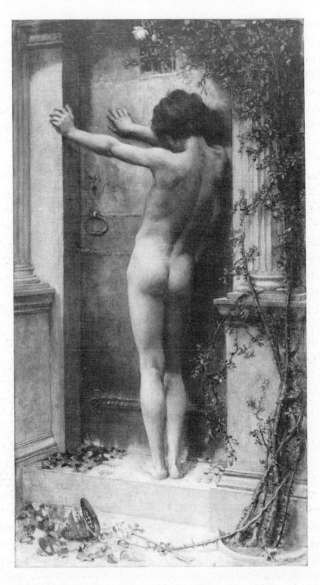

ANNA LEA MERRITT, *Love Locked Out*, 1889

became established on the London scene.

Recollections chronicles some seven years, the time in which she graduated from being a student of art to establishing herself as a professional painter. First accepted at the Royal Academy in 1871, she continued to show there until 1917, with conspicuous absences at times of stress or upheaval: in 1877, the year of Merritt's death, she showed nothing and between 1902 and 1904, when some crisis at which she hinted in a later book, *A Hamlet in Old Hampshire*, sent her into a temporary retirement, her name was again absent from the London exhibitions. Her exhibited work was a mixture of portraiture and figure pictures of an academic type, though she was up-to-date enough in her academicism to be invited to show at the fashionable Grosvenor Gallery alongside such artists as Edward Burne-Jones and G.F. Watts and at its successor the New Gallery.

In *A Hamlet in Old Hampshire*, published in 1902, she writes as if the success achieved in the 1880s and 1890s was ultimately meaningless. She describes her retirement to a country cottage:

Strange happiness and peace grew up in this rustic abode. I came to it when all my happiness seemed lost. Health with its power for work and enjoyment, companionship of the dear young sister who had filled my house with gladness, and treasures laid up in earthly places were all taken from me. Friends thought me ruined in health, and banished to a desolate solitude; but here the peace of Divine love surrounded me, and the possession of the whole universe was given in exchange for worthless securities.

These 'worthless securities', however, had included achievements and experiences which she had determinedly set out to attain at the time of which *Recollections* speaks: a diploma and medals from the American Centennial Exhibition in 1876, a commission to decorate the foyer of the Women's Building at the Chicago World's Fair in 1893, the distinction of having her

ANNA LEA MERRITT

painting *Love Locked Out* bought by the Chantrey Bequest for
the national collection in 1890, the acquaintance of other
artists famous in their day such as Elizabeth Thompson Butler
whom she met in Cairo in 1890, Frederic Leighton, a future
President of the Royal Academy and Annie Swynnerton, with
whom she shared the Chicago commission.

Anna Lea Merritt followed a classical tradition in her
themes and her technique: her most praised works reflect this
approach, whether it be *Love Locked Out* (p.47) with its nude
figure, *War* of 1883 (pp.50–51) with its historical costume and
classical architecture, or *Eve* (1885) with its moralising naked-
ness. It is therefore not surprising that she was put off art as
the nineteenth century waned and the developments of Post-
Impressionism and what she calls Futurism drew the long
classical tradition to an unwilling close. In her book *An Artist's
Garden* of 1908, she wrote with a touch of defiant facetious-
ness typical of many artists and art-lovers of her generation:

I have not acquired the latest impressionist style, which so ably
represents things as seen from a motor-car at full speed. I have been
obliged to sit out for many hours daily in freezing wind, and later in
burning sun, looking long and carefully at flower and leaf.

Such an assertion was not a testimony to an obstinate Pre-
raphaelitism, but a holding on to principles which the author
believed to be inviolable and fundamental to any practice that
claimed the title 'art'. She spent most of her time gardening
from then on and exhibited nothing in London after the first
World War. In 1924 she wrote an autobiography, *My Journey
Through Life From 1844 to 1924*; it lies unpublished in the
Victoria and Albert Museum. Towards the end of her life she
became blind, and the manuscript may have been her way of
writing the final chapter of her existence. She died in 1930.

Following page: ANNA LEA MERRITT, *War*, 1883 (detail)

The *Times'* obituary notice was augmented by an affectionate testimony from Edith Holman Hunt, who wrote that Anna Lea Merritt 'had a heart of gold, never complaining of her blindness'; all in all, she averred, her friend had been 'a rare woman'.

'RECOLLECTIONS'

THE march of the Prussians upon Paris, where I was then studying art and living with a sister at a boarding-school, drove me unwillingly to London, where the great good of my life awaited me.

My father, ready to gratify my wish to study art here as it could not be studied in Philadelphia, arranged that I should live with friends in London. A studio, however, could not be had under their roof, and chance led me to find one in the house where Henry Merritt lived. I soon heard that he was a restorer and a connoisseur, but with timidity natural in a woman living alone in a foreign country, I avoided every acquaintance which might seem to arise in an accidental manner. I shut myself into an ugly studio, with a window through which I could look neither on the earth nor into the sky, and produced ugly pictures with no truth in them.

A relative of mine, travelling in Austria picked up some wonderful pictures – wonderful bargains, at all events – and sent them to me to be housed until he sailed for America. He desired, moreover, that they should be restored by the artist living so near me.[2]

My landlord carried to Mr. Merritt my request that he would look at these pictures. The case when unpacked discovered two colossal canvases, representing dogs and cats fighting in a well-filled larder; two small, modest little pictures were by Paul Veronese, or so the dealer had sworn.[3] Other works were equally desirable. Mr. Merrit found me surveying the lot with no great satisfaction.

He paused on the steps leading down into my studio, and suddenly I felt anxiety lest he should in any way associate my idea of fine art with the specimens before him. I said apologetically, 'I was not consulted in the purchase, but my friend wishes to ask you to restore them.' 'They are hardly in my line,' he answered; 'but I will tell you of someone who can

C-E

53

wash them and give them a slight varnish. Now will you come to see my pictures?' I followed him along the corridor as he led the way to his studio. But first we passed through a little study, where I exclaimed with delight at the fine collection of Eastern china and enamel, at the Italian mirrors, the inlaid chairs and cabinets of antique design. Leopard skins and musical instruments hung in the corners, and carved brackets with vases of graceful form carried the precious colours over every wall. In the corner by the one long window was Mr. Merritt's chair, whence he could enjoy the grouping of his picturesque collection, or might look out on to his balcony. Here he had arranged a miniature fish-pond, shaded by some pieces of cork bark and a gnarled branch, from which a spray of ivy drooped over the water; a few gold crocus-cups unfolded in a shaded nook. It was never-ending amusement to him to feed the fish, and to rescue them from untimely death when they had jumped out of their shallow pond.

Looking into the room again, I saw that some oranges, carelessly placed, brought a delightful contrast into a group of blue jars and plates. Mr. Merritt let me look at everything, and enjoyed my pleasure; but I laughed at the untidy fashion in which he kept his list of engagements, written in chalk on the wall opposite where he sat. There were indications of caricatures, too, sketched anywhere on the green and gold paper, and everywhere a most odd mixture of splendour and carelessness. For his pipe and tobacco a common flower-pot saucer sufficed. 'Vile habits,' he said, 'should only use vile things.' When I could steal a glance at his face it could not be forgotten. He was not like anyone else.

In the studio I found a treat of another sort. On every side were stacked pictures upon pictures, leaving scarcely access to the book-shelves, but space enough for easel and chair. Here I was allowed to see the choicest of those paintings which had come to him for repair. Now panels blistered by fire, but not beyond his skill to recover; now a canvas torn by the house-

maid's broom; oftener pictures encrusted with old varnish and discoloured by time, or even modern paintings cracked in process of drying through use of unsuitable mediums.

'You must never tell what you see here,' he said. 'This is a hospital for pictures, and to have been in hospital makes their soundness suspected. When I have exerted my greatest skill to save a precious work from destruction its owner will be careful to conceal that anything has been done. It is my greatest success when my toil is invisible. Whatever I write is anonymous also. Think of that, little girl, and be glad that you may devote yourself to a beautiful art, and win fame and happiness in the pursuit.'[4]

He made me look at a group of saints by Bellini; then at a weird landscape by Carpaccio, where two ladies, walking in a dream-like garden, meet their own ghosts, bearing one a mirror, one a vase. An open grave separated the living and the spirits. Then he turned to a silvery group by Teniers, a party of gallants, dining before an inn, served in the open air by bustling hosts. A sketch from Tintoret's flashing brush, 'A Little Virgin,' thought to be by Raphael; a portrait by Sir Joshua.[5] When I had looked in amazement at all these treasures, looked long and silently into them, Mr. Merritt said:

'Now you have seen enough for one day, but you may learn a great deal here. I will show you whatever is good for you.'

After that I was often in this delightful studio; and it was a curious proof of a sort of commanding gentleness in the man that while I never dared approach him without an invitation, I also never thought of leaving him until he sent me away. I always felt in his company like a child on good behaviour.[6]

Being in great conceit of a picture by which I intended to win everlasting renown in the exhibition of the Royal Academy, when also it was quite too late to profit by any criticism, I begged my friend to give me his opinion of it.

I thought the Piper of Hamelin piping away the children, as Robert Browning has sung the story, would be a delightful

subject;[7] but having got the piper, I found models so expensive and my purse so slender, that I decided to design a swarm of rats instead of a bevy of children, hoping that the sale of my masterpiece would enable me to paint the companion picture afterwards.

Mr. Merritt did not look at it unkindly, 'but,' said he, 'it is as if you wanted advice about a book when it is printed and bound. Let me advise you next time when your picture is begun. In the first place, choose something of human interest, only a head or a portrait.'

From that time he assumed the direction of my studies. A portrait or two gave me the means to employ models constantly, and I set myself to study from them with all energy and happiness. Every impulse I had previously felt driving me to become an artist was now merged in the great wish to please my master.[8] I had scruples about occupying his time, for he took extraordinary pains with me, and after resolving a hundred times to ask what fee he would accept for these lessons, and never daring to approach the subject, I became more courageous at a distance, and wrote a letter with all the delicacy I could command, enclosing a cheque to begin with. And when it was posted I fell to trembling. Within five minutes after the postman's knock, which shattered my nerves as a hundred cannon might have done, the cheque was returned to me with a polite note. My master did not come that day, nor the next, nor the next. I heard his step, his voice; he seemed to go everywhere, to speak to everybody except me. All the following day I was making little efforts to knock at his door and beg his pardon. A dozen times I got to the end of the corridor, and ran back again, but at last, late in the afternoon, I actually stood before him.

He remained in his arm-chair enjoying the evening light; he only held out his hand, and I stammered something quite incoherent.

'Oh, I am not angry, little girl, I never thought of such a

thing. But you see if I teach you I must have the right to do it my own way. I must come when I like and scold you as much as I choose, and be altogether my own master if I am to be yours.' So it was: how he scolded me; how ruthlessly he rubbed out again and again the work of days, bidding me do it better; what pains he took to make me appreciate true points of excellence! When my work was dry, and had lain by awhile, he would sketch upon it in crayon, designing backgrounds or trying various effects of *chiaro oscuro*. No one ever witnessed as I have done his fertility of invention, his refinement of colouring, his variety in touch. Often he would work thus for a couple of hours, transforming my tame study of a model into a vision. The picture would go through a succession of different effects, any one of which could have satisfied a less imaginative mind. He would then throw down the chalks or the brushes, as the case might be, just give me time to study it, and wash off all he had done, bidding me make another design according to similar laws.[9]

In such lessons I used to stand behind him, breathless with excitement, never speaking a word, taking care to supply the pallet, and to remove all obstacles from his track, as he rapidly walked forwards and backwards or even up the stairs to have a better view of the effect.

The lesson over, I was often permitted to go with him to his window, to fill his pipe, and then sitting quietly in my own corner opposite him to wait for his words, 'You *may* come,' he would say; never 'Will you come?' I adore the recollection of these hours!

The rare charm of my teacher lay in his freedom from all affectation, his scorn of petty motives and selfishness, his conscious power and true dignity of soul. He must have been venerable in youth, and yet he kept his youth in middle age. Not seldom after my painting lesson I had a social lesson. Perhaps I had been thoughtless of my model and not observed her weariness. If I did not choose to eat or rest for hours, at

least I might allow others to do so. Sometimes I gave offence to people around me in a manner which earned me the name of 'proud Yankee'. I did not take pains to be gentle and thoughtful for all. Perhaps I wasted time in going to parties, or appeared extravagant in my dress. My faults were never passed over, but kindly shown up to me in a manner to fill me with remorse. He would say: 'There is no use in my teaching you a refined and noble art, if you cannot also learn to have a big soul; to be a great artist your whole character must be great.'[10]

Sometimes while he was thus discoursing, one of the little children of the house would come unasked, and climbing into his lap fall asleep there. Another, if she felt wronged in the nursery, would come to him with an appeal for justice. This, of course, when their mother had left them to the servants' care. Even the household cat, though he disliked cats, came complaining to him if her wants had been forgotten, and though very tired he descended into the kitchen to provide for her. His gentleness won all to love him.

I feel compelled to make some record of the courageous, upright, generous life revealed to me more plainly than to any other, and to bear witness, at least, to the deep impression this noble character has made upon my own. This mind so liberally endowed with genius, and developed through unusual experiences, is suddenly lost in darkness.[11] It is natural to cry out against the inevitable oblivion of time, natural to hoard a little longer some still warm embers of a fading fire.

How often I have listened to the anecdotes of his early days, told with such complete frankness that all he related seemed to have occurred under my own eyes, somehow to have been actually experienced by me. . . .

In the spring of 1874 a little sister was allowed to accompany me to London, and we then lived at Devonshire Street in an upper apartment.[12] The two years following were full of happiness for us. In the evenings Merritt delighted to have little Marion's company, and to invent for her romantic tales

which he knew how to present in quaint and simple language.

What humour there was in his caricatures of us. Marion always appeared as a young swan, with lifted head and a sidelong look from her eye; while I was easily recognised in a small bantam hen, looking up to the swan with a hopeless attempt at command.

He was fond at times of silent meditation, and then could tolerate no movement. Sewing he detested! he would not allow any sort in his presence. When his cough had somewhat yielded to mild weather, he would reach down a favourite guitar, and sing delightful old ballads with an accompaniment wholly original. We kept a programme written on the wall, and constantly he would remember new old ballads, not heard since childhood, and they were added to our list. In the course of time the melodies may have become somewhat transformed, but they never were sung with more pathos. I dared not in such happy evenings bring up a word about pictures. 'Romola!' with an air of reproach, would be his only reply.[13]

. . . In the spring of 1876 I was compelled to visit America, and to take my young sister back to our parents. It was promised me that I should return to England the following autumn. The thought of leaving him even for a few months was horrible, but there was no help. So long as I had a penny in my purse I had managed to postpone the dreadful day; but just then I had not a penny of my own. Therefore I was reduced to the sad plight of a dutiful child, and started on the dreaded journey. My dread of it was realised; circumstances quite unforseen arose to prevent my return. It depended, at least, upon my own exertions to find the means, and in America, in a financial crisis such as then existed, few people were likely to buy my pictures. The Centennial Exhibition, too, had overstocked the market. The long hot summer, six weary months, when all the world are scattered through mountain resorts or along the shore, had to go by before a chance of exercising my pencil could be expected, and

meanwhile I had double rents to pay in London, and for studios in America. Scarcely had I arranged on in Philadelphia, when a commission called me to New York. The kind and thoughtful tone in which my beloved master encouraged me in these trials can best be appreciated in a few of his letters.[14]

> 54 *Devonshire Street, Portland Place, W.*
> *London: May 8,* 1876

'My dear little Pupil,

'Lest the newspapers I post with this should be lost, I enclose a cutting of Article No. 3. No doubt there will be much confusion in Philadelphia, and therefore you will have no time to send me too many letters about the pictures. Please confine your remarks chiefly to your own concerns and of those more immediately around you.

'The place seems solitary now that you are away, no one knocking at my door any more. Even the ballad singers have disappeared, while the organ men sent by the Italian model are rarely heard.[15]

'You imagine that I shall forget you. Am I likely after all the trouble I have taken to make a painter of you? Do we plant fruit trees in order to leave them when the blossoms that are to produce peaches and apples appear? Some day you will learn to value your many precious gifts better than to surmise that anyone possessing understanding will fail to appreciate a talented girl. Those who have hearts – there are not many – will not fail to see that Anna M. Lea is also a generous girl. I saw it long ago, or I should hardly have taken the trouble to teach her to spread colours upon canvas.[16]

> 'Ever your sincere Friend,
> *Henry Merritt*'

> 54 *Devonshire Street, Portland Place, London*
> *November 25,* 1876

'My dear Pupil,

'Here are three sketches just to remind you of Europe where

you have been. You will no doubt come here again greatly
improved in all ways. In health, I hope, and as a painter. The
little sketches I send are made to fully realise the broader
features of the scenes depicted, leaving out trivial things. Do
likewise, only on a nobler scale. Seize upon the salient objects
first, and make out details after you have secured an idea of
what the total of a composition should be.

'So much for art. You are still the little bantam with those
children who have no imperfection. It is all very well, but my
heart goes with the poor. I stand and look at the schoolboard
children leaving school, and note among them many most
beautiful; and that with barely enough rags to cover them, like
the children of Murillo.[17] Love your own people, but remem-
ber those who claim to be fellow-creatures only. I say this
because an artist who would paint big pictures must needs
have a big heart and a sympathising soul, like the renowned
St. Christoper (whose name I formerly wrote under) who
could only be induced to mingle with the least fortunate of
mortals.

'I hardly know where you may receive this letter, possibly in
Canada, but wherever you may be remember me as one who
despises trivial things on canvas.
 'Your affectionate friend,
 H. Merritt'

After waiting for months fortune came to me all at once, and
important commissions crowded upon me. Scarcely had I a
chance to begin work when death snatched from us two of my
dearest relatives. Grief unfitted me for painting, but the
longing to see my master again gave me courage to return to it.
At last, about the middle of March, I reached Liverpool. Only
of late had I begun to realise the uncertainty of life, and on the
lonely ocean voyage a terror grew upon me that I might not see
again my dear master. As the distance between us shortened
greater was my fear, until at last it ended in a joyful meeting.

What a happy evening! A little festival was prepared for me. My studio in order, and lighted up, to show my last picture in the frame he had provided. My favourite plants carefully tended, primulas, crocuses, and tulips in bloom, wherever a nook could be found for them. A little supper spread for us. But all these cares were almost wasted upon me. I could only see my dear, dear master.

'Little Pupil,' he said, 'we shall be married. I cannot part with you again. I am like a ship at the end of a long voyage, after ploughing the ocean for many a year, become covered with barnacles and all sorts of queer clinging weeds. But I do not see why I should give up our happiness for the sake of ungrateful people, who only think of what money they can get from me. We can still spare something for them, but in time perhaps you will have to defend me from them. You will be happy living in a cottage, as we soon shall, when I show you what a beautiful life it can be made. You are my only true friend, we must never be separated.'

In about three weeks we were married privately in St. Pancras Church. We met in the vestry, and walked home together. Our most intimate friends were informed when we saw them. Even in this first happiness he began to speak of approaching death. 'We are too happy,' he would say, 'it cannot last. Learn to think of my death. You must accustom yourself to the idea. It appals me to think what will become of you when I am taken. Remember only to plant an elm-tree over me.'

How happy we were! – and yet, day by day, a terror grew into my joy. He suffered constantly, although his face expressed only supreme happiness. The last time he left the house was on his birthday, when we drove to Hampton Court, and spent the day in a little inn-parlour overlooking the river, and beyond the old brick palace, screened by stately elms. It was of all scenes near London that which he most enjoyed. We talked of the cottage we should have in that neighbourhood, and the

quiet rest of old age: of the book he would write out of his stores of strange experience.

Another rest was in store for him!

For some days he lay between life and death; then rallied so far that we felt safe and confident. But, so soon as he was allowed to give up the recumbent position, his weary heart refused to do its work, and surely and steadily failed.

Suffering became intense, but was never more nobly borne. His constant thought was for me. He feared my fatigue, he feared my anxiety; but it was my great comfort that he could not spare me from him. No one else could be permitted to wait upon him, and for every trifling service he was so grateful, as though he did not expect to be tenderly nursed. 'I have borne years of loneliness,' he said, 'but happiness is too much for me.'

After a fainting spell one night early in July Merritt seemed convinced of his fate. In the morning there was a sternness, or rather firmness, in his expression that awed me. His breathing was so shallow that he could hardly move, but he shaved himself and insisted upon dressing. Then he crossed the entry to our dining-room. There he summoned his assistants, devoted friends they were, who had worked for him, the one ten the other twenty years, and who now waited at hand every day on the chance of being useful. He insisted upon having at once their accounts for the past month, and sent me to look for any bills unpaid. He wrote cheques for all, and thought of those pensioners to whom he usually sent aid. Then for me, although he had provided me with a bank account of my own, he wrote a cheque for a large sum. I protested against it, but he insisted. These affairs settled to his mind, he returned to the bedroom. From the entry he could look down the mews through an open window. No beautiful view to most people, but he could see what he liked in anything. 'One last look,' he said, 'what a beautiful place, full of grottoes and nymphs!' In early dawn, at this season, about two o'clock, he would have

the curtains drawn aside that he might gaze upon the chimney-pots. In this light they were beautiful to him. He would say, 'That is how Velasquez would have painted them.'

After a few days, as suffering increased, we spoke together once of the parting that might be.

'I am not afraid to die,' he said; 'I have been a good man.'

His only other thought was anxiety for me and to console me. 'Do not despair. Take heart: I will try to live for your sake.'

Soon again the torture became so terrible that I cannot speak of it. To the last his mind was clear, his senses acute; only morphine injected into the veins brought a short forget-fulness. The long death-struggle lasted for hours. He held out his arm to me many times to be lifted up, and then, unable to speak, he still found strength to recognise me by gently moving his hand upon my shoulder. In eight hours he slowly breathed away, keeping his face towards mine, his eyes upon me. For ever his face in its agonised beauty floats before me. I see the world only through this pale shadow of pain and love.

Merrit died at the age of fifty-five. Mr. Frederick Willis Farrer offered a most touching mark of friendship in requesting that his friend might be buried in his vault at Brompton. I gratefully accepted the generous kindness, and there Merritt was interred. But when I felt able to realise all that had occurred, and remembered how often my beloved master had asked me to plant an elm-tree above him, and saw how impossible it was to do so at Brompton, Mr. Farrer with equal kindness permitted me to remove my husband to a ground I chose at Woking.[18] It seems a fitter place for one who so loved fields and flowers, and the promised elm-tree is planted there.

Notes

1 Whether or not the author means that the difficulty was for a *woman* to get a fine art training, the situation regarding art education for women in the eastern states was in some ways much better than it was in London at this time. For a concise account of the development of women's art education in nineteenth century North America, see Charlotte Streifer Rubinstein, *American Women Artists,* Boston/New York 1982, ch.3 and ch.4. Another example of a Philadelphian woman despairing of achieving her artistic ambitions at home and preferring to take her chance in Europe, at this same time, is Mary Cassatt who – unlike Lea Merritt – aligned herself with the avant-garde in her new environment, joining the Impressionists (see *Cassatt and her Circle*, ed. Mathews, NY 1984).

2 The use here of the term 'artist' is a conceit on the author's part. Merritt had ambitions to be an original painter, but it was as a restorer that he earned his living and got a place in the art world. His own comments (see below note 4) on his line of work hardly support the compliment intended here by the word 'artist'.

3 Paolo Veronese (1528-1588) was at this time one of the most popular Italian artists of the past in Britain. He was seen by many, including most notably John Ruskin, to be more praiseworthy than some earlier Italian artists of the High Renaissance who are now valued supremely, such as Raphael. In the wake of Preraphaelitism, early and late Renaissance artists were most approved, and Ruskin had particularly promoted the Venetian tradition, which Veronese, along with Titian and Tintoretto, represented. Therefore dealers would be likely to invoke the name of Veronese to aggrandise an inferior sixteenth-century Italian painting.

4 Merritt's description of the restorer's place in the art process would be disputed by many, but in the age of the commercial dealer, multiplying reproductive processes and an increasingly open and competitive art market, such a role for the restorer – as

the accomplice of the profiteer and the perpetuator of precious reputation of the art-object – was increasingly likely.

Merrit habitually spoke to Anna Lea in diminutive terms of address: he was twenty-two years older than she, but even so at this time she was twenty-seven years old. Merritt's insistence on her junior position has surely as much to do with his wish to patronise her as with any facts of age or experience.

5 This list represents a cross-section of the sort of old art which was popular on the London art market at the time. Italian art (Bellini, Carpaccio, Tintoretto) was always marketable, there was a selective taste for the Dutch tradition (Teniers), and Joshua Reynolds was still thought of by most people as the venerable figurehead of the British tradition. It is probably indicative of Merritt's conservatism that he has not been sent anything more out-of-the-way than this.

6 The relationship between the author and Henry Merritt is clearly one in which the man plays the father as well as the partner, defining the woman as the man's child more than as his equal or fellow. This sort of heterosexual coupling has become to seem almost typically Victorian: one thinks of Dickens' 'child-wives'. The appeal of such a relationship to the man is obvious, though unpraiseworthy: his ego is constantly flattered, his desire for power and authority continually fulfilled. The tolerance of, collusion in, or even desire for such a relationship on the part of the woman is discussed by Germaine Greer in *The Obstacle Race*, London 1979, where she suggests that there are many examples in nineteenth-century Britain of such a relationship between an aspiring woman artist and her male mentor. In addition to sociological, psychological and economic factors tending to such situations, the small number of women in positions of artistic status who could take on the role of 'master' to young artists of either sex, must be noted as an important fact.

7 *The Pied Piper* was shown at the Academy in 1872, and is now at Cheltenham Ladies' College. Subjects from Robert Browning

(and other modern poets) were not unusual at the Academy.

8 The degree to which the author willed such subjection for her own comfort is debatable, and crucial to consider for an understanding of women's perception of their own creative abilities and their acceptance or rejection of men's creative status. Lea was apparently prepared to give up her career once she became Merritt's wife, because this was 'proper': in the event, she had no cause to since he died very shortly after their marriage. Much later, in an open letter to artists in *Lippincott's Magazine* (1900), she wrote apparently uncritically of the inequality existing between creative men and creative women: 'The chief obstacle to a woman's success is that she can never have a wife. Just reflect what a wife does for an artist; darns his stockings; writes his letters; visits for his benefit; wards off intruders; is personally suggestive of beautiful pictures; always an encouraging and partial critic. It is exceedingly difficult to be an artist without this time-saving help.' (quoted in Rubinstein, *op.cit.*). For comparison with Lea's self-deprecating stance, consider Henrietta Ward's generous praise of her husband which does not yet deny her own ability, and Anna Mary Howitt's refusal or inability to control the effect of Ruskin's criticism on her ambitions (even though Ruskin was not her specifically desired audience). Even if a woman is not in dialogue with a particular man about her work – be he husband, fellow-artist, teacher, or critic – she is, however, inevitably in dialogue with men's idea about women (and women's work).

9 Such 'teaching' methods have been recorded by many women whose work has been directed, with their consent or not, by a self confident male in their circle. From the same era, see Berthe Morisot's accounts of how Edouard Manet would assist her (*The Correspondence of Berthe Morisot*, ed. Denis Rouart, London 1950).

10 This sentiment, by which the artist sets a moral example quite separate from the aesthetic example which s/he must also set, seems to be reflected by the author's choice of subjects over the

years. A rather conservative, Christian notion of the noble and
the refined, spiced with a feeling for woman that, though it
could by no means be called feminist, certainly wished to assert
women as societally and culturally important, produced such
pictures as *Miranda* (1876), *Ophelia* (1880), *Camilla* (1883),
St. Cecilia (1886), *Iphigenia* (1887).

11 Henry Merritt died, like so many of his contemporaries, of
consumption, the effects of which he was already overtly
suffering from eighteen months earlier. The melodramatic
suggestion of a *sudden* death is, surely, typically Victorian.

12 This was probably the sister whose death the author regrets in
the 1902 passage quoted above.

13 The reference is to the eponymous heroine of George Eliot's
novel of 1863, whose story is one of self-realisation through
renunciation. Françoise Basch has written: 'In *Romola* renun-
ciation characterises the stages of the heroine's development
. . . Her evolution is a journey . . . which leads a generous but
still limited soul to an identity that is raised to the dimensions of
humanity after the stages marked by the different men who
stand out in her existence: her husband, her father, and
Savonarola. In turn daughter, wife, then disciple, her devotion
to these three people only offers temporary objectives in her
quest for the absolute; she finds her reason for existence in
sacrifice to the community' (*Relative Creatures*, NY 1974).
One can imagine the attraction to Merritt of his reading of such
a character, though the real-life model for Romola was allegedly
Barbara Bodichon, a woman whom Merritt would surely *not*
recommend to his protegée.

14 Lea does not mention in this account of her 1876 trip home that
family reverses were also at the back of it. Neither does she say
that she was awarded honours for her work at the Centennial
Exhibition in her home town, nor discuss the controversy
surrounding women's contribution to this fulsome affair (see
Rubinstein, *op.cit.* and Jeanne Madeline Weimann, *The Fair
Women*, Chicago 1981).

15 Italian models were by this time an institution in the London art world: Italians immigrating to London, often because of political upheaval or economic hardship, had only restricted employment opportunities open to them, and modelling for artists was one line of work which Italians soon became sought out for, due not only to their low fees, but also to the fashion for the 'fancy picture' which featured peasants or rural workers from European regions which appeared exotic or picturesque to the racist and sentimental British patron.

16 This arrogant claim to have taught Lea everything she knows about art betrays a common nationalism on Merritt's part which assumes that anything Lea has learnt in France, Germany or Italy is worth nothing as compared with what is to be learnt in England. Equally we see in this remark Merritt's determined perception of Lea as the vessel of his expertise, kindness and wisdom. In fact, Anna Lea Merritt is described as 'self-taught' in some dictionaries.

17 Bartolomé Murillo (1617-1682) was one of the best-known Spanish artists in nineteenth-century Britain. A Seville painter, he had specialised in madonnas and groups of working-class children and peasants which latter type of picture was especially popular on the London art market as 'fancy pictures', at the middle of the century. By the time at which Merritt was writing, people who prided themselves on the modernity of their taste would have shifted their approval to Velasquez. For an account of the taste for Spanish painting in nineteenth-century London, see The National Gallery of London, *El Greco to Goya*, London 1981.

18 The choice of Woking is enigmatic, since Merritt had been born in Oxford. Let it be noted that, despite the desolation in which the author says her husband's death left her, she did not move to Woking when she left the city in 1894. She went to Andover, and then to Hampshire in 1901.

ELIZABETH THOMPSON BUTLER

An Autobiography (1922)
and *From Sketchbook and Diary* (1909)

THE books which Elizabeth Thompson Butler produced can be seen as an attempt to stay the tide of change: *Letters from the Holy Land* was published in 1903, *From Sketchbook and Diary* six years later, and by the time *An Autobiography* came out in 1922 its author was seventy-six years old and the Victorian age twenty years dead. The preface to the autobiography explains how she clung on to her artistic style well into the twentieth century: 'During the recent world-upheaval Lady Butler devoted herself in characteristic fashion to the pursuance of her aims. Many of the subjects painted and exhibited during those terrible years still preached her gospel.' The work for which the artist had become famous was irretrievably associated with the British Empire, and the prime of her life had also been the most imperialistic era of the Victorian age. Though many in the first two decades of the twentieth century welcomed changing attitudes, others looked back with nostalgia to a set of values, habits and figureheads whose day was definitely done. The author's preamble to her autobiography, which takes the form of an imaginary exchange with her friends, expresses her position clearly:

1: . . . remember that I am writing while the world is still knocked

70

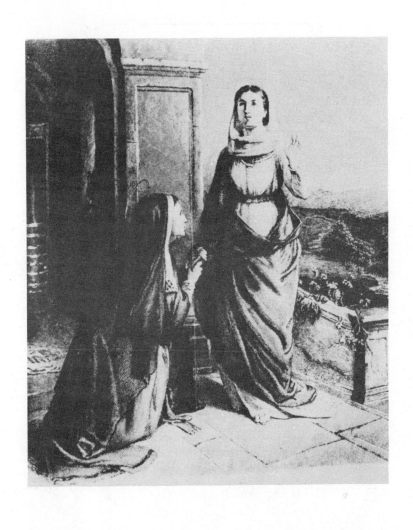

ELIZABETH THOMPSON, LADY BUTLER, *The Visitation*, 1872

off its balance by the Great War, and few minds will care to attune themselves to the Victorian and Edwardian stability of my time.
MY FRIENDS: There will come a reaction.

The extracts from *An Autobiography* presented here give an account of Thompson's beginnings and young life. She acknowledges the exceptional circumstances in which she was brought up, though she does not quite admit that they constitute privilege. She and her sister Alice both made their mark: Alice Meynell, as she became, constituted less of a shock to the system of her chosen field, poetry, than did Elizabeth to hers of painting, but both sisters were brought up to expect success. The idea that the noteworthy artist is inevitably an exceptional individual is suggested by M.E. Francis in her foreword; she describes the book as 'the revelation of a personality apart, at once feminine and virile, endued with the force engendered by unswerving allegiance to lofty aims'.

Such a characterisation would lead a reader to expect a history painter or an artist of epic themes rather than a portraitist or a painter of genre, and, indeed, the young Thompson devoted herself just as the mature Butler restricted herself to the unarguably epic theme of war. If the artist's readership, however, was the same audience that had flocked to view her paintings in the seventies, eighties and nineties, it would have been disappointed to find that the art work of *An Autobiography* was limited to pen and pencil sketches of the most informal sort and fell far short of the heroic themes with which she made her name.

In similar fashion, *Letters from the Holy Land* and *From Sketchbook and Diary* are illustrated with pleasant but unremarkable watercolour landscapes.

In contrast to the illustrations in her books, Butler's paintings turned on the immediacy of danger and death and the power of massed figures in action; all this drama achieved on a medium scale, with a conventional colour-range and an un-

varying confrontational composition. At one stage the artist decided to abjure all subjects but the religious, the *Athenaeum* reporting in July 1876 that 'Miss Elizabeth Thompson, who has joined the Roman Catholic church, has, it is said, foresworn the painting of battlepieces, and will hence-forward devote herself to Sacred Art'. This profession evidently came to nothing, for she produced only scenes of battle, soldiering and military life for exhibition, from her first success in 1874 till the end of her career in 1933. Only one religious painting survives, as an engraving, *The Visitation* of 1872 (p.71).

In 1877, Elizabeth Thompson married a soldier, William Butler, and thenceforward led a peripatetic existence, her experience of the world dictated by the administration of war, as she accompanied her husband to his various postings. She came to know the near and far east, Africa and Egypt, all places in which the British government had a military interest. She was never opposed to war: as well as taking a soldier as a husband, she was proud of one son following in his father's footsteps and the other serving as an army chaplain. But she did object to some aspects of the workings of war, such as military hierarchy and the classism of the ways in which inept but well-connected young men could become officers and leaders. She gives her point of view about war and how to paint it in Chapter Four of *An Autobiography*:

My own reading of war – that mysteriously inevitable recurrence throughout the sorrowful history of the world – is that it calls forth the noblest and the basest impulses of human nature. The painter should be careful to keep himself at a distance, lest the ignoble and vile details under his (sic) eyes should blind him irretrievably to the noble things that rise beyond.

Following page: ELIZABETH THOMPSON, LADY BUTLER, *Calling the Roll After an Engagement, Crimea (The Roll Call)*, 1874

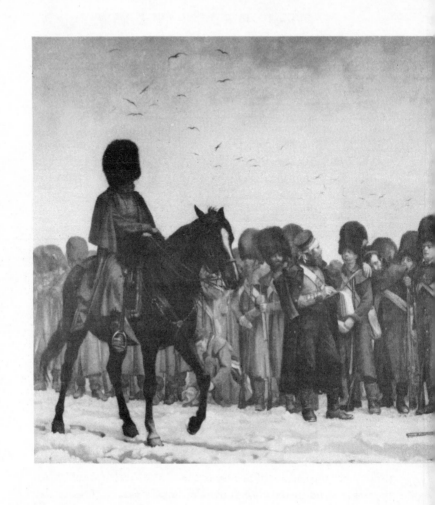

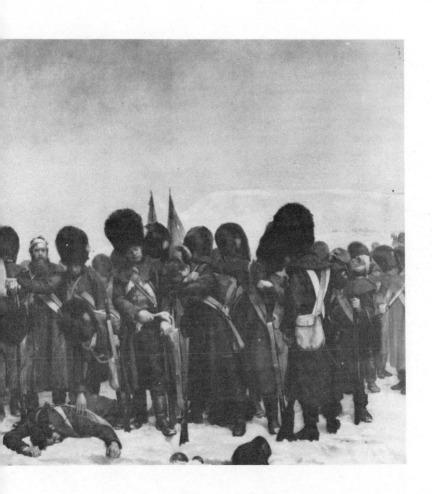

ELIZABETH THOMPSON, LADY BUTLER photographed in 1874 by
Fradelle and Marshall

She claimed, even so, to have realism as her aim, which is why she shunned the celebration of leadership, and emphasized the experience of the rank-and-file. Her subjects veer apparently arbitrarily from recent history to Napoleonic times: *The Roll Call* (pp.74–75, 1874) and *Balaclava* (1876) refer to the Crimean War of 1854, *Quatre Bras* (1884) to the Napoleonic Wars, and *Missing* (1873) to the Franco-Prussian War of 1870-1.

Not surprisingly, critics constantly discussed gender when addressing themselves to Butler's work. That a woman should have a keen interest in the masculine preserve of war was peculiar to many, piqued others, and challenged still more to rethink their terms of praise. Female artists might often produce images of women mourning the effects of war, welcoming soldiers home or waving them tearfully off, but the only actors in Butler's dramas are men. Most of her pictures were of the essential activity of war, killing, and its counterpart, dying. 'My idea of war subjects has always been antisparkle', she writes towards the end of her autobiography.

Elizabeth Thompson Butler was held up before the public of the 1870s and 1880s as the model of the female artist – her photograph was sold in the streets and newspapers collected and doled out any anecdote about her that could be believed – yet she shunned women's experience in her work, and whether or not her paintings convey a woman's point of view is arguable. She preferred being compared with war artists such as Edouard Detaille or Alphonse de Neuville to being contrasted with women artists such as Rosa Bonheur who had male approval. She distanced herself piously from emancipated women and their continuing struggle, writing towards the end of *An Autobiography*: 'The queen was buried today beside her husband at Frogmore. It is inexpressibly touching to think of them side by side again. Model wife and mother, how many of your women subjects have strayed away, of late, from those virtues which you were true to to the last!'

In comparison with Helen (Paterson) Allingham, an equally popular female artist at the end of the century, Butler seems to have adopted and been accepted in the role of the pseudo-male – what would be called today the Margaret Thatcher syndrome. This makes the authenticity of her work a pressing question, and causes problems for the contemporary viewer. What does the male viewer see in such work? What experience does it give the female viewer? Do her paintings help alter fixed ideas about 'women's work' or do they bolster the authority of the masculine by appearing to endorse it?

The problems which Elizabeth Thompson Butler's paintings pose for us today are evident in the extracts presented here. *An Autobiography* appears before the *Sketchbook*, although published later, because it accounts for the early part of the artist's life. The travel writings are presented in the author's original unchronological order; her trip to Ireland took place in 1905 and she was stationed in Egypt in 1891 and 1892.

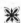

FIRST IMPRESSIONS

I was born at the pretty 'Villa Claremont,' just outside Lausanne and overlooking Lake Leman. I made a good start with the parents Providence gave me. My father, cultured, good, patient, after he left Cambridge set out on the 'Grand Tour,' and after his unsuccessful attempt to enter Parliament devoted his leisure to my and my younger sister's education. Yes, he began with our first strokes, our 'pot-hooks and hangers,' our two-and-two make four; nor did his tuition really cease till, entering on matrimony, we left the paternal roof. He adopted, in giving us our lessons, the principle of 'a little and often,' so that we had two hours in the morning and no lessons in the afternoon, only bits of history, poetry, the collect for the Sunday and dialogues in divers languages to learn overnight by heart to be repeated to him next morning. We had no regular holidays: a day off occasionally, especially when travelling; and we travelled much. He believed that intelligent travel was a great educator. He brought us up tremendous English patriots, but our deepest contentment lay in our Italian life, because we loved the sun – all of us.

So we oscillated between our Ligurian Riviera and the home counties of Kent and Surrey, but were never long at a time in any resting place. Our father's daughter by his first wife had married, at seventeen, an Italian officer whose family we met at Nervi, and she settled in Italy, becoming one of our attractions to the beloved Land. That officer later on joined Garibaldi, and was killed at the Battle of the Volturno. She never left the country of her adoption, and that bright lure for us remained.

Although we were very strictly ruled during lessons, we ran rather wild after, and, looking back, I only wonder that no illness or accident ever befell us. Our dear Swiss nurse was often scandalised at our escapades, but our mother, bright and beautiful, loving music and landscape painting, and practising

both with an amateur's enthusiasm, allowed us what she considered very salutary freedom after study.[1] Still, I don't think she would have liked some of our wild doings and our consortings with Genoese peasant children and Surrey ploughboys, had she known of them. But, careful as she was of our physical and spiritual health, she trusted us and thought us unique.

My memory goes back to the time when I was just able to walk and we dwelt in a typically English village near Cheltenham. I see myself pretending to mind two big cart-horses during hay-making, while the fun of the rake and the pitchfork was engaging others not so interested in horses as I already was myself. Then I see the *Albergo*, with vine-covered porch, at Ruta, on the 'saddle' of Porto Fino, that promontory which has been called the 'Queen of the Mediterranean,' where we began our lessons, and, I may say, our worship of Italy.

Then comes Villa de' Franchi for two exquisite years, a little nearer Genoa, at Sori, a *palazzo* of rose-coloured plaster and white stucco, with flights of stone steps through the vineyards right down to the sea. That sea was a joy to me in all its moods. We had our lessons in the balcony in the summer, and our mother's piano sent bright melody out of the open windows of the drawing-room when she wasn't painting the mountains, the sea, the flowers. She had the 'semi-grand' piano brought out into the balcony one full-moon night and played Beethoven's 'Moonlight Sonata' under those silver beams, while the sea, her audience, in its reflected glory, murmured its applause.

Often, after the babes were in bed, I cried my heart out when, through the open windows, I could hear my mother's light soprano drowned by the strong tenor of some Italian friend in a duett, during those musical evenings so dear to the music-loving children of the South. It seemed typical of her extinction, and I felt a rage against that tenor. Our dear nurse, Amélie, would come to me with lemonade, and mamma, when apprised of the state of things, would also come to the rescue,

her face, still bright from the singing, becoming sad and puckered.

A stay at Edenbridge, in Kent, found me very happy riding in big waggons during hay-making and hanging about the farm stables belonging to the house, making friends with those splendid cart-horses which contrasted with the mules of Genoa in so interesting a way. How the cuckoos sang that summer; a note never heard in Italy. I began writing verse about that time. Thus:

> The gates of Heaven open to the lovely season,
> And all the meadows sweet they lie in peace.

We children loved the Kentish beauty of our dear England. Poetry filtered into our two little hearts wherever we abode, to blossom forth in my little large-eyed, thoughtful sister in the process of time. To Nervi we went again, taking Switzerland on the way this time, into Italy by the Simplon and the Lago Maggiore.

As time went on my drawing-books began to show some promise, so that my father gave me great historical subjects for treatment, but warning me, in that amused way he had, that an artist must never get spoilt by celebrity, keeping in mind the fluctuations of popularity. I took all this seriously. I think that, having no boys to bring up, he tried to put all the tuition suitable to both boys and girls into us.[2] One result was that as a child I had the ambition to be a writer as well as a painter. We children were fanatically devoted to the worship of Charlotte Brontë, since our father had read us 'Jane Eyre' (with omissions).[3] Rather strong meat for babes! We began sending poetry and prose to divers periodicals and cut our teeth on rejected MSS.

We went back to Genoa, *viâ* Jersey (as a little *détour!*) The war against Austria had been won. Magenta, Solferino, Montebello – dear me, how those names resounded! One day as we were running along the road in our pinafores near the Zerbino

palace, above Genoa, along came Victor Emmanuel in an open carriage looking very red and blotchy in the heat, with big, ungloved hands, one of which he raised to his hat in saluting us little imps who were shouting 'Long live the King of Italy!' in English with all our might. We were only a *little* previous(!)[4] Then the next year came the Garibaldi enthusiasm, and we, like all the children about us, became highly exalted *Garibaldians*. I saw the Liberator the day before he sailed from Quarto for his historical landing in Sicily, at the Villa Spinola, in the grounds of which we were, on a visit at the English consul's. He was sitting in a little arbour overlooking the sea, talking to the gardener. In the following autumn, when his fame had increased a thousandfold, I made a pen and ink memory sketch of him which my father told me to keep for future times. I vividly remember, though at the time not able to understand the extraordinary meaning of the words, hearing one of Garibaldi's adoring comrades (one Colonel Vecchii) a year or two later on exclaim to my father, with hands raised to heaven, '*Garibaldi!! C'est le Christ le revolver à la main!*'

Our life at old Albaro was resumed, and I recall the pleasant English colony at Genoa in those days, headed by the very popular consul, 'Monty' Brown, and the nice Church of England chaplain, the Rev. Alfred Strettell. Ah! those primitive picnics on Porto Fino, when Mr. Strettell and our father used to read aloud to the little company, including our precocious selves, Shakespeare, Wordsworth, Keats, Tennyson, under the vines and olives, between whose branches, far below the cultivated terraces which we chose for our repose, appeared the deep blue waters of the Sea of seas. My early sketch books are full of incidents in Genoese peasant life: carnival revels in the streets, so suited to the child's idea of fun; charges of Garibaldian cavalry on discomfited Neapolitan troops (the despised *Borbonici*), and waving of tricolours by bellicose patriots. I was taken to the Carlo Felice Theatre to see Ristori in 'Maria Stuarda,' and became overwhelmed with

adoration of that mighty creature. One night she came on the stage waving a great red, white, and green tricolour, and recited to a delirious audience a fine patriotic poem to united Italy ending in the words '*E sii Regina Ancor!*' I see her now in an immense crinoline.

A charming autumn sojourn on the lakes of Orta and Maggiore filled our young minds with beauty. Early autumn is the time for the Italian lakes, while the vintage is 'on' and the golden Indian corn is stored in the open loggias of the farms, hanging in rich bunches in sun and luminous shade amongst the flower pots and all the homely odds and ends of these picturesque dwellings. The following spring was clouded by our return to England and London in particularly cold and foggy weather, dark with the London smoke, and our temporary installation in a dismal abode hastily hired for us by our mother's father, where we could be close to his pretty little dwelling at Fulham. My diary was begun there. Poor little 'Mimi'[5] (as I was called), the pages descriptive of our leaving Albaro at that time are spotted with the mementos of her tears. The journey itself was a distraction, for we returned by the long Cornice Route which then was followed by the *Malle Poste* and Diligence, the railway being only in course of construction. It was very interesting to go in that fashion, especially to me, who loved the horses and watched the changing of our teams at the end of the 'stages' with the intensest zest. I made little sketches whenever halts allowed, and, as usual, my irrepressible head was out of the Diligence window most of the time. The Riviera is now known to everybody, and very delightful in its way. I have not long returned from a very pleasant visit there; everything very luxurious and up-to-date, but the local sentiment is lessened. The reason is obvious, and has been laboured enough. One can still go off the beaten paths and find the true Italy. I have found one funny little sketch showing our *Malle Poste* stopping to pick up the mail bag at a village (San Remo, perhaps),

which bag is being handed out of a top window, at night, by the old postmistress. The *Malle Poste* evidently went 'like the wind,' for I invariably show the horses at a gallop all along the route.

My misery at the view of our approach to London through that wilderness of slums that ushers us into the Great Metropolis is all chronicled, and, what with one thing and another, the Diary sinks for a while into despondency.[6] But not for long. I cheer up soon.

In London I took in all the amusing details of the London streets, so new to me, coming from Italy. I seem, by my entries in the Diary, to have been particularly diverted by the colour of those Dundreary whiskers that the English 'swell' of the period affected. I constantly come upon 'Saw no end of red whiskers.' Then I read, 'Mamma and I paid calls, one on Dickens (*sic*) – out, thank goodness'. Charles Dickens, whom I dismiss in this offhand manner, had been a close friend of my father's and it was he who introduced my father to the beautiful Miss Weller (amusing coincidence in names!) at an amateur concert where she played. The result was rapid. My vivid memory can just recall Charles Dickens's laugh. I never heard it echoed by any other man's till I heard Lord Wolseley's. The volunteer movement was in full swing, and I became even more enthusiastic over the citizen soldiers than I had been over the *Garibaldini*. Then there are pages and pages filled with descriptions of the pictures at the Royal Academy; of the Zoological Gardens, describing nearly every bird, beast, reptile and fish. Laments over the fogs and the cold of that dreadful London April and May, and untiring outbursts in verse of regret for my lost Italy. But I stuffed my sketch books with British volunteers in every conceivable uniform, each corps dressed after its own taste. There was a very short-lived corps called the Six-foot Guards! I sent a design for a uniform to the Illustrated London News, which was returned with thanks.[8] I felt hurt. Grandpapa attached

himself to the St. George's Rifles, and went, later on, through storm and rain and sun in several sham fights. Well, *Punch* made fun of those good men and true, but I have lived to know that the 'Territorials,' as they came to be called, were destined in the following century to lend their strong arm in saving the nation. We next had a breezy and refreshing experience of Hastings and the joy of rides on the downs with the riding master. London fog and smoke were blown off us by the briny breezes.

EARLY YOUTH

In December we migrated back to London, and shortly before Christmas our dear, faithful nurse died. That was Alice's and my first sense of sorrow, and, even now, I can't bear to go over those dreadful days. Our father told us we would never forgive ourselves if we did not take our last look at her. He said we were very young for looking on death, but 'go, my children,' he said, 'it is right.' I cannot read those heartbroken words with which I fill page after page of my diary even now without tears. She had at first intended to remain at home at Lausanne when my parents were leaving for England, shortly after my birth, but as she was going I smiled at her from my cradle. '*Ah! Mademoiselle Mimi, ce sourire!*' brought her back irresistibly, and with us she remained to the end.

As we girls grew apace we had a Parisian mistress to try and parisianise our Swiss French and an Italian master to try and tuscanise our Genoese Italian, and every Saturday a certain Mr. Standish gave me two hours' drill in oil painting.[9] How grand I felt! He gave me his own copies of Landseer's horses' heads and dogs as models. This wasn't very much, but it was a beginning. My lessons in the elementary class at the S. Kensington School of Art are not worth mentioning. The

masters gave me hateful scrolls and patterns to copy, and I relieved my feelings by ornamenting the margins of my drawing paper with angry scribblings of horses and soldiers in every variety of fury.[10] That did not last long. This entry in the Diary speaks for itself:–

'*Sunday, March* 16*th,* 1862 We went to Mr. Lane's house preparatory to going to see Millais in his studio. Mr. Richard Lane is an old friend of papa's.[11] The middle Miss Lane is a favourite model of Millais' and very pretty. We entered his studio, which is hung with rich pre-Raphaelite tapestry and pre-Raphaelite everything. The smell of cigar smoke prepared me for what was to come. Millais, a tall, strapping, careless, blunt, frank, young Englishman, was smoking with two villainous friends, both with beards – red, of course. Instead of coming to be introduced they sat looking at Millais' graceful drawings calling them 'jolly' and 'stunning,' the creatures! Millais would be handsome but for his eyes, which are too small, and his hair is colourless and stands up in curls over his large head but not encroaching upon his splendid forehead. He seems to know what a universal favourite he is.'[12] I naturally did not record in this precious piece of writing a rather humiliating little detail. I wanted the company to see that I was a bit of a judge of painting, ahem! In fact, a painter myself, and, approaching very near to the wet picture of 'The Ransom' (I think), I began to scrutinise. Mr. Lane took me gently, but firmly, by the shoulders and placed me in a distant chair. Had I been told by a seer that in 1875 – the year I painted 'Quatre Bras' – this same Millais, after entertaining me at dinner in that very house, would escort me down those very steps, and, in shaking hands, was to say, 'Good night, Miss Thompson, I shall soon have the pleasure of congratulating you on your election to the Academy, an honour which you will *t'oroughly* deserve' – had I been told this![13]

Our next halt was in the Isle of Wight, at Ventnor, and then

at Bonchurch, and our house was 'The Dell.' Bonchurch was a beautiful dwelling-place. But, alas! for what I may call the Oxford primness of the society! It took long to get ourselves attuned to it. However, we got to be fond of this society when the ice thawed. The Miss Sewells were especially charming, sisters of the then Warden of New College. Each family took a pride in the beauty of its house and gardens, the result being a rivalry in loveliness, enriching Bonchurch with flowers, woods and ornamental waters that filled us with delight. Mamma had 'The Dell' further beautified to come up to the high level of the others. She made a little garden herself at the highest point of the grounds, with grass steps, bordered with tall white lilies, and called it 'the Celestial Garden.' The cherry trees she planted up there for the use of the blackbirds came to nothing. The water-colours she painted at 'The Dell' are amongst her loveliest.

Ventnor was fond of dances, at Homes, and diversions generally, but I shall never forget my poor mother's initial trials at the musical parties where the conversation raged during her playing, rising and sinking with the *crescendos* and *diminuendos* (and this after the worship of her playing in Italy!), and once she actually stopped dead in the middle of a Mozart and silence reigned. She then tried the catching 'Saltarello,' with the same result exactly. 'The English appreciate painting with their ears and music with their eyes,' said Benjamin West (if I am not mistaken), the American painter, who became President of our Royal Academy.[14] This hard saying had much truth in it, at least in his day. Even in ours they had to be *told* of the merits of a picture, and the *sight* of a pianist crossing his hands when performing was the signal for exchanges of knowing smiles and nods amongst the audience, who, talking, hadn't heard a note. For vocal music, however, silence was the convention. How we used inwardly to laugh when, after a song piped by some timid damsel, the music was handed round so that the words and music might be

seen in black and white by the guests assembled. I thankfully record the fact that as time went on my mother's playing seemed at last to command attention, and it being whispered that silence was better suited to such music, it became quite the thing to stop talking . . .

The Ventnor dances were thoroughly enjoyable, and the croquet parties and the rides with friends, and all the rest of it. Yes, it was a nice life, but the morning lessons never broke off. No doubt we were precocious, but we like to dwell on the fact of the shortness of our childhood and the consequent length of our youth. I now and then come upon funny juvenile sketch books where I find my Ventnor partners at these dances clashing with charges of Garibaldian cavalry. There they are, the desirable ones and the undesirable; the drawling 'heavy swell' and the raw stripling; the handsome and the ugly. The girls, too, are there; the flirt and the wallflower. They all went in.

These festive Ventnor doings were all very well, but it became more and more borne in upon me that, if I intended to be a 'great artist' (oh! seductive words), my young 'teens were the right time for study. 'Very well, then – attention! – miss!'[15] No sooner did my father perceive that I meant business than he got me books on anatomy, architecture, costume, arms and armour, Ruskin's inspiring writings, and everything he thought the most appropriate for my training. But I longed for regular training in some academy. I chafed, as my Diaries show. For some time yet I was to learn in this irregular way, petitioning for real severe study till my dear parents satisfied me at last. 'You will be entering into a tremendous ruck of painters, though, my child,' my father said one day, with a shake of his head. I answered, 'I will single myself out of it.'

So, then, the lovely 'Dell' was given up, and soon there began the happiest period of my girlhood – my life as an art student at South Kensington; *not* in the elementary class of unpleasant memory, but in the 'antique' and the 'life.'[16]

But our father wanted first to show us Bruges and the Rhine, so we were off again on our travels in the summer. Two new countries for us girls, hurrah! and a little glimpse of a part of our own by the way. I find an entry made at Henley.

'*Henley, May* 31*st* Before to-day I could not boast with justice of knowing more than a fraction of England! This afternoon I saw her in one of her loveliest phases on a row to Medmenham Abbey. Skies of the most telling effects, ever changing as we rowed on, every reach we came to revealing fresh beauties of a kind so new to me. The banks of long grass full of flowers, the farmsteads gliding by, the willows allowed to grow according to Nature's intention into exquisitely graceful trees, the garden lawns sloping to the water's edge as a delicious contrast to the predominating rural loveliness, and then that unruffled river! I have seen the Thames! At Medmenham Abbey we had tea, and one of the most beautiful parts of the river and meadowland, flowery to overflowing, was seen before us through the arcades, the sky just there being of the most delicious dappled warm greys, and further on the storm clouds towered, red in the low sun. What pictures wherever you turn; and turn and turn and turn we did, until my eyes ached, on our smooth row back. The evening effects put the afternoon ones out of my head. I imagined a score of pictures, peopling the rich, sweet banks with men and women of the olden time. The skies received double glory and poetry from the perfectly motionless water, which reflected all things as in a mirror – as if it wasn't enough to see that overwhelming beauty without seeing it doubled! At last I could look no more at the effects nor hear the blackbirds and thrushes that sang all the way, and, to Mamma's sympathetic amusement, I covered my eyes and ears with a shawl. Alas! for the artist, there is no peace for him. He cannot gaze and peacefully admire; he frets because he cannot 'get the thing down' in paint.[17] Having finished my row in that Paradise, let me also descend from the

poetic heights, and record the victory of the Frenchman. Yes, 'Gladiateur' has carried off the blue ribbon of the turf. Upon my word, these Frenchmen!' It was the first time a French horse had won the Derby.

Bruges was after my own heart. Mediæval without being mouldy, kept bright and clean by loving restorations done with care and knowledge. No beautiful old building allowed to crumble away or be demolished to make room for some dreary hideosity, but kept whole and wholesome for modern use in all its own beauty. Would that the Italians possessed that same spirit. My Diary records our daily walks through the beautiful, bright streets with their curious signs named in Flemish and French, and the charm of a certain *place* planted with trees and surrounded by gabled houses. Above every building or tree, go where you would, you always saw rising up, either the wondrous tower of the Halle (the *Beffroi*), dark against the bright sky, or the beautiful red spire on the top of the enormous grey brick tower of Notre Dame, a spire, I should say, unequalled in the world not only for its lovely shape and proportions, but for its exquisite style and colour: a delicious red for its upper part, most refined and delicate, with white lines across, and as delicate a yellow lower down. Or else you had the grey tower of the cathedral, plain and imposing, made of small bricks like that of Notre Dame, having a massive effect one would not expect from the material. Over the little river, which runs nearly round the town, are oft-recurring drawbridges with ponderous grey gates, flanked by two strong, round, tower-like wings. Most effective. On this river glided barges pulled painfully by men, who trudged along like animals. I record with horror that one barge was pulled by a woman![18] 'It was quite painful to see her bent forward doing an English horse's work, with the band across her chest, casting sullen upward glances at us as we passed, and the perspiration running down her face. From the river diverge

canals into the town, and nothing can describe the beauty of those water streets reflecting the picturesque houses whose bases those waters wash, as at Venice. When it comes to seeing two towers of the Halle, two spires of Notre Dame, two towers of the cathedral, etc., etc., the duplicate slightly quivering downwards in the calm water! Here and there, as we crossed some canal or other, one special bit would come upon us and startle us with its beauty. Such combinations of gables and corner turrets and figures of saints and little water-side gardens with trees, and always two or more of the towers and spires rising up, hazy in the golden flood of the evening sun!'

Notes

1 Women artists of the nineteenth (and twentieth) century often credit their mother with engendering their interest in art, often through her own practical example. Starr and Canziani are obviously relevant examples, while Ward saw in her mother the example of an exhibiting artist.

2 This is evidently an exaggeration flattering to the author's father's progressiveness, but at the same time it is true that the closedness or openness of a girl's upbringing depended very much on the whim or will of her father. Many women who became public figures in Victorian Britain had benefited at an early age from a liberal middle-class father's scorn for conventional ideas about women.

3 Charlotte Bronte's immediately famous novel had appeared in 1847. No doubt the two young girls were struck as much by the work produced by the Brontes, as by the melodramatic and eminently romanticiseable circumstances of the three sisters' becoming artists.

4 This is Victor Emmanuel II, who became king of Italy in 1861,

after a complex political manoeuvre carried out in complicity with France, whereby the unification of the separate Italian states was meant to be achieved. Victor Emmanuel was ruler of Piedmont, which was the territory at the core of Italian unification; the war against Austria which Thompson refers to here was a contrived attempt by Piedmont (with French backing) to eliminate Austria as a threat to the northern unification of Italy. Giuseppe Garibaldi arose to prominence as the self-styled pro-unification leader of the southern Italian states, becoming an adopted British hero because of his acceptance of the rule of monarchy over an Italy apparently unified by self-determination.

5 The chief female character in Henri Murger's novel of Parisian artistic life *La Vie de Boheme* (1847-9). She became one of the most popular operatic heroines after the appearance of Puccini's *La Boheme* (1896), based on the literary source.

6 London's slums, lack of hygiene, and appalling poverty were notorious; the most graphic visual exposé of the inequities of mid-Victorian London was (and is) Gustave Doré's series of engravings *London, a journey* (1870), but see also Dyos and Wolff, eds, *The Victorian City: images and realities*, London/ Oxford 1973 and Henry Mayhew's earlier research, *London Labour and the London Poor*, 1851.

7 'In 1859 there was a panic over the supposed ill intentions of Napoleon III, though his real desire was to live on friendly terms with England. So the islanders had one of their periodic frights that punctuated their perpetual unpreparedness, and the result on this occasion was the starting of the Volunteer movement, the drilling of business men and their employees in off hours, consonant with the civilian and individualist spirit of the time.' G.M. Trevelyan, *Illustrated English Social History*, vol. 4, London 1964, p.167.

8 This was evidently a practice which she continued, for some years later, in the *Anthenaeum* this time, is the following item on the art news page: 'Miss E.S. Thompson sends us photo-

graphs from four designs by herself to illustrate a popular novel. Her note states she does this "for criticism, with a view to having them published". About the publication we know nothing; but have much pleasure in saying that the designs are remarkably good in their way'. (January 1867, p.94).

9 Probably W. Standish, an undistinguished painter of horses, who lived nearby.

10 This is the first hint of the obsession which the artist's work was to develop with such subject-matter. 'How strange it seems that I should have been so impregnated, if I may use the word, with the warrior spirit in art, seeing that we had no soldiers in either my father's or mother's family!' she writes later on. 'My father had a deep admiration for the captains of war, but my mother detested war . . .'

11 John Everett Millais, who had come to fame as an infant prodigy at the RA and then as a member of the Preraphaelite Brotherhood, seems to be a statutory ingredient of the Victorian artist's memoirs. He figures in many recollections of the later Victorian era, too, because he shrugged off his youthful radicalism in the sixties and achieved great popular success, becoming also an Academy favourite before his death in 1896. Richard Lane (1800-72) was an engraver, draughtsman and lithographer; his daughter Clara was an amateur artist and is represented in the National Portrait Gallery by a drawing of her uncle.

12 'Millais was undoubtedly vain of his handsome appearance and, feeling that he looked his best in profile, usually posed that way', writes Jeremy Maas (*The Victorian Art World in Photographs*, London 1984, p.106). Henrietta Ward waxes lyrical about Millais' good looks in *Reminiscences*, London 1911, p.77, and William Michael Rossetti, the PRB's recorder, called the artist 'a very handsome, or more strictly, a beautiful, youth' (*Some Reminiscences*, London 1906, vol.1, p.74).

13 Women remained tacitly banned from Academy membership until the twentieth century. Annie Swynnerton was elected an

Associate of the Academy in 1922, and Laura Knight elected a full Academician in 1936. Even so, in protest against the continuing ban on women, during Academy elections of the 1880s some members put forward women's names, including those of Butler, Ward and the flower painter Annie Mutrie.

14 Benjamin West (1738-1820) came to Britain in 1763, was a founder member of the Academy, and became its second president in 1792.

15 Note the military language, used though it is in jest. The joking about her ambition veils a stern ambition which is evident throughout her accounts of her student days. Her sense of her own importance comes out, surely quite unconsciously, in such comments in later chapters as: 'My fellow students were a great delight to me, so enthusiastically did they watch my progress and foretell great things for me.'

16 These are the next stages on the ladder: the first consisting in copying from casts and drawings and revered classical works, the second based on observation and drawing from the life model, whether dressed, draped or naked. The latter was considered the crucial element of a training which would enable one to produce figure paintings and sculpture, and it was this aspect of fine art training which was withheld most obstinately from female students throughout the Victorian age. In the RA Schools, female students were only given a naked model in 1895!

17 This rather precious idea of the artist's sensibility to nature and environment comes out clearly in the author's descriptions of places in her travel books.

18 Butler's upbringing must have been very sheltered indeed: see Ivy Pinchbeck, *Women Workers and the Industrial Revolution*, 1930; Ray Strachey, *The Cause*, 1928; Margaret Llewelyn Davies ed., *Life as We have Known It*, 1931 and 1977.

COUNTY MAYO IN 1905

I WISH you would make a summer tour to Mayo. It is simple; yet what a change of scene, of sensations, of thoughts one secures by this simple and direct journey – Euston, Holyhead, Dublin, Mulranny. You travel right across Ireland, getting a very informing vista of the poverty and stagnation of those Midland counties till your eyes greet the glorious development of natural beauty on the confines of the sea-girt Western land.[1] I went there tired from London and came on a scene of the most perfect repose imaginable, with the sound of the motor buses still buzzing in my ears.

Mulranny is supremely healthy – a place of rosy cheeks and sunburn, bracing yet genial, clear-aired, majestic in its scenery, unspoilt. As you near your journey's end and enter Mayo the change in the scenery from the emptiness of Roscommon develops rapidly. Magnificent mountains rise on the horizon, and the grandeur of the landscape grows into extraordinary beauty as the train rounds into Clew Bay. The great cone of Croagh Patrick rises in striking isolation at first, and then the surrounding mountains, one by one, join it in lovely outlines against the fresh *clean* sky. It was a beautiful afternoon when I was introduced to this memorable landscape, and the waters of the Bay were quite calm. After sunset the crescent moon gave the culminating charm to the lovely scene in the west, while to the south the red planet Mars flamed above Croagh Patrick, and all this beauty was mirrored in the Bay. What an emancipation from the fret and fuss of little Piccadilly in a hot July to find oneself before these mountain forms and colours that have not changed since the cooling of the earth. You might travel further a great way and not find such a virgin land.

And there is Achill Island, a one-day's excursion from Mulranny, poignantly melancholy in its beauty and remoteness beyond anything I have seen in the west. Achill has often been described; it holds the traveller's attention with a wild

95

appeal to his heart; but I don't know that one little detail of that land 'beyond the beyond' has ever been described. It is Achill's mournful little Pompeii, a village of the dead, on a bare hillside, which we passed one day on our way to an unfrequented part of the island.[2] This village was deserted in the awful famine year of '47, some of the inhabitants creeping away in fruitless search of work and food to die farther afield, others simply sinking down on the home sod that could give them nothing but the grave. In the bright sunshine its roofless cabins and grass-grown streets looked more heart-breaking than they might have done in dismal rain. I wish I could have made a sketch of it as I saw it that day – a subject strongly attracting the attention of the mind rather than the eye. Pictorial beauty there was none.

Everywhere in this country there is that heart-piercing contrast between natural beauty and human adversity – that companionship of sun and sorrow. But the light and the darkness seem blended by the unquestioning faith of these rugged Christians into a solemn unity and harmony before which any words of mine sound only like so much dilettantism.

There are wonderful studies of old men's and women's heads here, full of that character which in the more 'educated' parts of Ireland the School Board seems to be rubbing out,[3] and I was delighted to see the women and girls wearing the head-shawls and white caps and the red petticoats that charmed me in Kerry in '77. The railway is sure to bring the dreadful 'Frenchy' hat here in time, and then good-bye to the comely appearance of these women. Their wild beauty undergoes an extraordinary change under the absurd hat and feathers – these winsome colleens then lose all their charm.

I must thank the same railway for having brought us to this haven of rest, right up to the doors of a charming, very modern hotel, on quite different lines from the dear little inn that fascinated me in the old Glenaragh days. In its way it is

fascinating too, for here you have all the up-to-date amenities in the very heart of the wildest country you could wish for. The electric light is generated by the mountain streams and the baths filled from the glorious bay that lies below the hotel terraces, a never-failing delight in all its moods of sun and shadow, wind and calm.

Sad it is to see so many cabins deserted. The strength of the country is ebbing away. The few people that are left are nice and wholesome in mind and manner; they have the quiet urbanity of the true peasant all the world over. They remind me of the Tuscan in this particular, but, of course, they have not his light-heartedness.[4] More seriousness, I should think, these Irish have. I was sketching sheep, for a contemplated picture, in the evenings, on the lovely marshes by the sea, and one evening a widow, left completely lonely in her little cabin on the heights above by the departure for America of her last child,[5] came down to fetch home her solitary sheep from amongst the others, and I told her I thought these creatures were leading a very happy life. 'Yes,' she answered, pausing for a moment and looking down on the flock, 'and they are without sin.'

My studies of the wild mountain sheep on the marshes came to an abrupt close. I was reposing under a rock (it was well on in July) with palette and panels ready, waiting for the sunset and its after-glow, to get final precious notes of colour upon the fleeces. One particular sheep had been a very useful model. It ambled in a graceful way on three legs and we call it 'Pacer.' I became aware of an opaque body rising between my closed eyes and the sun, and looking up I beheld the head of 'Pacer' peering at me over the edge of the rock over my head. But what had happened to 'Pacer's' neck? Good gracious! I jumped up and beheld a shorn 'Pacer' and all the flock in the same lamentable condition. It had all happened in twenty-four hours.

I want to bring before your mind two little rocky islands

with green summits off the coast of Clare, not far from here. Of all the wind-swept little islands none could be more wind-swept. On one, the smallest, I heard that a ferocious and unmanageable billy-goat was deposited as a useless member of the community, and one night he was blown out to sea – a good riddance. On the other you perceive, through the spray, little nodules on the turf – the graves of unbaptized infants. And the sea-gulls along the cliffs are for ever crying like legions of children. . . .

You will have the wish to 'Come back to Erin, Mavourneen,' after making this little tour. To me Ireland is very appealing, though I owe her a grudge for being so tantalizing and evasive for the painter. The low clouds of her skies cause such rapid changes of sun and shadow over her landscapes that it requires feats of technical agility to catch them on the wing beyond my landscape powers. My only chance is to have unlimited time and thus be able to wait a week, if necessary, for the particular effect to come round again. An artist I heard of thought he had 'bested' the Irish weather and its wiles when he set up this clever system: six canvasses he spread out before him on the ground in a row, each with a given arrangement of light and shade sketched out ready. But when the psychological moment arrived he was so flurried, that while he was wildly running his hand up and down the row of canvasses for the right one he could never find it in time.

A nice dance you are led, sketching in Ireland, altogether![6] You are, for instance, intent on dashing down the plum-like tones of a distant mountain, when lo! that mountain which in its purple mystery seemed some fifteen miles away, in a moment flashes out into such vivid green that, as the saying is here, 'you might shake hands with it,' so close has it come. Even its shape is changed, for peaks and buttresses start forth in the sunburst where you imagined unbroken slopes a few minutes before. Shadowed woods spring into dark prominence by the sudden illumination of the fields behind them and as

suddenly are engulfed in the golden haze of a shaft of light that pierces the very clouds whose shadows had a minute before given them such a startling prominence on the light background. Unsuspected lovelinesses leap forth while those we saw before are snatched away, and the sunlight for ever wanders up and along the mountain sides, as some one has finely said, 'like the light from a heavenly lantern.'

What those changes from beauty to beauty do towards sunset I leave you to imagine. I have never seen Ireland at all worthily painted. I think we ought to leave her to her poets and to the composers of her matchless music.

To the East! What a thrill of pleasure those words caused me when they meant that I was really off for Egypt. The East has always had for me an intense fascination, and it is one of the happiest circumstances of my life that I should have had so much enjoyment of it.

My childish sketch-books, as you remember, are full of it, and so are my earliest scribblings. To see the reality of my fervid imaginings, therefore, was to satisfy in an exquisite way the longing of all my life.

The Gordon expedition was my opportunity, and it was a bold and happy conception of W.'s that of my going out with the two eldest little ones to join him on the Nile when the war should be over.[7] I may say I – and the British Army – had the Nile pretty well to ourselves, for few tourists went up the year I was there. But I had to wait some time at Cairo and at Luxor before all trouble had been put an end to by the battle of Ginniss, which closed the recrudescence of rebellion that burst out after the great Khartoum campaign.

The emotion on seeing the East for the first time can never be felt again. The surprise can never be repeated, and holds a type of pleasure different from that which one feels on revisiting it, as I have so often done since.

One knows the 'gorgeous East' at first only in pictures; one

takes it on trust from Delacroix, Decamps, Gérôme, Müller, Lewis, and a host of others. You arrive, and their pictures suddenly become breathing realities, and in time you learn, with exquisite pleasure, that their most brilliant effects and groups are no flights of fancy but faithful transcripts of every-day reality.[8]

But at first you ask, 'Can those figures in robes and turbans be really going about on ordinary business? Are they bringing on that string of enormous camels to carry real hay down that crowded alley; are those bundles in black and in white wrappers, astride of white asses caparisoned in blue and silver, merely matter-of-fact ladies of the harem taking their usual exercise?[9] That Pasha's curvetting white Arab horse's tail is dyed a tawny red, and what is this cinder-coloured, bare-headed, jibbering apparition, running along, clothed in rattling strings of sea-shells and foaming at the mouth? A *real* fanatic? That water-seller by Gérôme has moved; he is selling a cup of water to that gigantic negro in the white robe and yellow slippers, and is pocketing the money quite in an ordinary way. And there is a praying man by Müller, not arrested in mid-prayer, but going through all the periods with the prescribed gestures, his face to the East, and the declining sun adding an ever-deepening flush to the back of his amber-coloured robe.'

It takes two or three days to rid oneself of the idea that the streets are parading their colours and movement and their endless variety of Oriental types and costumes for your diversion only, on an open-air stage.

What a treat, to put it in that way, it was to rove about in the reality of the true East, to meet beauty of form and colour and light and shade and movement wherever one's eyes turned, without being brought up with a nasty jar by some modern hideosity or other. This was contentment. You know what a bit of colour in sun or luminous shade does for me. Think of

my feelings when I walked through the narrow streets where the rays of the sun slanted down through gaps in the masonry, or, as in some, through chinks in the overhead matting – now on a white turban, now on a rose-coloured robe relieved against the rich dark background of some cavernous open doorway, now on a bit of brass-work. The soft tones of the famous Carpet Bazaar in noon-day twilight, with that richness of colour that tells you the invisible sunshine is somewhere, fulfilled – yea, over-filled – my expectations, and close by in real working trim were the brass-workers tinkering and tapping musically, the while smoking their hubble-bubbles in very truth. The goldsmiths, in their own particular alley, were sitting in the rich chiaroscuro of their little shops waiting for me.

Added to those feasts for the eyes were the sounds which pictures could not give me – the warning shouts of the donkey and camel-drivers, the 'by your leave' in Arabic, followed by the shuffling sound of hoof and foot in the soft tan; the tinkling of the water-sellers' brass saucers; the cries, like wild songs in the minor, of hawkers of all kinds of things. Then the scents, also unpaintable. Incense, gums, tan, ripe fruit, wood-smoke. And the smells? Ah, yes, well – the smells, goaty and otherwise. They were all bound up together in that entirety which I would not have deleted.

There was one particular angle of street in front of I forget what ripe old mosque, before which I would have liked to establish myself all day. The two streams of passers-by, human and animal, ceaselessly jostling each other, came at one particular hour into a shaft of sunlight just at the turn where I could see them in perspective. Now a splendid figure in yellow robe and white turban, accentuating the streak of gold to perfection, occupied the centre of the composition and I would make a mental note: 'daffodil yellow and white in intense sunlight; dull crimson curtain in shade behind; man in half-shade in dark brown, boy in indigo in reflected light' –

when in the shaft of light now appeared a snow-white robe and rosy turban, putting out the preceding scheme, till a *hadji* in a turban of soft bluey-green and pale-blue drapery came to suggest a very delicate emphasis to the rich and subdued surroundings.

In the first fresh days how mysterious these covered streets appear, these indoor thoroughfares, muffled with tan, where towering camels and shuffling donkeys and curvetting horses seem so astonishingly out of place.

Anglo-Egyptians who have to live in Cairo smile at my enthusiasm, and tell me they get tired of all this in time, and they are certainly helping to attenuate the charm. A late high official, on leaving Egypt, in his farewell speech told his audience that that day had been the happiest in his life, for he had seen the first 'sandwich man' in the streets of Cairo. Since then another charming form of advertisement from the go-ahead West has appeared over the minarets of the alcohol-abhorring Moslems – a 'sky sign' flashing out against the stars the excellence of somebody's whisky.[10] Can they now say 'the changeless East'? And what a whirlpool of intensely Western amusements you may be sucked into if you are not wary. You may hide in the bazaars but you cannot live there, and teas, gymkanas, dances, and dinners will claim you for their own as though you were at Monte Carlo or still nearer home. In fact I have found New Cairo a little London and Monte Carlo rolled into one.

As to worthily painting the Egyptian landscape, I cannot think any one will ever do it – the light is its charm, and this light is unattainable. There is one thing very certain, oil paints are hopelessly 'out of it,' and in water-colours alone can one hope to suggest that light. I soon gave up oils in Egypt, not only on account of their heaviness, but the miseries I endured from flies and sand were heart-breaking; your skies are seamed with the last wanderings and struggles of moribund flies, and

coated with whiffs of sand suddenly flung on them by a desert gust![11] I was particularly anxious to get a *souvenir* of the doorway in the court of the temple on Philæ Island, where Napoleon's soldiers engraved their highsounding '*Une page d'histoire ne doit pas,*' etc.[12] Unfortunately, on the day I chose, we had a high wind, a very exasperating ordeal, and my attempt at oil-sketching this subject was a fiasco. After persevering with one half-blinded eye open at a time and with sand thickly mixed with my paints, I saw the panel I had been desperately holding on the easel hurled to the ground on its buttered side as for a moment I turned to answer a remark of Mrs. C.'s. She said I bore it angelically. As since those days lovely Philæ Island is being submerged and the temple melting away, the poor little panel has become more historically valuable than I thought it ever would do at the time.

W. could not spare the time for lotus-eating under sail, so a 'stern-wheeler' towed us from Philæ to Wady Halfa. It took very little away from the romance, and the steady progress was very grateful. On that glassy river, as it was now, we would have been an age getting to our goal.

I was greatly struck with Korosko, a place which, besides its natural desolate and most strange appearance, was sad with memories of Gordon. This was his starting-point as he left the Nile to travel across the desert to Khartoum, never to return. From a height one can see the black and grey burnt-up landscape which lonely Gordon traversed. It is a most repellent tract of desert just there, calcined and blasted. A view I had of the Nile, southward, from the mountains of Thebes one day, though bathed in sunshine, has remained most melancholy in my mind, because, looking towards Khartoum, I thought of the hundreds of my countrymen who lay buried in already obliterated graves all along those lonely banks, away, away to the remote horizon and beyond, sacrificed to the achievement of a great disaster. Others like them have arisen since and will arise, eager to offer their lives for success

or failure, honours or a nameless grave.

In the first really hot days of March, I and the children came home – Wady Halfa was becoming no place for us, and W. remained with his Brigade through the weary days of summer, unknown in their exhausted and horrible listlessness to me who will always think of the Nile as an earthly paradise. One halt I must make on our way down, at Abu Simbel, that mysterious rock temple I had longed to see in the first ray of sunrise, for it faces due east. W., who accompanied us as far as Assouan, gave orders that our stern-wheeler (the old '*Fostât*' had been dismissed) should tie up overnight at the temple, and before daylight I was up and ready. I had packed my water-colours and had only a huge canvas and oil-paints available. With these I climbed the hill and waited for the first ray in the wild wind of dawn.

The event was all I hoped for as regards the effect of those 'scarlet shafts' on the four great figures (how many sunrises had they already awakened to?) 'A great cameo,' Miss Amelia Edwards calls that façade at sunrise in her fascinating book,[13] and that phrase had made me long for years for this moment. But alas! my canvas acted as a sail before the wind and nearly carried me into the river, the sand powdered the wet paint more viciously than ever, and I returned very blue to breakfast. Still, I had got my 'Abu Simbel at Sunrise'.

I cannot hope ever to convey to the mind of those who have not experienced Cape Colony the extraordinary powerful local feeling of these days and nights. Melancholy they are – at least to me – but most, most beautiful and *pungently* poetical. The aromatic quality of the odours that permeate the air suggests that word. Yet all is too strange to win the heart of a newcomer, however much his eyes and mind may be captivated.

If an artist wanted to accomplish that apparently impossible feat of painting Fairyland direct from Nature, without one touch supplied out of his own fancy, he would only have to

come here. There are effects of light and colour on these landscapes that I never saw elsewhere. The ordinary laws seem set aside. For instance, you expect a palm-tree to tell dark against the sunset. Oh, dear me no, not necessarily here. I saw one a tender green, and the sand about it was in a haze of softest rose-colour, through which shone the vivid orange light of the sunset behind it. Incredible altogether are the colours at sunset, but áll so fleeting. And there is no after-glow here as in Egypt and Italy; the instant the glory of the setting sun is gone all is over and all is grey.

Even the melancholy-quaint sound of the frogs through the night suggests fairy tales. It is appealing in its own way. I thought the Italian maremma frog noisy, but no one can imagine what an orgy of shrill croaking fills the nights here. They are everywhere, these irrepressibles, though invisible; near your head, far away, under your feet, at your side, in the tree-tops, in the streams, for ever springing their rattles with renewed zest. I shall never hear noctural frogs again without being transported to these regions of strange and melancholy nights.

Table Mountain rises square and precipitous above our garden, far above the simmer of the frogs, and looks like an altar in the pure white light that falls upon it from the Milky Way. How still, how holy in its repose of the long ages it looks, and the thought comes to one's mind, 'Would that all the evil brought to South Africa by the finding of the gold could be gathered together and burnt on that altar as a peace offering!'[14]

On this Rosebank side there is nothing that jars with the majestic feeling of Table Mountain, but to see what we English have done at its base on the other side, at Cape Town, is to see what man can do in his little way to outrage Nature's dignity.[15] The Dutch never jarred; their old farmhouses with white walls, thatched roofs, green shutters, and rounded Flemish gables look most harmonious in this landscape.

Wherever we have colonized there you will see the corrugated iron dwelling, the barbed-wire fence, the loathsome advertisement. We talk so much of the love of the beautiful, and yet no people do so much to spoil beauty as we do wherever we settle down, all the world over. I respect the Dutch saying; 'The eye must have something' – beauty is a necessity to moral health. A clear sky and a far horizon have more value to the national mind than we care to recognize, and though the smoking factory that falsifies England's skies and blurs her horizons may fill our pockets with gold, it makes us poorer by dulling our natures. I am sure that a clear physical horizon induces a clear mental one.

As you gaze, enraptured, at the rosy flush of evening on the mountains across 'False Bay' from some vantage point on the road to Simon's Town, your eye is caught by staring letters in blatant colours in the foreground. 'Keller's boots are the best'; 'Guinea Gold Cigarettes'; 'Go to the Little Dust Pan, Cape Town, for your Kitchen things.' I *won't* go to the Little Dust Pan. Of all the horrors, a dust pan at Cape Town, where your eyes are probably full enough of dust already from the arid streets, and your face stinging with the pebbles blown into it by a bitter 'sou'easter'! I once said in Egypt I knew nothing more trying than paying calls in a 'hamseem,' but a Cape Town 'sou'easter' disarraying you, under similar circumstances, is a great deal more exasperating.

I am told the Old Cape Town, when Johannesburg was as yet dormant, was a simple and comely place – its white houses, so well adapted to this intensely sunny climate, were deep set in wooded gardens, a few of which have so far escaped the claws of the jerry builder. (O United States, what things you send us —— 'jerry,' 'shoddy' ——!) But now the glaring streets, much too wide, and left unfinished, are lined with American 'Stores' with cast-iron porticoes, above which rise buildings of most pretentious yet nondescript architecture, and the ragged outskirts present stretches of corrugated iron

shanties which positively rattle back the clatter of a passing train or tram-car. And all around lie the dust bins of the population, the battered tin can, the derelict boot. No authorities seem yet to have been established to prevent the populace, white, brown, and black, from throwing out all their old refuse where they like. Some day things may be taken in hand, but at present this half-baked civilization produces very dreadful results. There is promise of what, some day, may be done in the pleasing red Parliament House and the beautiful public gardens of the upper town. There is such a rush for gold, you see! No one cares for poor Cape Town *as* a town. The adventurer is essentially a bird of passage. Man and Nature contrast more unfavourably to the former here than elsewhere, and the lines,

> Where every prospect pleases
> And only man is vile,

ring in my ears all day.[16]

Altogether our Eden here is sadly damaged, and I am sorry it should be my compatriots who are chiefly answerable for the ugly patches on so surpassingly beautiful a scene. Our sophisticated life, too, is out of place in this unfinished country, and we ought to live more simply, as the Dutch do, and not feel it necessary to carry on the same *ménage* as in London. Liveried servants in tall hats and cockades irritate me under such a sun, and the butler in his white choker makes me gasp. An extravagant London-trained cook is more than ever trying where all provisions are so absurdly dear. The native servant in his own suitable dress, as in India and Egypt, does not exist down here.

One of the chief reasons, I find, as I settle down in my new surroundings, for the feeling of incompleteness which I experience, is the fact of this country's having no history.[17] We get forlorn glimpses of the Past, when the old Dutch settlers used to hear the roar of the lions outside Cape Town Fort of

nights; and, further back, we get such peeps as the quaint narratives of the early explorers allow us, but beyond those there is the great dark void.

This is all from my own point of view, and I know there is one, an Africander born,[18] who, with strong and vivid pen, writes with sympathy of the charms of Italy, but only expands into heartfelt home-fervour when returning to the red soil and atmospheric glamour of her native veldt. This personal way of looking at things makes the value of all art, literary and pictorial, to my mind. Set two artists of equal merit to paint the same scene together; the two pictures will be quite unlike each other. I am of those who believe that picture will live longest which contains the most of the author's own thought, provided the author's thought is worthy, and the technical qualities are good, well understood.

Nowhere have I seen such intense unmixed ultramarine shadows as those that palpitate in the deep kloofs in contrast with the rosy warmth of their sunlit buttresses and jagged peaks. And as to the foregrounds here, when you get into the primeval wilderness, what words can I find to give an idea of their colouring, and of the profusion of the wild shrubs, all so spiky and aromatic, and some so weird, so strange, that cover the sandy plains? Here are some notes. In distance, blue mountains; middle distance, pine woods, dark; in foreground, gold-coloured shrubs, islanded in masses of bronze foliage full of immense thistle-shaped pink and white flowers; bright green rushes standing eight feet high, with brown heads waving; black cattle knee-deep in the rich herbage and a silver-grey stork slowly floating across the blue of the still sky.

But this most paintable and decorative vegetation is not friendly to the intruder. These exquisitely toned shrubs with wild strong forms are full of repellent spikes which, like bayonets, they seem to level at you if, lured by the gentle perfume of their blossoms, you approach eye and nose too near.

Depend upon it, this country was intended for thick-skinned blacks.

Notes

1 Butler's account of Ireland is long on sentiment and short on analysis: for a background to many of her references and interpretations, see L.M. Cullen, *The Emergence of Modern Ireland*, 1981.

2 Pompeii was devasted by a natural disaster, the eruption of Mount Vesuvius, but, as she explains, this nameless community was ruined by one of the famines that struck Ireland not just through natural causes, but because of political and social factors too. See, for instance, R.D. Edwards and T.D. Williams, *The Great Famine*, NY 1956.

3 Butler's lament is based on nostalgia, but at the same time Irish people were concerned, for political reasons, that their indigenous culture was being eroded by English structures and ethics. Education had been supervised by the Board of National Education, based in Dublin, since 1831, and this Board survived until 1922. Rather than the costume, which Butler misses, the Irish themselves were anxious to keep a hold on their language: the Society for the Preservation of the Irish Language was set up in 1876 and the Gaelic League continued the battle against Anglicisation from 1893.

4 Butler was very attached to Italy and particularly to Tuscany, where she had been as a child, as a young woman and again in later life. Her *Autobiography* contains many descriptive references to Tuscany and other parts of Italy and, although it is not included here, *From Sketchbook and Diary* includes a chapter on Italy.

5 During the nineteenth century countless thousands of Irish

people emigrated to the USA, and many others to Britain. It has been estimated that Ireland lost about 2½ million people through emigration from the time of the famine to the end of the nineteenth century. See P.S. O'Hegarty, *A History of Ireland under the Union*, 1952.

6 Butler fails to mention any Irish artists, but instead treats Ireland as a site for visitors to work on as a picturesque, if not exotic, world. The native painter had already presented his or her picture of Ireland to the British public, but it seems as if Butler was not interested. This is the more to be marked since it has been suggested that Irish painting came particularly into focus round about 1880 in Britain, France and at home, with several Irish artists gaining reputations in the early years of the twentieth century, the time of which and at which Butler is writing. See *The Irish Revival*, Pyms Gallery London, May/ June 1982.

7 The author is recalling the disastrous episode in Victorian imperialism whereby the British sent General Charles Gordon and troops to conquer the Sudan as part of the British policy protecting Egypt, and Gordon was ultimately killed at the siege of Khartoum. Butler's attitude to the matter is equivocal, but G.M. Trevelyan has written that 'the conscious Imperialism of the national sentiment in the following generation received an impulse from the fate of Gordon. An idealist, a soldier and a Christian hero, he supplied to the popular imagination whatever was lacking in Disraeli as the patron saint of the new religion of Empire'. *British History in the Nineteenth Century*, London 1928.

8 Butler refers to the trend called Orientalism, which was noticeable in French and British art in the earlier part of the century. Eugène Delacroix (1798–1863), Alexandre Decamps (1803–60), and Jean-Leon Gérôme (1824-1904) were active in France, and William Müller (1812-45) and J. F. Lewis (1805-76) in Britain, all more or less as orientalists.

9 The harem had become a motif of particular interest to some

people in the wake of the Orientalist trend, and subjects set in the harem were regrettably frequent at the Salon and the Academy from the 1850s on. The moral and social questions of the harem were discussed by Harriet Martineau (*Eastern Life, Present and Past*, London 1848) in vigorous style relating urgently to the 'woman question': when Butler recounts a visit to a harem, however, she has disappointingly nothing to say about the pros and cons of this practice (*Autobiography*, p.209).

10 The author means to be facetious here: she is very critical of the environmental pollution and cultural imperialism effected by colonising powers. Neon lighting was invented in 1894 by British scientist William Ramsay.

11 This recalls William Holman Hunt's exploits in Palestine many years before, while painting his famous picture *The Scapegoat*. See William Holman Hunt, *Pre-Raphaelitism and the Preraphaelite Brotherhood*, 1905.

12 Napoleon's Egyptian campaign occurred in 1798, and was one of his less successful gambits.

13 Butler must be thinking either of Amelia Edwards'*A Thousand Miles up the Nile* (1877 and 1889) or of the same author's *Pharoahs, Fellahs and Explorers* (1891).

14 The gold and diamond rush had begun in 1867, and by the 1870s it was obvious that this mineral wealth was going to continue indefinitely. See Oswald Doughty, *Early Diamond Days*, 1963.

15 The British had taken possession of Cape Town in the Napoleonic Wars to safeguard their trade route to India. One of its attractions for an occupying power at the time of which Butler writes was its strategic location vis-à-vis the rest of South Africa, which could easily be reached by railway routes to all areas.

16 The reference is to Reginald Heber's poem *From Greenland's Icy Mountains* (pub. 1819) and is misquoted: 'Where' should read 'Though'.

17 One of the most resounding myths created by the Victorian

expansion was that Livingstone had 'discovered' Africa, and that -- by extension of the logic -- a country does not properly exist until white people have acknowledged it, or named and structured it. Butler's turn of phrase suggests that history only exists if the past in question involved white people.

18 She means Olive Schreiner (1855-1920). Author of *The Story of An African Farm* (1882), *Women and Labour* (1911) and other writings. See Ruth First and Ann Scott, *Olive Schreiner*, 1980.

HENRIETTA WARD

Memories of Ninety Years (1924)

WARD'S second volume of memoirs, *Memories of Ninety Years*, came out in the year of her death. Since it repeats the earlier book *Reminiscences* (1911) to a considerable extent, it is difficult to see a reason for its publication, particularly since the artist had by then faded from the public eye and memory. Her obituaries were few and brief.

Henrietta Ward was born into a family of art workers: her grandfather was the painter James Ward, her father was a popular engraver, her mother had been an exhibiting miniaturist before becoming engrossed by childcare, and various aunts, uncles and cousins were professional portrait and landscape painters. She married an artist, the similarly-surnamed Edward Matthew Ward, and several of her children took up an artistic activity of one sort or another. Connection with a family practising art was seen by commentators and critics in the 1850-1900 period to be typical of the new breed of female artist: Sarah Tytler, in her entry on Henrietta Ward, comments in her book *Modern Painters and their Paintings* (1874):

I may observe, in proof of the difficulty which the technicalities of art must present to women, that of all the women painters whom I

have chronicled, I am not aware of one, unless it be Suor Plautilla, or Mrs. Wells, with whose antecedents I am only partially acquainted, who did not overcome the difficulty, by the advantage of an early familiarity with art, from having been the daughter of a painter, or, at least, of an engraver.

Ward's family encouraged her interest in art and she was given both an informal domestic training plus a more 'legitimate' one outside the home, a benefit only women in a family which expected its female members to take up art would enjoy in the 1840s. An apparently precocious and spoiled child, she became infatuated with the 30-year-old E.M. Ward at the age of fourteen, eventually marrying him secretly against her parents' wishes and causing a breach with her mother which was never to be closed.

Ward's early association with a male painter whose genre she then took up – both Henrietta and Edward specialised in historical genre – gave rise to questions which dogged many female artists' footsteps in this period and which still attach themselves to discussion of women artists today. These arise, sometimes between the lines, in the reviews which Ward's work attracted: '*Episode in the life of Mary Queen of Scots* is thoroughly a woman's subject, which a women's heart and hand may best understand and paint' . . . '*Joan of Arc*, if too faithfully reproducing the manner of her distinguished husband, has excellent points both of conception and execution' . . . 'Mrs. E.M. Ward enters this year upon the domain of her husband, and produces a theatrically historical picture, *Scene at the Louvre in* 1649 . . . Subjects of this kind are at best uninteresting, and least of all fitted for a lady's pencil'. Always the anxiety to preserve distinct differences of rank between men's and women's work forefronts the critic's evaluations. History painting consisted by tradition of records of battles, important individuals' births and deaths, the careers of kings and princes – in short, what men deemed important and what

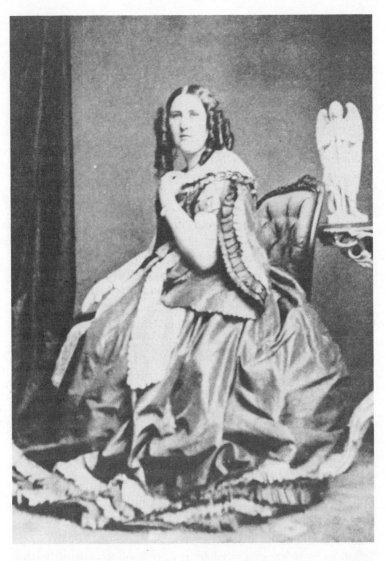

Henrietta Ward photographed in 1866, photographer unknown.
Published in *Memories of Ninety Years*, 1924

men had done. Henrietta Ward, referred directly to her husband by most critics if not also by the majority of the public, was caught in a cleft stick: if she painted masculine history she was bound to be judged less effective than her husband, who for critical purposes represented 'the male artist'; if she 'feminised' history, her work would be demoted from history to anecdote, since the experience of women has been given so little status in history and in culture. Not that a female artist necessarily had a free choice in her approach to such a problem: the education and life-experience she used to interpret and understand the past differed from male experience, even when both were from the middle classes.

Ward was considered by much critical opinion to be the best representative of British female efforts in fine art. The editor of the *Art Journal*, Samuel Carter Hall, and his wife, Anna Maria Fielding, were personal friends of the artist and both Ward and her husband were favourites of Queen Victoria and Prince Albert, and friends of Charles Dickens and William Frith, giving them a firm backing from middle-of-the-road opinion. The Academy was where Ward had most of her exhibiting success, and because she fitted in there, her simultaneous support of the Society of Female Artists could be seen not as discomfiting radicalism but as an honourable and womanly gesture of charity.

It was the mainstream, too, that Henrietta Ward served in her treatment of history. Her preference for female protagonists asserts women as historically important in a refreshing way, but her general perception of history seems to accept a middle-class, Christian-based appraisal of life as the site of the individual's eternal struggle to be good and successful. She certainly featured less hackneyed figures from European history than did many of her contemporaries, but her chosen cast of characters form a motley group, dominated by royalty. Perhaps the reading of her work which takes us furthest is one which notes that in Ward's pictures history pivots on emotion-

al experiences and feelings: disappointment and futility in *Palissy the Potter* (pp.118, 119, 1866), despair and grief in *Scene at the Louvre in 1649* (1862), nostalgia in *The Poet's First Love* (1875). Further, from the confrontation between informal or spontaneous emotion and the result or representative of institutionalised power in *First Interview of the Divorced Empress Josephine with the King of Rome* (1870) or *Mrs. Fry at Newgate*, 1818 (1876), we can infer that she saw the wielding of institutional power as dehumanizing. Ward was praised for her colouring and her eye for detail and grouping; another strong point, her sensitivity to the emotional relationships between and among her figures, manifested through composition and expression, is perhaps an expression of gender. Though her ability was no greater and no less than that of many mid-Victorian narrative painters, critics would invidiously categorise her as the *best female* artist rather than simply as a good painter. Critics might declare her pictures to be 'painted with an almost masculine vigour' and 'though by a female hand, essentially a masterly picture' – comments revealing of the role of gender in critical evaluation – but they would not give up their insistence on male and female artists occupying different categories, regardless of the lack of evidence supporting that insistence.

The extracts from *Memories* presented here are taken from the middle and later part of the book, and describe the 1870s and early 1880s, a period which pivoted for the author on her husband's death in 1879 which left her with an established career and eight dependent children.

Following page: HENRIETTA WARD, *Palissy the Potter*, 1886

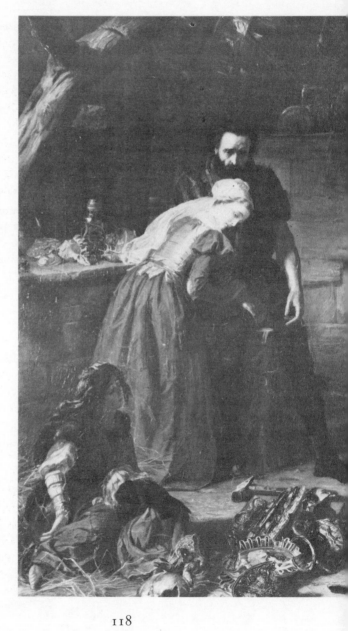

119

LIFE AT KENT VILLA

M RS. FRY, the great Quaker philanthropist, accomplished her life's work before my time, but her fame was still ringing when I was young. I was impressed by her mission of mercy to unfortunates, and I painted a picture called *Mrs. Fry Visiting Newgate*, 1818.[1]

Prison life to-day is a very different thing from what it was in 1818. Sad and grim and severe it must always be, or it would fail as a deterrent to criminals. But in 1818 it presented an aspect which was nothing short of terrible. People were herded together under dreadfully insanitary conditions, irrespective of the different degrees of crime – in fact, many who were merely the innocent victims of circumstances were there, and many who had never deserved such a cruel fate.[2]

All these facts crowded into my mind and induced me to depict as realistic a presentment as I could gather. Mrs. Fry was the forerunner of the woman of to-day who champions liberty and hope for herself and for everyone.[3] She ran the gauntlet of much criticism, and received scant praise at the time for her merciful actions. She was a woman of strong principles, possessing a fine brain, a great heart, with the independence of mind that ignores all opinions.

Mary Sanderson, her friend, who afterwards became Mrs. Fox, used her persuasive powers, as well as the gaoler, to induce her to refrain from entering Newgate. All traditions were against the sheltered woman of the upper classes ever seeing or knowing the real state of such heartrending facts. But for once conventionality was to receive a shock. Mrs. Fry was determined to probe to the depths of humanity's miseries, not from any curiosity, but because she had realised the truth of vital Christianity and took literally those glowing words: 'Inasmuch as ye did unto the least of these My brethren, ye did it unto Me.'

Spirits were sold at Newgate to anyone who had the money

to pay for them. The pewter pot painted in my picture came from Newgate. I have it now as a memento. Sir George Richmond painted a portrait of Mrs. Fry, which enabled me to represent her just as she must have appeared then.

Her daughter, who was then living, gave me some of the accessories for the dress, and a Quakeress made the bonnet. In 1876 I exhibited *Mrs. Fry*, and I was amused at the number of letters it brought forth, full of criticism.[4] One wrote that no Quakeress would 'possess such a disgraceful thing as a scarlet Bible. And thus to malign Mrs. Fry was unpardonable.' The Bible, which belonged to Mrs. Fry, had been lent to me by her daughter, and it showed by many marked passages how carefully it had been studied. Another said: 'If only I had known you were going to paint Mrs. Fry I would have sent you the right headgear.' I had chosen the regulation bonnet with Miss Fry's approbation. She also sent her mother's shawl, a lock of her hair, and some roses from the conservatory, for Mrs. Fry believed in giving the prisoners flowers from this same plant; she said they proved a means of softening their hearts and giving them a vision of beauty. The picture was engraved and then stolen, and afterwards found at a pawn-broker's. I recovered it and sold it to America. I received ever so many letters asking for impressions. It was reproduced by the Fine Art Society many times.

In my young days most people would have agreed with Mrs. Collins that a wife and mother had no right to be a practitioner in paint,[5] and I think in most households it would have been rendered impossible by the husband's and relations' combined antagonism to the idea. Edward was greatly in advance of his age in broadmindedness, and this fact spurred me on to success. My work required great concentration, and orders were strictly enforced that I was not to be disturbed during certain hours of the day. And Edward observed the rule, being also immersed in his own artistic problems quite to the

exclusion of the whole world. But there were exceptions: I was occasionally confronted by an alarmed servant coming to tell me of a domestic tragedy; some knotty point that could only be solved by the mistress of the house.

One morning when I was wrapped up in my work the door slowly opened, and Edward, with a white face, announced, 'I am dying!' I sprang up in alarm exclaiming: 'What do you mean?' He said he had mistaken a bottle of benzine for the tonic he had been ordered to take by the doctor, and in his absent-minded way had helped himself to a wrong dose. Though I was dreadfully frightened I summoned up all my fortitude, and seeing the alarmed face of a servant looking in at the doorway, I managed to convey the order to go for the doctor, without Edward's knowledge. The benzine bottle was examined and I calmed his fears as best I could, till two doctors arrived – they gave him an antidote and he recovered.

After our great anxiety we held a little thanksgiving service at which we offered up our gratitude that his life had been spared. I recollect that this incident happened on the day that Edward's picture of Luther was to be presented to the 'Bible House,' and we had all arranged to be present. I always attributed the mistake he made in taking the wrong medicine to be due to the fact that he had been greatly worried by the life-sized picture of Luther.

At this period Edward painted *Amy Robsart and Leicester at Cumnor Hall* and the *Marriage Between Little Ann Mowbray and the Duke of York*. In the seventies came *Anne Boleyn*, *Doctor Goldsmith*, *The Return from Flight of Louis the Sixteenth and Marie Antoinette*, and his last picture, *The Eve of St. Bartholomew*. My husband was always a strenuous worker, and a long day's work had been completed before he allowed himself the necessary recreation at the close of the day.[6] He would be in his studio at 6 a.m., where he would concentrate so fully on what he was engaged upon as to forget everything else. At half past eight we breakfasted, after which

he scanned the newspaper, whilst I went to the kitchen and nursery in turn before settling down to my painting till lunch, which used to be served in our respective studios. After the children's dinner in the nursery Edward would spend half an hour playing with them, and when I went in I would find him drawing pictures for their amusement or playing bears. Great would have been their grief if he had failed to appear, as it was their great time.

To encourage them in a love of art I used to allow my two elder daughters to paint on the lower corners of my canvas, and the three of us would solemnly and silently work away on my picture for the next Academy. Then, as my work grew, theirs had to disappear, but they felt very important while doing it, and as they grew older I provided them with canvas and easels, with the result that both exhibited later at the Royal Academy.[7]

I had one tragic result through allowing my children in my studio. I was painting a picture called *The Birthday*,[8] and Enid, then two and a half, was the model catching hold of a box of sweets lying on a table, on which was also the birthday present. I crossed the studio to look out of the window, hearing a carriage drive up, and on my return to my easel found, to my dismay, that she had industriously removed all my painting, having vigorously rubbed it all over with a paint rag, besides having decorated herself and her pinafore very thoroughly in her efforts.

It was my husband's idea that we should celebrate every year my birthday on June 1 with an excursion to the Crystal Palace in a private omnibus. It was a big undertaking, and the special young friends of the children used to be invited. Edward and I sat inside the vehicle with the girls; the young Bensons, the Yateses, and Lehmanns, and the boys rode outside in charge of the servants. We took hampers of delicacies which had to include ducks and fowls, salad, new potatoes, asparagus, green peas, great raspberry and cherry tarts,

and cream – for nothing short of a sumptuous feast would satisfy my family on these occasions. A private room used to be given us for luncheon by one of the Directors of the Palace, and here we entertained our boisterous young company bubbling over with merriment. It was considered the rule for all to amuse themselves as they liked, and I found my children used to scamper off first to see the gigantic models of prehistoric animals, which enchained their fancy and seemed to have a fearsome fascination for the whole party. As the Palace is a famous place to lose children in, I used to fasten my two girls together with a long piece of ribbon, so that at least they would not be separated if they missed the party, and to make up for this temporary likeness to Siamese Twins each was rewarded with sixpence. I suppose every mother thinks her children abnormally good and sensible. I believe I may truthfully say I found mine well up to the average, and on these occasions they gave us no anxiety. My husband, who had the 'childlike spirit', used to become 'a boy amongst his boys', and for the entire day would keep up an endless flow of fun and nonsense to amuse us. It was this same happy disposition that endeared him to many friends; indeed, he was universally loved by all who knew him, and friends of his own generation were always anxious to secure him in their midst at dinners and social gatherings, where he would keep the ball of wit and conversation tossing backwards and forwards. His charm of voice and manner, added to intellectual powers and unfailing tact, made him welcome among such men as Thackeray, Dickens, Hallam, Macaulay, Lord Lytton, and the late Lord Stanhope.[10]

In worldly matters my husband was like a child, a trait that I believe most artists share.[11] He knew nothing about commercial matters, and trusted his business to me entirely. He would be touched by any case of distress and hasten to alleviate it if the person who told the tale was only plausible enough. He trusted his fellow-creatures to the last day of his life, and gave liberally to many who were mere rogues, believing always that

they were as himself, single minded and incapable of evil. He was scrupulous, just, and firm in what he deemed right; hasty in his temper, the next minute it would have passed like a summer cloud. His absence of mind used to amuse us heartily when I first knew him, and I remember after he had spent the evening at our house we heard a timid knock, and there he stood holding a long white antimacassar in his hands, which he told us he had found adorning his coat when he arrived home.

When we were living at Slough I saw on the lawn two slips of thin paper, and as they looked untidy I went to remove them. It was well that I did so. They proved to be two important Shares that had been sent him from Coutts's. Another time when going to stay with friends at Preston, he took with him forty pounds. On arriving he emptied his pockets to dress for dinner, and found that he had put the money down at the station to get some small change, and had forgotten it. Fortunately the clerk was an honest man and restored it immediately.

Throughout my married life Edward was always the first to be thought of, my children occupied the second place in my home. My husband and I were entirely of one mind, even in our amusements and hobbies, and as we both had a passion for antiques and old masters, after our work was over we would take long walks through the streets, examining old furniture, silver, jewellery: in fact, everything of artistic merit appealed to us. In this way we developed our taste and formed a thorough knowledge of works of art; we bought largely, and many a dealer would ask my husband's opinion about his treasures. Edward's art generally related to past periods of history, and demanded a knowledge of the costumes then worn. Fancy dress balls were in fashion for a long time, and he would design our dresses for these occasions.

One of the best-known art dealers of Victorian times was Mr. Gambart,[12] who lived at St. John's Wood, and I can recall vividly a large fancy dress ball to which he invited many

celebrated artists. My husband, my eldest daughter, and I had special dresses designed by him, of the Elizabethan era, my husband's being a real satin tunic and tights, with a baldrick of gold, and red hat. My daughter's was pale-blue satin strewn with pearls, and mine a grey satin, richly embroidered in pearls and gold, with elaborate sleeves.

We took a good deal of pains over these costumes, knowing that some magnificent dresses would inevitably appear on that night. More than satisfied with our dresses we anticipated an enjoyable time, but a message came in the morning to say that Mr. Gambart's house had been blown up by a gas explosion and his housekeeper killed.

We hastened to the spot, where a scene of utter ruin and desolation met our eyes. The heaviest pieces of gorgeous furniture had been blown to atoms, and the very many priceless treasures the house had contained were gone for ever.

Yet when I went into another ruin of what was once a room, the strangest sight was to be seen. First of all the remnants of some priceless antique tables with twisted legs, and behind, a whole aviary of over fifty birds, rich in plumage, were singing as gaily and joyously as if nothing had happened. Two of Creswick's valuable pictures were afterwards found impaled on the railings of a neighbouring house.[13] The poor house-keeper met her death through entering the ballroom, where additional gas had been laid on, with a lighted candle in her hand. She had noticed the escape of gas, and took this unwise method of finding out where it was. Some months later Mr. Gambart gave the ball in a magnificent new ballroom, but the accident and untimely death of the housekeeper threw a gloom over the proceedings.

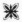

MY SCHOOL

A YEAR after Edward's death I had the additional sorrow of losing my father. There always had been a room reserved for him at our house, and he used to come whenever he felt disposed, whilst Sundays were always spent with us.[14]

The only period of my life when I ceased to paint pictures was at this time. The artist must feel happy when producing creative work, and my mind was in a state of chaos. My friends saw that work was the best panacea for me; they rallied round and urged me to teach others how to produce art. I accepted the idea readily being anxious to engage in any work that would occupy my time and thoughts. Accordingly I took a studio at 6 William Street, where I started my art classes with four pupils, and soon had more than I could possibly cope with. When I used to arrive in the morning from Windsor, I was soon accustomed to finding the hall full of parents and guardians, wishing to place their daughters under my charge. I was obliged to refuse many applicants, as well as offers of partnership in the school.

The academic outlook is very different to-day with art centres everywhere, with many teachers, and every facility for specialised subjects. The difficulty to-day is to find pupils, and certain painters have abandoned the idea, as it does not recompense them sufficiently.[15]

My school was the only one of its kind in London, and I had the sole monopoly, I believe.

As patrons I had the Duke and Duchess of Connaught, the Princess Louise Duchess of Argyll, and the Duke and Duchess of Edinburgh.

Amongst the visiting professors were Sir Lawrence Alma Tadema, R.A.; Briton Rivière, R.A.; John Horsley, R.A.; Marcus Stone, R.A.; Frank Dicksee, R.A.; and Sir Luke Fildes, R.A.; with, of course, dear William Powell Frith, R.A., whose devotion to the school and to his ideals of

friendship led him to regard with indignation any defaulter who through pressure of work ever failed to attend regularly.[16] When John Horsley resigned, he told me he had not the time to attend his own son's school, and was obliged unwillingly to relinquish his visits to my school, which of course I understood; but when Frith heard of it he replied with an indignant letter:

'My dear Mrs. Ward,

'I never read a more characteristic note than the enclosed, or more clearly reflecting the writer's character. I am quite sure you may take 'No' for an answer, and I am sure that anything I could say or do would have no effect.

'I have always maintained that there is human nature and R.A. nature, and here is a proof! Why not try Goodall?[17] He is a very kind fellow, and would very likely spare the terrible loss of time that four hours in the year might imply!

'My wife joins me in kindest regards. Glad the young ladies are pleased.

'Ever faithfully yours,
'W. P. Frith.'

Thus earnestly working together I found my time fully occupied with teaching and my family, so that I had no time to dwell on my loss, yet through it all, the triumphs of success, and the difficulties which, in turn, were overcome, I missed the advice I valued so highly, and often found myself wondering what Edward would have done, what he would have thought of certain problems which I had to solve alone.

After three years' teaching at William Street I left Windsor, and took a house in Gerald Road, where I built a studio at the back, and transferred my pupils there.

I took members of the Royal Family as private pupils – Her Royal Highness the Duchess of Albany, and her daughter, Princess Alice of Albany, now the Countess of Athlone.[18]

During the two years I went to Claremont, Esher, the

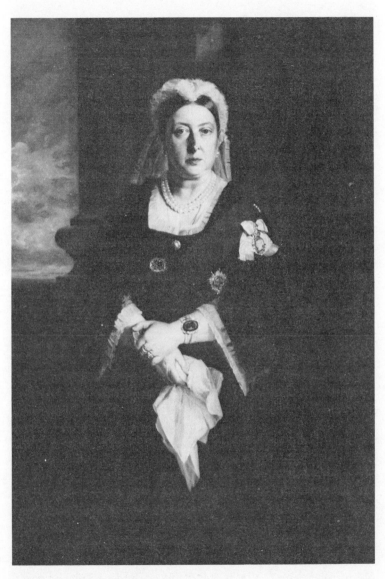

HENRIETTA WARD, *Queen Victoria*, n.d.

Duchess of Albany's residence, to give her lessons in painting, she made rapid progress, and only abandoned her studies on account of numerous public engagements. Her daughter, the Princess Alice, came to my studio with her governess for four years. She was clever and industrious, and possessed such a sunshiny nature as to win my heart entirely. When she came for the first time, she was the prettiest little girl imaginable, with golden hair and blue eyes, a veritable fairy princess. Hanging on the walls were engravings of two of my pictures, *Elizabeth Fry* and *God Save the Queen.* 'Why, we have those in our nursery,' she said in surprise.[19]

She and her brother used to take me round the lovely grounds of Claremont, and give me bouquets of flowers. The gardens of that Esher estate, with classical temples enriched by sculptured portraits of poor Princess Charlotte, possess an historic interest. Princess Charlotte lived at Claremont for a year, then came her tragic death. She endeared herself to the people by many acts of kindness, and was deeply mourned. I copied a portrait of her by Lawrence, and from this did the picture *Princess Charlotte in the Lanes at Windsor,* which pleased Queen Victoria. In St. George's Chapel, Windsor, is a piece of sculpture by Wyatt, *Princess Charlotte Ascending to Heaven with her Child.*

When the Duchess of Albany left Claremont, The Clock House, Kensington Palace, became her residence. Only recently I have heard with sorrow of her death.

The Countess of Athlone, with dear children of her own, has developed into a fascinating woman. She still comes to see me, and on my eighty-sixth birthday appeared bearing a golden basket of orchids.

During the intervals between teaching, my daughters often amused Princess Alice, and one day I found Enid and the little Princess on the ground watching the slow antics of our dear old tortoise, and to please the Princess Enid had placed a toy one beside it, to see if he would recognise his counterfeit

brother. To our amazement a notice of this little incident appeared in a society paper, with the addition that Sir Lawrence Alma Tadema, R.A., had seen them thus engaged, and that it suggested the subject for his picture *Lady Feeding the Goldfish*. It required a big stretch of imagination to find any point of resemblance to truth in this statement. My daughter was grown up, and the Princess only a child: Sir Lawrence's picture was painted before the little incident took place, and of which he had never heard.

I taught Lady Olivia Taylour, now Lady Henry Cavendish-Bentinck, Lady Helen Grosvenor and Mrs. Sandeman, whose ability John Horsley recognised. He advised her to send her picture *African Trophies* to the Royal Academy, and it was well hung.[20]

Amongst my first pupils were the gifted daughters of Sir Robert Phillimore. One of the sisters survives, and is a writer as well as a painter. Her versatility extends from a treatise on Charles I to editing sermons. Many years ago I stayed at her villa in Rimini. I often visit her now at Shiplake House, Henley. Lady Randolph Churchill was a brilliant pupil, a musician as well as a painter. She brought her father, Mr. Jerome, to introduce to me, and her son, Winston, a small boy in knickerbockers. When I lunched with her I saw the new departure of offering cigarettes to ladies.[21] I got used to the scent of tobacco at an early age, when my dear father used to take me to the Chalcographic Society and other male meetings – I like the aroma.

Through the kindness and active suggestions of Sir Edward Levy-Lawson, afterwards Lord Burnham, I received a Civil List Pension of £100 a year, with a letter signed by Lord Beaconsfield:

10 *Downing Street, Whitehall*
15*th May,* 1879

'Madam,

'I have the pleasure to inform you that the Queen has been graciously pleased to confer on you a pension of one hundred pounds a year from Her Majesty's Civil List, in consideration of the Services rendered to Art by your late husband.[22]

'I have to request that you will furnish me with your names and address in full, together with the names and addresses of two gentlemen who would be willing to act as your Trustees in this matter.

'I have the honour to be,
'Yours faithfully,
'*Beaconsfield.*'

By this time Leslie was firmly installed on the staff of *Vanity Fair,* making a big income, and my second daughter, Eva, who had received a thorough art training, had been exhibiting at the Royal Academy since 1875, when two of her pictures were hung – *The Bouquet Stall* and *Absent.* She also designed pottery, and was accustomed to having her portrait painted, and to posing for me. Her beauty was unquestioned, and Edwin Long, R.A., wanted to paint her portrait. He began the work, then gave it up in despair, as he said he found it impossible to render her justice. Eva was named after Eva Garrick, an aunt of David Garrick's. I remember it was then considered a very uncommon name. She married Mr. Rice Lyster of Liverpool, and her daughter, Ina (Mrs. Bracegirdle), has inherited her mother's taste for art. My eldest daughter, Alice, married Mr. Grimble, and Flora became Mrs. Chappell. Flora exhibited at the Royal Academy several times.

My handsome son, Wriothesley, was a godson of Lord Wriothesley Russell, Chaplain to Queen Victoria. After leaving Eton he went on the Stock Exchange, then to California,

where he married a Spanish lady, Miss Dolores Bandini. He met with his death in a train accident.

Stanhope, my youngest son, was named after his godfather, Earl Stanhope the historian. Stanhope, who was also at Eton, fought through the greater part of the South African War, in which he gained medals. He first joined the Bechuanaland Police and then the Rhodesian Horse. He died of enteric fever. He was considered a wonderful shot, and owing to his brilliant complexion he was called 'Ruby Ward'. Though he was not so handsome as Wriothesley, he was very good-looking.

My daughters Beatrice and Enid are fond of art; the former prefers water-colour portraitures, the latter has a gift for animal painting. They are both musical, fond of theatricals, and extremely devoted to animals.[23]

Notes

1 This work is probably still in the United States (see below, at the end of the author's account of this project), though a replica painted in 1895 is in the Friends' House, London. The artist does not mention this second version in her writings, and its owners know nothing of its origin.

2 The Prisons Act of 1835 was a notable attempt to reform a truly scandalous situation, which had first been defined as a social and political problem by the philanthropist John Howard before the end of the eighteenth century.

3 It is difficult to know whom the author is praising here: writing in 1924, she could not mean the Suffragettes, and it is doubtful that she would mean women working in anti-war movements. More likely, 'today' means the period which she is recalling, the 1870s, and the women she is acknowledging are the feminists of the day who were still working for change in many areas of

social and political life (see Ray Strachey, *The Cause*, London 1928). Ward's politics are typical of many middle-class mid-Victorian women in Britain who believed that women generally had a poor deal because of male privilege but whose idea of desirable change would not extend to a fundamental refashioning of Victorian society – see below, for instance, for her monarchism.

4 Shown at the Academy with this accompanying quotation: 'Mrs. Fry conducts her young friend Mary Sanderson for the first time to visit the female prisoners. The latter thus describes the scene – The railing was crowded with half-naked women struggling together for front situations with the utmost vociferation – and she adds that she felt as if she were going into a den of wild beasts'. It was exhibited in Manchester later the same year, and engraved shortly afterwards.

5 Mrs. Collins is the mother of Wilkie Collins, novelist, a friend who had helped the artist and her husband to marry secretly in 1848. Mrs. Collins had written Ward an admonishing letter early on in her married life, which the author tells of in chapter four: 'I received a letter from old Mrs. Collins on my maternal duties, which I was foolish enough to take to heart for a time. She told me I was very wrong not to make my child's clothes and give all my time to domestic matters, and that if I did my duty to my husband and home there would be no time left to paint. I listened to her and said: "If you think so, I will do it for a year," and a very miserable time it proved to be without my art.' The young couple was, of course, only able to continue artistically because they could afford to employ servants and nursery help.

6 Despite such industry, E.M. Ward's reputation never rose above the heights of respectable and steady success, and the highpoint of his career was probably when he was included in the commissions for the decoration of the Palace of Westminster (Houses of Parliament). Since Henrietta Ward was consistently seen by critics as following in her husband's tracks, it is

legitimate to speculate on how much her art was held back by the conservatism of her husband's example.

7 Ward's oldest daughters were Alice and Eva, but the former is not listed as an Academy exhibitor in Graves' catalogue. Eva showed at the RA from 1873-79, as did the next daughter Flora (1872-74). See below, note 23 also.

8 Whereabouts unknown. Similar domestic subjects which featured the artist's own children as models include *The Bath* (1858), *A first Step in Life* (1871), *The Crown of the Feast* (1868?), *God Save the Queen!* (1857), *Bedtime* (1858). Overt portraits of the artist's children included *Alice and Leslie* (1857), *Flora*, (1857), and *Flora – A nursery Sketch* (1858).

9 The Crystal Palace, designed and built for the great Exhibition in 1851, was originally constructed in what is now Hyde Park (Exhibition Road in South Kensington was named for the events of 1851 when it was built some time afterward). After the Exhibition it was removed to Sydenham, having been bought by a private entrepreneur, to serve as a general leisure venue for the public. It burnt down in 1936. Ward's fascinating account of the Palace on the occasion of the Great Exhibition appears in chapter four.

10 Throughout her memoirs, Ward is at pains (like so many of her contemporaries) to emphasise the quality of her social set. It is noteworthy that some figures (Dickens, Millais, Lord Leighton) seem to crop up in *everyone*'s memoirs! This gives a clue as to what emphasis was put on certain individuals in mid-Victorian London.

11 Such comments expose clearly the limitations on a woman's self-identification as an artist. Ward believes 'most artists' are like children, but she obviously excludes herself from that generalisation since in the following paragraphs she is the 'mother' to such a child. She is the responsible adult who mitigates the consequences of her child's behaviour – yet she too is an artist. She surely really means that many men who are

135

artists are child-like, or many husbands are child-like. She apparently means this observation to be read as indulgent and not critical, yet the tedium and annoyance of living with such behaviour can readily be imagined, especially by the modern female reader. The lack of criticism in her remark fuels the Romantic tradition of the artist as other-worldly, too poetical or sensitive or on too high a plane to heed the prosaic requirements of the real world. Ward might not acknowledge it, but readers will see the logical discrepancy between her support of this licence in her husband and the fact that she, an artist too, has a firm hold on mundane matters. Compare Anna Lea Merritt's letter to *Lippincott's Magazine* on the value to an artist of a wife (note 8).

12 Ernest Gambart came to London from France in 1840. He became the most conspicuous example of what was virtually a new breed on the British art scene, the commercial dealer, who substantially changed the state of patronage and exhibition. See Jeremy Maas, *Gambart, Prince of the Victorian Artworld*, London 1975.

13 Thomas Creswick (1811-1869), landscape painter.

14 E.M. Ward died in 1879, after Bright's Disease. George Raphael Ward also died in 1879. Ward does not mention her mother's death, probably because of the breach between them caused by her secret marriage: 'my poor mother never really forgave me', writes Ward in chapter three.

15 The system of established artists opening their studios as learning places for apprentice artists, so much the norm in nineteenth-century Paris, was never really so flourishing in London. 'Name' artists might rather visit at schools run by people of no or little reputation, and the different schools competed for the illustriousness of their visiting tutors, rather as they still do today in Britain. See Tessa Mackenzie, *The Art Schools of London*, 1895, for a picture of this situation.

16 The range of names with which Ward means to impress her readers shows where her artistic loyalties lay as well as the type

of pupil she meant to attract. Mackenzie (*op. cit.*) says on this point: 'Although professional pupils study with Mrs. Ward, her classes appeal most particularly to ladies who wish to have the moderate talent they possess trained so as to be a source of interest and amusement to them.'

17 Probably Fred Goodall (1822-1904), one of a large family of artists; other members were his brother Edward Alfred and their sister Eliza.

18 Queen Victoria was very interested in art, as a patron and as an amateur practitioner (see Marina Warner, *Queen Victoria's Sketchbook*, London 1979). She encouraged her daughters – not her sons – in drawing, painting, and perhaps surprisingly, sculpture. The princesses exhibited occasionally in the London shows, especially Princess Louise, who studied sculpture.

19 The engraving of popular paintings (and sometimes sculptures) was a flourishing business in the Victorian era. Illustrated magazines were a principal vehicle for such reproductions of art works, the *Art Journal* leading the field and the *Graphic* introducing a more topical and newsy approach in the 1870s. Such bodies as the Printsellers' Association (established in 1847) and the Art Unions promoted and influenced the market for cheap replicas of the year's gallery successes, amongst the working and middle classes. The rise of engraving as a means of reproducing paintings added another dimension to the means by which artists earned a living from their works.

20 It seems a shame that Ward took so little pride, apparently, in her own professionalism that she thought the tuition of aristocratic amateurs more worthwhile than teaching serious female artists to succeed her generation, especially as she makes much of her own dedication to art earlier on in her memoirs, and since she quite knowingly espoused history painting as being of more consequence than some other forms of work more often associated with and practised by women (such as portraiture or still life).

21 She is talking only of bourgeois and upper-class society, of

course. William Frith had painted a scene of a man offering a woman a cigarette in the bourgeois resort of Homburg, Germany in 1870, and concluded that his public was not ready for such 'advanced' scenes. The objection to women smoking, amongst the bourgeoisie, was that it offended the notion of femininity, and from the middle of the century onwards, feminists or 'strong-minded' women were often caricatured as masculine by cartoons or verses which showed them wearing trousers and smoking, as well of course as having plain or ugly faces and oddly-shaped figures.

22 The Civil List pension was awarded, be it noted, for Edward's services to art, and was awarded to a widow on the assumption that, having lost her husband, she had lost her income. In this light, though it might have truly been a help to the author, it also constituted something of a slight.

23 Beatrice and Enid did not exhibit professionally, but occasionally appeared in charity shows of art.

LOUISE JOPLING

Twenty Years of my Life (1925)

LOUISE Jopling opens her reminiscences with an intriguing disclaimer: 'I have the feeling,' she writes, 'that I am describing the life and adventures of someone else. I am like the old woman in the nursery legend, who did not know if she were she herself, or somebody else, after her petticoats were cut.' The book bears out this comment, insofar as it presents the reader with a cast of thousands – relatives and friends of the author – who obscure the portrait of Jopling we expect. Even so, the artist's work is illustrated liberally and there is an appendix of her exhibition record.

Louise Jopling had no thought of a career in art until her twenties, when on her first husband leaving her, she turned her pastime to serious, bread-winning use to support herself and her children. She was born Louise Goode in Manchester, one of nine children, and was early left an orphan. She married at seventeen and was a mother of two by the time she was twenty-two. Her husband was a civil servant, and his career ambitions took the family to Paris in 1865, where Louise Romer, as she now was, took painting lessons at Chaplin's, a studio which specialised in teaching women. She testifies in the early chapters of her book to the support which she received from other women, then and later:

I had not worked with other girls, save my own sisters, and it took me a little time to acclimatize myself. However, my companions were charming, and the fact of my being a foreigner, and the mother of the two pretty little boys who, with their nurse, used to fetch me from the Studio, made the other students take an affectionate interest in me . . . The women I met – few in those days – were encouraging too: Mrs. E.M. Ward; Miss M.E. Edwards; and the Misses Mutrie, the clever painters of flowers.

When the family returned to Britain, Louise quickly got into the flow of the London art scene. It is clear from the book, however, that domestic matters were always of equal moment to art in her life, and she felt as responsible to her children as she did to her paintings. One of her sons died in 1869 but she had another the next year; when Romer abandoned her in 1871, she was left to all intents and purposes a single mother. Her husband's family quarrelled with her over maintenance and though she vowed not to remarry, she acknowledged that marriage held an economic interest for her, and in 1874 she became Louise Jopling. Another son was born the following year.

Joseph Jopling was also an artist, but not a distinguished one. The couple kept fashionable artistic company: their friends included Oscar Wilde and his wife Constance, Sir Coutts and Lady Lindsay, founders of the Grosvenor Gallery, and the painter Millais and his wife Effie. Her husband's friend, James McNeill Whistler, became her particular favourite as we see from the extract here. Her oldest son died in 1881, and her husband in 1884. Shortly afterwards she set up a school for female art students, which she continued after her third marriage, in 1887, to a lawyer friend George Rowe.

Though the almost frenetic social round which Jopling describes in her book was necessary to her character, it was also dictated by her specialisation as a portrait-painter and it

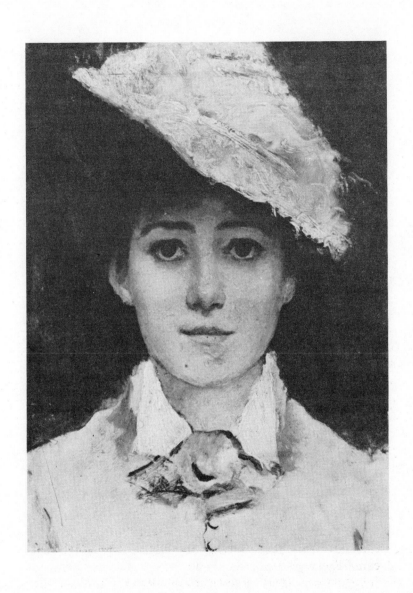

LOUISE JOPLING, *Self Portrait*, 1877

covered over a continual concern with how one was to live as a woman with children and a certain talent but not a distinguished one. In *Hints to Amateurs*, published in 1891 and republished in 1911, she is clear that her situation as a wife and mother had determined her career's pattern:

I myself commenced to learn the rudiments of my profession at the age of three and twenty, heavily handicapped as I was at the time by my duties of wife and mother. However, I had plenty of time for each and all, but of course I had to work much harder than a younger woman need have done . . . I would have given much if all this had happened in my girlhood, particularly as I had to leave off studying sooner than I had originally intended in order to support myself and my two children.

Her general understanding of the female condition and solidarity with women is attested to in many ways. Her school employed three female tutors and only one male and sculpture was taught by one of the women, a most unusual arrangement in comparison with the other art schools in London, even those expressly for female students. She supported the Society of Female Artists (by then the Society of Lady Artists) for years, despite being regularly accepted at other, more prestigious, mixed venues such as the Royal Academy and the Grosvenor Gallery. Florence Fenwick-Miller, the feminist writer of the Ladies' Column in the *Illustrated London News*, reported in 1881 on the salon held by Jopling, writing that 'in Mrs. Jopling's studio (where the popular painter, who says frankly that she loves her own sex, always has on these occasions a gathering of most interesting women), are at one moment four well-known literary ladies and two pretty actresses . . .'

Jopling's work pivoted on women, or rather Woman. Yet the need to give pleasure and gain commissions dominates her oeuvre, submerging the more disturbing or challenging themes and images. Strong topical subjects like *Weary Wait-*

ing (1877), *A Modern Cinderella* (1875), and *The Song of the Shirt* (187?) dissolve under the gloss of prettiness or sentimentality, fluent surface, and ingratiating smile which define the majority of her pictures. Although she painted straightforward portraits of many notable women, like Ellen Terry and Lily Langtry, she also in painting such pictures as *The Faraway Heart* and *Forlorn* followed the practice (surely a male idea) of using a female image to conjure up any pleasant or sentimental association, as if a woman were an empty vessel to be filled up at the artist's will with any idea he might want to evoke.

The typical note struck in press comment on Jopling at the turn of the century as an example of the hard-working but ever smiling woman triumphing over obstacles put in her way by an unfair world, is encapsulated in an article in *The Lady* in 1890 which presents her as an example to us all:

Unlike other lady artists, she has high hopes of the future of women as wielders of the pen and pencil. She is inspired with a warm enthusiasm in her work of tuition, which leads her to scorn all such suggestions as that girls are too frivolous for art and prefer the sweet dalliance of a Lydia Languish to all the fame and success of a Rosa Bonheur or a Lady Butler.

The selection from *Twenty Years* shows all the characteristic sides of the author: the socialite, the struggling artist, the wife and mother. The years accounted for are between 1867 and 1887, when the artist was aged between twenty-four and forty-four.

I T was with very mixed feelings that I entered upon the New Year.

Deserted; with grave responsibilities; an uncertain future – the success or failure of which would depend upon my precarious health – the outlook was not exhilarating.

Against these drawbacks, I could count upon loyal friends; dogged determination to succeed in my profession – and we all know that 'it's dogged that does it' – and a devotion to my children that made working for them a pleasure and a delight.

Lewis Carroll used to write down, on every successive New Year's Eve, 'good resolutions' for the coming year. I didn't write mine, but I hope I made them all the same.

I couldn't help wondering what the future had in store for me. I was drifting on an unknown sea, and Heaven only knew whether I should be able to steer my barque into safe harbourage. The first thing to do was to take a furnished Studio, in order to finish the pictures I intended sending to the Royal Academy.

One I called *The Betrothal,* for which dear Willie Lewin and his sister sat for me; a head, from my sister, Mrs. Cockell, called *La Mantille Blanche*, which Tom Taylor bought; and another, a still life. A velvet pall, crucifix, and some yellow and white chrysanthemums composed the picture. It was painted in memory of my dear little Geoffrey, and I called it *In Memoriam*.[1] The three pictures were accepted and *In Memoriam* was hung on the line in the big room.

I found it at first a very difficult matter to price my work. The monetary side to an artist's career seems sordid. Somehow, in asking money for one's work, one has the feeling, more or less of being a robber and a thief.

A note in Shirley Brooks's Diary reminds me of the price I got for one of my pictures:

'L. Romer has got £100 for her picture of *The Betrothal* from Waring. Come, my protégée prospers; she calls herself so, though I have not done so much, yet I have served her.'

Indeed, he had. Never had a woman a truer, kinder friend. No wonder that I quickly made a name in my profession with such a true friend to look after my interests.[2]

After my pictures were off my mind I devoted my time to looking about for another little home, where I and my children and my work could be together. The Williamses kindly asked me to stay with them. The children and their nurse I sent down to a farm-house in the country, and boarded them there, until I had prepared a nest for them. Every week-end I went down to see them. The farm was seven miles from the station, and the only means of getting there was to go, like a parcel, in the carrier's van.

To this day I remember those drives!

It was my first experience of the country since my marriage, and the seven-mile-long drive, with its frequent stoppages, seemed all too short. It was in the spring-time too, and all the earth was full of promise. The tender green of the budding trees; the bewildering peeps of the pale yellow primroses that starred the ground; the brighter colour of the gorse, which like 'kissing time' is always in season, enchanted me.

Oh, why do I not paint landscape instead of being a portrait painter? I exclaimed inwardly.

But one cannot choose one's way in life: circumstances are our master. I had to follow along the path that gave me the wherewithal to pay the grocer, the butcher, and the baker. Overtures had been made to me, by my husband's family, that I should ignore the past and live with Frank again. But that seemed to me impossible at the time. Looking back, through the vista of years, I still think so. One thing is incumbent upon parents and that is to give a happy home to the children that they bring into the world.[3]

Subsequently a citation was served on Frank for a divorce. Although I was very happy in my unfettered state, I was driven to these extreme steps by a threat to take my children away from me, and to commandeer any money I had in the Bank.

This was before the Married Women's Property Act, and in those days no money belonged to the wife, even if it had been left to her by will.[4]

I remember when I was twenty-one, I had a small legacy of about two hundred pounds, of which I did not receive the value of a pair of gloves. This influenced me in wishing to have entire control of my children, and, of course, of the money that I earned.

The only way to accomplish these two objects was to sue for a divorce, for which, unfortunately, there were ample grounds.

Of course, when the citation was served, I had to go through terrible scenes, but nothing would alter my determination to have the custody of my children.

The threat to take them from me had aroused all my fighting spirit.

I found out from my lawyer, Mr. Day, who was introduced to me by Mrs. Cashel Hoey, the novelist, that a judicial separation would serve my purpose just as well; so I applied for that instead of the divorce.

I was too much in love with my profession to run the risk of abandoning it by marrying again; and I was glad of the restraining bar that a separation afforded.

In July I heard that Frank had gone to America, where a lucrative position awaited him. The family lawyer, Mr. Rockingham Gill, tried his best to arrange something definite about the maintenance of the children, which, at that time, and ultimately, fell entirely on me, to my great and constant happiness.

OURS was a very quiet wedding. We were married in the church at The Boltons, South Kensington.[5]

Sir John Millais came, and was full of fun. He was struck by the good looks of my sister, Mrs. Cockell, and, putting her arm under his, he said:

'We are the best-looking couple here, so we must walk out, arm in arm.'

After a very hurried lunch at Clareville Grove, Joe and I took the train to Dover, and added one more couple to the many who passed their wedding night there.

Sophie Caird, Lady Millais' sister, found us rooms in Paris. Sophie was the wife of the millionaire, Sir James Caird, the great Scottish jute merchant. Her younger sister, Alice, who was married to Mr. Stibbard two days after our own marriage, came also to spend her honeymoon in Paris. So that we were three newly married couples, for Sophie was still on a lengthened honeymoon, and we met every evening to dine somewhere together. The Cairds were a delightful couple, and she was one of the most fascinating women I have ever met. She had an inimitable manner of describing people, and events, that made them live before you.

I often said to her:

'Oh, Sophie, why don't you write a book? You describe everything so well.'

'All my ideas seem to go when I write,' she answered.

And indeed her letters were not half so interesting as her talk.

We two workers could not afford more than a fortnight in Paris, as the Academy work had to be started.

When we returned to Clareville Grove, I found the little house quite transformed, as all Joe's belongings had been brought there from his chambers in Piccadilly; and as they were both picturesque and comfortable, they made a welcome addition.

It was an odd sensation to me, having worked so long alone,

to have a fellow-worker. I am afraid that, as an oil painter, I took the lion's share (although we each had our own model every other day), particularly as I started a big canvas, six feet by four, on which I painted, *Five o'Clock Tea* – a bevy of Japanese maidens, seated on the floor, drinking tea. In this picture I utilized the pretty dresses that I had bought at the Japanese warehouse when I was in Paris.

It was great fun painting this picture. I made my girl friends pose for me, and afterwards I regaled them with real tea.

Another picture was from myself in Japanese attire.[6]

These two pictures were accepted at the Academy, and both were well hung. I sent them in under my prettier name of 'Louise Romer.' However, my husband begged me on Varnishing Day to change it to 'Louise Jopling.' He was so genuinely interested in my success as an artist that I was only too glad to accede to his wishes.[7]

Soon after the Private View, I was taken in to dinner by Sir Frederic Leighton,[8] who said, as he gave me his arm, 'But not to "five o'clock tea",' which was a charming way of saying that he had noticed my picture. But, then, kindness was one of Sir Frederic Leighton's most charming qualities.

Five o'Clock Tea was purchased by Messrs. Agnew for £400. In the same Exhibition was the brilliant picture *The Roll Call*, painted by Elizabeth Thompson (now Lady Butler). It was so popular that the coveted railing had to be placed in front, so great were the crowds that surrounded it. I heard that, when passed by the Council, the members took off their hats to it, if not in fact, metaphorically so.

Elizabeth Thompson was very nearly elected a member of the R.A. after this great success, and I heard that it was chiefly the determined opposition of Sir John Gilbert, R.A. that prevented her being elected. Sir John is credited with declaring that he didn't 'want any women in.' Needless to say that he was an old bachelor.[9]

Miss Thompson's election was such a close shave, however,

that a law was passed that, if women were elected, the right to go to the Annual Dinner was to be denied to them!

Amongst many notices of my pictures, one amused me, in which I was described as 'Mrs. Louise Jopling (*née* Mrs. Romer)'. I was much chaffed about my precocity in being married at such a phenomenally early date!

I cannot remember when I first knew John Tenniel. Probably at the usual rendezvous for artists, the Varnishing Day.

Although drawings do not need to be varnished, black-and-white artists like to meet their friends. Du Maurier was once asked why he went to Varnishing Days; he replied:

'Oh, to talk with Mrs. Perugini and Mrs. Jopling.'[10]

I was at a conversazione one evening with a friend, who lived in the country. She asked me to point her out the celebrities.

'There is Tenniel,' I said.

'I should love to know him. Do introduce me,' she begged.

'I will; as soon as he has finished his talk with the woman he has just met.'

I continued pointing out other celebrities to her.

When I saw that Tenniel was alone, I took her up to him, but, at the moment, I couldn't for the life of me remember his name. I laughed and told him so.

'Try Du Maurier,' he said, putting me on the right track.

One afternoon Joe said to me:

'We will go and see Jimmy Whistler.'

Whistler, at that time, lived in a house in Lindsay Row, Chelsea. It commanded a beautiful view of the river, just at the commencement of Battersea Reach.

We were shown into a nearly empty drawing-room, with only a large sofa, one or two occasional chairs, and a small Chippendale table. The floor was covered with fine, pale, straw-coloured matting.

Some priceless blue china was distributed about the room, which had a wonderful air of refined simplicity.

The door opened, and a slight, black-haired, blue-eyed man entered. I recognized him as some one I had seen at a Soirée given by the Arts Club. I particularly noticed him on that occasion, as he seemed unaware that a white feather had settled upon his raven locks.

'Won't some one tell that man that he has got a feather on his head?' I asked; and then I was told that it was entirely natural, and that the owner was very proud of it, as it was an inherited peculiarity.

He and I became great friends. He took to me, I think, because he said I was so like a Japanese, a people whose art he much appreciated, and on which his own was modelled.[11]

The first work I saw of his was a portrait of himself, painted when he lived in Paris, where he had studied in the same atelier as Du Maurier. I was struck with the masterly manner in which it was painted. Whistler was always a welcomed and honoured guest at our house. We were continually at his, and it was most interesting to see him print his celebrated etchings. At one of the 'breakfasts' for which he was famous, a guest expressed a desire to see him paint.

'If Mrs. Louise will sit, I should like to paint her.'

I was only too proud to do so. I stood for two hours without a rest, in which time he had painted a life-sized full-length of me.

I spent a great deal of the summer of 1877 at my little cottage, as I had many commissions for portraits of people living near, amongst the number that of Sir Nathaniel de Rothschild (later Lord de Rothschild) and his little daughter, Evelina. I found Sir Nathaniel a delightful man to talk to, but very difficult to paint, as he was anything but a good sitter.

The first sitting he gave me at Tring Park, his two children, Walter and Evelina, were in the room, and Sir Nathaniel,

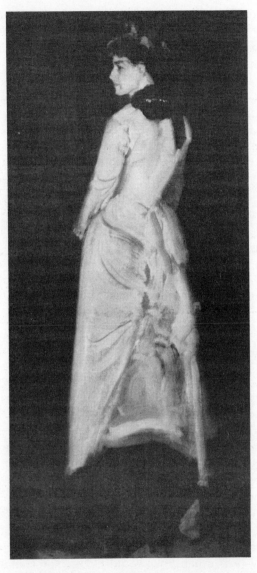

JAMES McNEILL WHISTLER, *Portrait of Louise Jopling*, 1888

being a devoted father, allowed his attention to be entirely taken up with them. Finding it severely handicapped me, I carried my plaint to Lady de Rothschild, who saw that I was in future uninterrupted.

Sir Nathaniel did not wish his portrait exhibited. It went, when finished, to the home of Disraeli, to whom it was given. Lady de Rothschild, with her characteristic kindness, told me afterwards that Mr. Disraeli had written to say how much he admired it.

Evelina's portrait was exhibited at the Grosvenor Gallery. I depicted her feeding pigeons, of which there were a great many at Tring Park. I wanted to make studies of these birds. Sir Nathaniel gave me his card to a pigeon breeder, who introduced me to the pigeon loft at his establishment, where hundreds of birds were kept.

It was very amusing to watch them at such close quarters, and I thoroughly enjoyed my morning in their society.

The rest of the summer was occupied with painting other portraits of people in the neighbourhood.

I sent up to the Academy the portrait of Col. the Hon. Charles Lindsay, Mrs. Crawford and Miss Gertrude Lewis, and a picture called *Weary Waiting*.[12]

To be a woman, a wife, and a mother, and to work at an arduous profession besides, is as much as one person can undertake, and to endeavour not to fail in either capacity seems a Herculean task. Like a good organizer, I try to make other people work, as the following letter rather infers, and I am afraid it also shows that it is no sinecure to be the husband of a professional woman:

'I went to Tring Park, and had a sitting, with, I fear, not much result. Sir Nathaniel was very nice, though. Mrs. Bright told me yesterday that Hannah de Rothschild asked her whether she knew how much you would charge for copying an oil picture in water-colour, a life-sized head in small; no doubt,

her likeness. Babs seems to be getting rather fretty again. Perhaps Nurse is not lively enough with him although there is no lack of merriment, apparently, in the kitchen at supper-time, for the shrieks of laughter that proceed from there are something to be heard, and not described. Please go and see the framemaker in Dorset St., and tell Batty, the stationer, to put in an advertisement about letting the cottage for the winter. Word it as you like but do see about it. I am sorry about young George Millais' health. Jack must feel it very much. Does he know that I am painting Evelina de Rothschild? Sir Nathaniel told me to-day that he thought the likeness wonderful, and that probably Lord Dudley might like his children painted. I worked at the Rectory yesterday morning. The picture looked so well, I thought. Then in the afternoon I painted Georgie St. Aubyn for my Cinderella picture to get the effect of firelight.[13] I don't know how it looks, as it was pitch dark when I left off. I am glad the painters are out of Beaufort St. What about the gas? Have you seen to it? Please order me three different sizes in canvases. Head; Kitcat; and three-quarter.'

In the year 1877 the Grosvenor Gallery held its first exhibition. It was built by Sir Coutts Lindsay.

With the help of Charles Hallé, an artist (the son of the distinguished pianist, Sir Charles Hallé), and Comyns Carr, a brilliant writer on the staff of *The Westminster Review*, the Gallery was an assured success. When it was finished, it was undoubtedly the finest building of its kind in London. The principal room looked like one of those one sees in Italian palaces. The walls were hung with old red damask, and the ceiling was a blue firmament, powdered over with stars, copied from the Studio in Sir Coutts' own house at No. 5 Cromwell Place, now the residence of that distinguished artist, Sir John Lavery.

The Gallery was opened with great éclat. The Prince and

153

Princess of Wales were invited to dine, which they graciously consented to do, and all that London held of talent and distinguished birth were summoned to meet them. We dined in the restaurant underneath the Picture Gallery, and afterwards a large reception was held upstairs.

Sir Coutts Lindsay made a point of securing for his Exhibition those artists who disdained to exhibit in the *omnium gatherum* of the Royal Academy.[14]

That man of genius, Burne-Jones, exhibited there, and his pictures became the rage. Fashion, always ready to adopt anything new, set all the town wild to copy the dress and attitudes of his wonderful nymphs. As Schwenck Gilbert wrote in his amusing play *Patience*, 'greenery, yallery Grosvenor Gallery' costumes were the mode.[15]

Many were the reputations made at the Opening. Artists saw, for the first time, justice done to the creations of their brain.

There was no overcrowding in the hanging. Each picture had a certain space surrounding it, so that it could reign alone, without being spoilt by the close juxtaposition of another work entirely out of harmony with it.

I exhibited a picture called *It Might Have Been*. Its subject was a young girl, seated beside a Japanese cabinet, on which she leant her head, whilst in her hands, lying on her lap, was a letter she had just been reading. She had a far-away look in her eyes – she was evidently going back in memory to happier days.

The Grosvenor Gallery was such a success that, at one time, it was considered a great compliment to be invited to exhibit in it. The glamour of Fashion was over it, and the great help that Lady Lindsay was able to give, by holding Sunday receptions there, made it one of the most fashionable resorts of the London seasons.

ND now I enter upon the saddest period of the whole of my long life.

It wrings my heart, even now, to look back upon it. If 'many waters cannot quench love,' neither can the lapse of time make any alteration in love and grief. Memory, which can be either a curse or a blessing, keeps alive for us all that has been.

Thank God for that! I would not lose the remembrance of these years, with all the sadness that encompassed them, for the riches of Golconda.

'I and Sorrow sat together' for two long years, and the experiences of that time make me fully realize all the heart pangs that the poor mothers bore in the late Great War.

When my Percy came home for the summer holidays, he looked the picture of health, but, as often happens with that fell disease, consumption, appearances were deceptive. I noticed, however, that when walking up any hill he seemed breathless.

Dr. Broadbent, then the great specialist for any diseases of the chest, to whom I took him, told me: 'Your son has his lungs very seriously attacked; he must spend the winter abroad; otherwise, I cannot answer for the consequences.'

I shall never forget that ride home in the hansom, with Death staring me in the face for one of my beloved ones, and all the time I had to simulate the highest of spirits, in order not to let my dear boy suspect anything. When I told him that the doctor had advised his not going back to school, but to go abroad instead, he was wild with excitement, and his tongue never stopped chattering about where we should decide to go.

Luckily this year I could very well manage to go abroad, as I had an order to paint life-sized portraits of the Rajah of Kapurthala and his son, for the sum of seven hundred guineas. Val Prinsep had been asked to paint them, but at that time he was very much occupied with

his Durban picture. As he could not execute the commission, he very kindly recommended me.[16]

At the Academy I had exhibited two portraits – Mrs. James Tomkinson and Miss Beatrix Phillips.

Joe, instead of going abroad, thought he would prefer to live in the Studio he had taken, where he could sleep as well, and occupy himself in looking out for a house for us against our return. And so it was arranged. I had a busy time, before starting, in packing up all our goods and chattels and sending them off to be stored. Joe's Studio in Trafalgar Square was very comfortable, and his next-door neighbour was that delightful man and artistic genius, Holman Hunt.[17]

After I had shut up the Cottage, warehoused the furniture of Clareville Grove – as we had let it for the remainder of our lease – installed Joe in the Studio in Trafalgar Square, packed up myself and little family, I, with Percy and Lindsay, went off to spend the winter in Italy. I had chosen Bordighera, because an artist friend of mine, Carl Schloesser, always went there every winter, and he was full of its praises.

. . . The sun and beautiful air soon worked wonders with my dear invalid's health, and as he was always full of life and vim I looked forward to a complete cure.

To my great delight, the Anstruthers passed through Bordighera on their way to San Remo, and came to luncheon, and extolled the *risotto* that I gave them, and that my old Italian cook made to perfection. They were much amused at the name of Lindsay's nurse, Apollonia, who really looked the name as she was a creature of massive proportions. I wonder if our English name 'Polly,' supposed to be the short for 'Mary,' is an abbreviation of Apollonia. A legacy from the Romans perhaps.

Joe was a very good correspondent, and gave me all the home news. The famous trial, Whistler *v*. Ruskin, came on in November of this year.

Ruskin criticized Whistler's art in a quite unjustifiable

manner, and Whistler brought an action against him. He won his suit, but was only awarded one farthing damages.[18]

Baron Huddlestone, who tried the case, was anything but sympathetic to the plaintiff, asking him questions such as:

'How long do you take to knock off one of your pictures?'

'Oh, I knock off one possibly in a couple of days.' (Laughter.)

'And that was the labour for which you asked two hundred guineas?'

And then Whistler made the historic answer:

'No; it was for the knowledge gained through a lifetime.' (Applause.)

Baron Huddlestone said that if this manifestation of feeling were repeated he should have to clear the court. I notice that he made no remark to those who indulged in laughter.

Joe wrote to me:

I have not seen Jimmy since the verdict, but I hear he is very jolly over it. I should say it would cost him about three or four hundred pounds. The Fine Art Society is getting up a subscription to defray Ruskin's costs, but I have not heard of any movement of the sort on behalf of the other side.

This was the year that Sir Frederic Leighton was made President of the Royal Academy. The Arts Club gave him a dinner, and Joe writes me a graphic description of it:

'*5th Dec. 1878* – The dinner at the Arts Club was a great success. Over 100 sat down. Only 80 in the large room – and some 40 or 50 in the small adjoining one. Marks was in the chair, and Dr. Buzzard was Vice-Chairman. On the right of Marks was Sir Frederic Leighton, P.R.A., the guest of the evening, and on his left Millais, the latest member of the Club. Marks spoke admirably, and Leighton, of course, to perfection. But most thought the speech of the evening was Millais'. In fact, there was but one feeling in the Club, and that was, better after-dinner speaking is seldom heard, and many re-

gretted the absence of reporters. I daresay I bore you with all these minutiæ but you asked me to give you an account of the dinner, and I have done so to the best of my ability.'

One appreciates hearing from one's friends, when one is abroad, and I had many kind correspondents, amongst the number, Kitty Perugini, daughter of Charles Dickens, who writes:

'I am sorry you are away! It was so nice to have you. I feel now I hardly made enough of you when I had you. Well, never mind. You are coming back again – and then you shall see! Tell me all you do – and give my love to Percy and the Babs. Val Prinsep (whom we happened to meet in Paris) said he liked Percy very much, and seemed to be struck by his kind and gentle care of that small tyrant. Mrs. —— dined with us last night. She was cattish – and I thought of my blessed and generous Lou! The comparison, I am afraid, was odious to one.'

Kitty Perugini and I used to make a practice of dining *à deux* at each other's houses, when our husbands went to play billiards at the Arts Club. Only by this means could two very busy people get to know each other intimately.

I first met Kitty Peru (the name by which her friends love to call her) at a Ladies' Night at the Arts Club, Hanover Square. I remember so well being struck with her elegance and her beautiful, sympathetic manner. She had quantities of golden hair, and her eyes were of a tender blue, with a delightful hint of humour in them. We had much in common with each other, as she was an artist.[19] Our lengthy friendship has been a source of infinite delight to me.

Notes

1 The artist's son Geoffrey had died shortly before the second setback to her household, the defection of her husband Frank, had occurred. The mood of despondency which she describes here evidently did not dictate the subjects of her paintings, apart from the memorial of her child named after Tennyson's famous poem of 1850: this dislocation between the artist's lived experience and the ideas presented in the work seems to be typical of Jopling's practice, and results in a certain vapidity or absence at the heart of the paintings.

2 Shirley Brooks was the editor of *Punch*: see G.S. Layard, *A Great Punch Editor: being the Life, Letters and Diaries of Shirley Brooks*, 1907.

3 How much of this sentiment was born of the artist's own circumstances as a child can only be speculated, since she does not describe her young life in her memoirs. Of the nine orphaned siblings, Jopling and her fours sisters remained close throughout their adult lives.

4 The first Married Women's Property Act was passed in 1857, but left much to be desired. Real change came with the Second Married Women's Property Act of 1870: the author is misremembering the date, though it must have been true that the passing of a law did not change people's attitudes and behaviour overnight.

5 Joseph Jopling was chiefly a watercolourist, of no particular genre. He had exhibited in the London galleries from 1848, and died in 1884 at the age of fifty-three. At the time of their marriage, Louise Romer was thirty and Joseph Jopling was forty-three.

6 The craze for things Japanese in the west had arisen in Paris and London at the end of the 1850s, after trading links between Japan and the west had been opened up by the United States government. In London, Japonisme was chiefly associated with Dante Gabriel Rossetti and James McNeill Whistler.

7 Although the logic here is a bit tortuous, Jopling is thinking of the ways in which a woman artist's change of name often changes her reputation also. A number of women artists of Jopling's generation and the one before either kept on their former name in brackets after their married name, or simply added their husband's name to theirs on which their reputaiton was already founded. Critics sometimes complained at the difficulty of keeping up with the identities of women artists, because of the habit of name-changing on marriage, and because women did not use the titles Mrs. and Miss to aid the reviewer. One would want to know why it was so important for the critic to know these things before evaluating the work in hand!

8 Leighton, eventually president of the R.A., seems to be an obligatory figure in Victorian artists' memoirs (like Millais). Though quite explicitly of the neo-classical school and an enthusiast for the Academy and for the establishment, his popularity was not restricted to conservatives. His self-parading home, Leighton House, in Kensington, is now a museum open to the public.

9 See Elizabeth Thompson Butler, note 13. Sir John Gilbert (1817-1897), primarily an illustrator, was a very well-known artistic name, and at the period was President of the Royal Watercolour Society. He had been knighted in 1872, and became elected to the R.A. in 1876. His work was historical, literary and classical.

10 Mrs. Perugini is the painter Kate Perugini, née Dickens, with whom Jopling was very friendly. She had earlier been Kate Collins also, but the only name she exhibited under was Perugini (see Gladys Storey, *Dickens and Daughter*, London 1939). John Tenniel was the well-known illustrator of Lewis Carroll's *Alice*, and George Du Maurier was a popular satirical draughtsman for *Punch*, the *Illustrated London News* and other magazines, and latterly the author of *Trilby* (1894).

11 Jopling herself went into the Japanese fashion for a while (see

above, note 6), but was otherwise uninfluenced by Whistler. He was considered one of the leaders of the art-for-art's-sake, or aesthetic movement, along with Dante Gabriel Rossetti and Oscar Wilde. Though Whistler painted her portrait, Jopling did not attempt to return the compliment – knowing, perhaps, that Whistler would not willingly place his public face in the hands of a female artist.

12 Exhibited at the R.A., 1877. This painting, recently sold at Sotheby's, shows a woman and a little girl sitting in a middle-class parlour, the child nursing a doll, the woman pausing from her knitting to muse on something undefined. The clue to her thoughts must be the absence of a husband-father figure, and the picture's title. Many scenes of domestic life from which the husband and/or father is absent, were produced by Victorian women artists, with differing attitudes to this absence implied. Deborah Cherry has suggested that in many cases these pictures present a subversive alternative view of the domestic and familial ideal promoted by the dominant ideology ('Picturing the Private Sphere', *Feminist Art News*, no.5).

13 There is some confusion of dates here: although 'my Cinderella picture' is discussed after *Weary Waiting*, it in fact predates it: *A Modern Cinderella* appeared at the Academy in 1875, accompanied by *Elaine*; the artist also made two watercolour copies of it during 1875. Although she pays the model the respect of identifying her, in the picture she is standing with her back to the viewer, reaching up to a clothes-peg in the corner of an artist's studio, so the average gallery-goer would not have known who she was at all. The painting's whereabouts are presently unknown.

14 Thus the Grosvenor became quite an exclusive arena, especially as exhibition there, to start with, was only at Sir Coutts' and Lady Lindsay's invitation. Jopling showed there 1877-9 and 1880-3.

15 The reference is to Gilbert and Sullivan's comic opera of 1881, *Patience*, which satirised the aesthetic movement and carica-

tured the persona adopted by Wilde and Whistler.

16 Valentine Prinsep (1838-1904) was a member of the Kensington clique which lionised G.F. Watts, heroised Frederic Leighton, and took up Edward Burne-Jones. For British artists to receive commissions from the Indian aristocracy was not unusual, though it was more frequent for the work to be done while the Indian patron was in Britain, indeed as a memento of such a visit. The Rajah's portrait was shown at the R.A. in 1880.

17 William Holman Hunt (1827-1910) had been famous at the middle of the century for being one of the Pre-raphaelite brotherhood, and he was the only one of the original PRs to continue his dedication to the concepts relatively unchanged. Although Pre-raphaelitism could be said to have died out in the 1860s, Holman Hunt's popularity enjoyed a second wind and the publication in 1905 of his memoirs *Pre-raphaelistism and the Pre-raphaelite Brotherhood* brought the movement and its proponents back into the public eye again.

18 Ruskin was sued for libel by Whistler; the trial constituted an analysis of the development of the British avant-garde, wherein Ruskin held out for a negotiated realism against Whistler's French-inspired painterliness which saw the subject as a vehicle for painting, not *vice versa*. See Hilary Taylor, *James McNeill Whistler*, London 1978, and *From Realism to Symbolism: Whistler and his World*, Philadelphia Museum of Art, 1971.

19 She exhibited between 1877 and 1904, at the R.A., the Grosvenor and other venues. An unidentified newspaper article of 1893 suggests that 'Mrs Perugini's most successful pictures have been studies of children, painted with singular sympathy and felicity, and showing a keen appreciation of all the joys and sorrows of their little lives.' Although some five years older than Louise Jopling, Kate Perugini had in common with her friend that she had been widowed before remarrying happily, and that she had lost a son through premature death. She died in 1929 at the age of ninety.

ESTELLA STARR
CANZIANI

Round About Three Palace Green
(1939)

THIS book is not so much an autobiography as a family
memoir, for its main impetus was 'the fulfillment of a resolve
made in student days that I would write my mother's life'. Its
secondary aim was to try 'to give a glimpse of the camaraderie
of artists and friends – their little jokes, their banter, their
kindly amusing stories – and of the joy of life'. It therefore
covers a longer period than the author's lifespan (from 1887),
looking back to 1845, when her mother, Louisa Starr, was
born.

Born to an artist mother who lived a cosmopolitan existence
and was enthusiastic for women to live life as freely as men,
Estella Canziani learned an unconventional view of the world.
She had little formal education as a girl, but, she says, 'the
surrounding of artists and interesting people, who were in and
out of the house, could not fail to be an educational influence.'
Louisa Starr, who was the parent with the major responsibil-
ity for the child since the father spent much time in his native
Italy, was an assertive mother who passed on to her daughter a
code of self-help and a will to 'get on' often seen as archetypally
American. 'I also grew up to realize,' writes Canziani, 'that my
mother was a very busy professional woman always occupied
by her portraits, that work of any kind must not be inter-

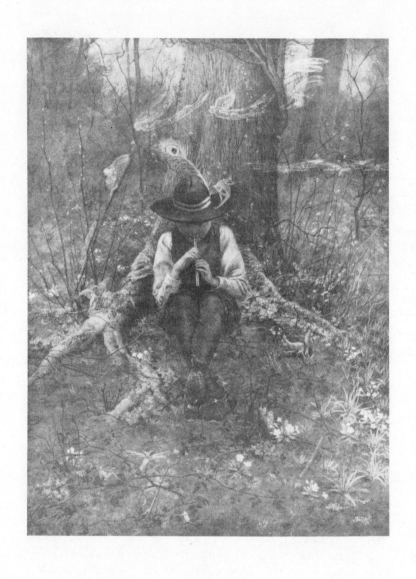

ESTELLA CANZIANI, *The Piper of Dreams*

rupted, except out of necessity.' The two women had a very close relationship.

Her mother's profession was an important factor in Estella's life. Comments suggest what a mixed blessing this was for the girl: 'My mother often said she was living her student days over again through me'. Louisa Starr hoped that Estella would become an artist, and the girl considered drawing her chief pastime from an early age. Her first public appearance as an artist was at the age of twelve, at the Society of Women Artists (formerly the Society of Lady Artists and originally the Society of Female Artists), a safe haven from which to embark. On leaving school she took up full-time art education, studying eventually at the Royal Academy Schools where her mother had made her historical impact in the 1860s. While Estella was a student there, her mother became ill; she died in 1909 when Canziani was twenty-one years old.

Louisa Starr painted portraits in oil; her daughter specialised in watercolour, producing portraits and illustrations for children's books, newspapers and periodicals. In 1911 Canziani and her friend Eleanour Rhode published *The Costumes, Traditions, and Songs of Savoy*, a large and sumptuous collection of verses, descriptions, and water-colour drawings drawn from their travels in that part of Italy. This was followed two years later by a companion volume on Piedmont, and eventually by a third book, *Through the Appenines and the Lands of the Abruzzi*. Italy remained important to Canziani, and even when her father's relations had died out and there was no longer a ritual visit to the homeland every summer, her identification with her Italian antecedents remained strong, more so than with the American inheritance from her mother.

Canziani exhibited at various London venues, and certain of her pictures became very popular through reproduction: the *Piper of Dreams* (p.164) published by the Medici Society, is one of the best known. During the 1914-18 war, she worked as a medical artist, becoming so absorbed in medicine and

health that she considered changing her occupation: 'Sometimes I wonder if I have shirked a higher service, but having set a hand to the plough of Art, it is now too late to turn back.' She continued as a prolific illustrator, particularly of children's books and poetry, illustrating much of Walter De La Mare's verse, until 1931 when her father died. It was his death which prompted her to stop working and travelling and write *Round About Three Palace Green*.

The extracts have been chosen to emphasise Louisa Starr rather than the author since Canziani's motivation for the book was her esteem for her mother and her conviction of the importance of her mother's experience. Starr was heralded in the mid-1860s as the 'coming woman', though her ultimate choice of portraiture as her principal genre caused her to lose status with critics. Perhaps they could not forget or forgive the unprecedented trouncing of male ambition and smugness dealt out by her much-publicised success as an R.A. student: 'Miss Starr scarcely maintains the rich promise of last year in two small heads. Our first female gold medallist must not yet relax her efforts' (1871) . . . 'We may note in Miss Starr's *Sintram* a defeat hardly to have been expected in the picture of an artist who was the first lady to carry off the highest Academic honour before Miss MacGregor – that is the strange disproportion between the cloistered mother and the warrior son . . .' (1873).

Despite such criticisms, Starr continued to find patrons; the stream of portraits which she produced until her death is proof of this. She took on male, female and infant portraiture with equal conviction. One of her finest accessible pieces, the National Portrait Gallery's *Brian Hodgson*, painted in 1872, (p.167) gives the lie to the prejudice that women cannot paint men effectively.

At Starr's death in 1909, the feminist paper *The Englishwoman's Review* described her in its obituary as a woman 'who found time in her busy life to take an interest in all

LOUISA STARR CANZIANI, *Brian Hodgson*, 1872

movements concerning women', telling its readers that she was 'assisted by a clever daughter (also an artist of no mean attainment) and her husband, who was ever ready to second all her best efforts.'

ROUND ABOUT 3 PALACE GREEN

A FTER leaving school I was allowed six months to go my own way in London, in museums, galleries, sketching in Kensington Gardens and grubbing in our own garden. My first exhibited drawing was of a 'newsboy,' done in 1900, when I was twelve, and Miss Partridge, Secretary of the Society of Women Artists, asked for it for their exhibition.[1] She was an old friend, I loved her because she knew all about my bullfinch in particular, besides all other bullfinches. The drawing was sold for 10s. 6d.

I did another water-colour of pine woods, toad-stools, and heather at Hindhead, and this was well hung in the Grosvenor Gallery and bought by Mrs. Charles Hancock.[2] Then my mother said I must retire into the ordinary private life of a child. When I was fifteen and a half I did a drawing of olives and cypress on Lago di Garda. A peasant riding past at full tilt on a bicycle shouted, 'I could do better than that with a broom.' That drawing my mother allowed me to send to the R.A. and to our surprise it was well hung, and we had our first Varnishing Day together.

We met Sir Alfred East; he looked at me, and my mother explained that I had not come under false pretences, but I was not to exhibit again till I was older, for she did not believe in prodigies, and this was only as an encouragement. All was well and Sir Alfred made no objection. Another time when I was painting the Sunk Garden in Kensington an American who had come to see Europe in fourteen days and England in three, exclaimed 'My, large as life and twice as natural'.

When I was seventeen I had my first life-sized portrait in the R.A. hung on the line by Sir David Murray. My sitter desired that it should take its chance at the Academy. I had entered the R.A. schools that year and the keeper, Ernest Crofts, gave me fourteen days off to finish this work. My mother and I, therefore, had another happy Varnishing Day; these yearly events continued until her death, four years later. . . .

My mother, *née* Louisa Starr, who entered the Royal Academy Schools at the age of about sixteen, was the youngest student in the schools.[3]

Louisa Starr Canziani was the only child of Henry Starr, of Philadelphia. Several members of this family distinguished themselves in music and literature, but it was reserved for Louisa Starr to become an artist.

From a tiny child she loved drawing and from the age of six her parents kept her little sketches of fairies and letters written in Italian in a clear childish hand. When I demanded stories of her childhood she told me about the crabapple tree in the old garden at Rockferry, how the fantail pigeons flew down all over her and she carried them hidden in her pinafore to the hayloft where they stuffed with corn unknown to the gardener. She also had a pony and kept Bantam chickens. She was always highly sensitive, and said how, all her life, the memory worried her because she felt she had been unkind, when one wet day she stood at the window watching the crabapple tree, a tramp came and picked up the windfalls on the grass and she tapped on the window-pane and he went away.

Her first drawing-lessons were from a country master,[4] with whom she copied landscapes, which he touched up with Chinese white, and fixed on fancy mounts. She was next permitted to copy certain sentimental crayon heads. Her instructor also gave her some idea of perspective by arranging square blocks for her to copy; at the same time he explained his object.

When she was about thirteen her parents left Rockferry and moved to London. She cried at leaving the pigeons, the chickens, the crabapple tree, the river and country, but persisted in her entreaty that she might be allowed to continue her drawing-lessons. By some happy chance her mother visited the well-known art school of Heatherley's in Newman Street,[5] where the young girl was permitted to attend at such intervals as were regarded as being consistent with her general

education. Here the learner made so much progress that her first finished drawing from the antique was the means of securing her admission to the Royal Academy Schools as a probationer, and this was followed by her becoming a student. Out of the thirty-eight students who tried to get into the Schools in 1862 my mother was one of the two admitted. But in those days stratagem was also necessary to enable women to enter the Academy Schools. My mother signed her name 'L.Starr'. The sex of the artist was not suspected by the Academicians, and there was general amazement and consternation when the young aspirant appeared in feminine guise and claimed to be received as a student! The president said the admission of ladies was not permitted by the constitution. The future artist firmly asked to see the clause in the constitution which excluded them. The constitution was examined, no such clause could be found, the Academicians had no authority to dismiss ladies, and six other students were then admitted to chaperone each other.[6]

As their number soon increased students and professors made a loud outcry, but no efforts made to deter the women from prosecuting their studies proved successful. At the end of two years the Council was induced to pass a law, not to exclude those already admitted, but to prevent the reception of any more until they could be furnished with separate accommodations.[5]

When my mother worked at Heatherley's preparing to get into the R.A. her mother always took her to the school and called for her at the end of the day, for it was not the custom for girls to go about alone. She was so slim that Heatherley demonstrated anatomy on her through her clothes. Judging by the ribbon which tied her old-fashioned lace collar he said she had a sense of colour. She did a sketch of this school, with Heatherley on the staircase. It is now in the Birmingham Museum. The students said that Heatherley's gentle manners reminded them of Christ. Pinwell, who was a student, took a

prize for a sketch, and George Howard, afterwards Lord Carlisle, and Lady Nicholson, were also fellow-students with my mother. The R.A. Schools were then in the National Gallery, in the domed 'Pepper Box', and my mother was allowed out in London alone and every day crossed the rough and dangerous district of Seven Dials.

On his way to America my grandfather wrote from Liverpool saying he did 'not like Louisa going alone to the R.A. and getting out of the buses quite unprotected, but he knew my grandmother had other ideas on the subject'. He signed this letter *'yours affectionately* but sometimes *cross husband'*.

Describing how my mother gained the first medal ever awarded by the R.A. to a woman, (1865) . . . my mother wrote:

'The students came tramping in and gave three cheers for the ladies, and then three for the gentleman in front, meaning a poor little boy who had been shown in all alone to the visitors' seats, and who sat blushing and awkward. They followed up with three for the perpetual student and three for the gentleman with his hat on, who directly took it off.

'There were various awards. Then suddenly I heard Mr. Boxall say in a clear, low voice the words "To Louisa Starr, for the best copy of *Two Spanish Peasant Boys*, by Murillo, a medal is awarded". Oh! it was so strange. In a second or two I had risen and was making my way round and down, with a clapping in my ears, and yet very far off, it sounded. I thought it was some one else going up, not myself, then I found myself standing before Mr. Boxall on the lower step, my lips were quivering and I trembled all over. The students clapped so loudly, and long, that I had to stand a long time until it was over. . . .

'. . . I came home in a cab. I ran up the steps and kissed Mamma who was waiting in the hall, so then she guessed and said, "Have you got it?". I said, "Yes," and she said "*Is* it possible! You don't say so!". Then I rushed into the parlour,

and began to tease Papa, asking him to guess what I had brought him from the Academy: he couldn't guess at all and told me not to be so frantic. At last I was obliged to tell him, and explain how all this time I had been trying for the medal and had intended it for a surprise should I be successful. He was so pleased, and his eyes twinkled, and the corners of his mouth twisted and turned up all the evening although he did not say much. I was happy in my own and Mamma's and Papa's delight. And so ended that day, but I did not sleep one wink all night.

'Next day, Monday 11th, at the R.A., Mr. Alldridge asked me if I had seen the notice of myself in the paper, and told me they had said, "Miss Starr is apparently about eighteen years of age, and as the police reports would say, of very prepossessing appearance". I asked Mr. Cauty what paper it was in, and he said the *Star*.'

Subsequently the gold medal with scholarship of £60 was won by my mother for the most successful historical painting of *David with the Head of Goliath Before Saul* in 1867. Unable to get a model for Goliath's head, she had been in despair until her mother suggested that the milkman, who was very bushy-haired would make a good model. He was surprised to be paid for lying asleep on a platform and wished he could often be an artist's model.[8]

My mother then asked Messrs. Spink for the loan of gold jewellery, and without a question they handed to her all she chose to take away in her bag. 'And you let her take it in this casual manner?' remarked a customer. 'It's as safe with her as with us, probably safer,' was the answer.

On the night of the prize distribution the young artist went to the Academy, and not daring to hope, sat as far back as she could in the crowded lecture-room. There was great excitement in the air, and many more friends of the Academicians were present than usual.

When, after the preliminary remarks of the president, Miss

Starr heard her name called out as the winner of the highest distinction awarded to Students by the Council, and the clamours of applause which shook the room, she could hardly realize that it was she herself who was scrambling over seats and forms to gain the estrade, but she became more composed under the kindly gaze of Sir Francis Grant, who handed her the medal.[9]

My father [Enrico Canziani, Starr's future husband] wrote:

'What a success! the first young lady to receive a prize, and that prize the gold Medal! Indeed, all London will be surprised and astounded; your name will be in all the papers and in all mouths; nothing will be spoken of but you and your fine picture. I am very proud, and all my people know that I have a cousin and that this cousin has won the gold Medal. So you can imagine how glad I shall be to see you; I am eagerly longing for the spring to come, the time when you will be in Milan and then we will go to the Brera every day if you like, and to the Biblioteca, for there, too, are most beautiful pictures; in short, you shall do everything you like best. It is a pity that, perhaps, I shall be still at Pavia, but I will do everything possible to finish my studies quickly, and stay longer with you.'

In an article called 'Twelfth Night Thoughts', *Punch*, January 18th 1868, named people 'who really find their Christmas merry . . . the young lady, the bright new *Starr* in the horizon of Art, who won the Academy Gold medal for the best historical painting, the only one of her sex who has so triumphed since Sir Joshua first took snuff in the presidential chair.'[10]

After taking these medals my mother became a regular exhibitor in the Academy and other exhibitions, and *The Times* of May 24th 1868 said there were pictures by an artist whose name is new. '*The Pet of the Brigands* is a lovely dark girl, three-quarter face, life size, attired in the usual white

head-gear of Italian women, but painted with so direct and vigorous a brush that one refers to the catalogue to see that he has made no mistake in the name of the artist. That artist is Louisa Starr, a young pupil of the Academy and one of the first fruits of the wise course of opening the school to ladies.'[11]

All her life my mother had many friends both amongst artists and others. She was very popular and always in demand. She had many proposals and my grandmother must have been a dragon, for she got rid of a would-be lover by giving him gruel, and sending my mother to her room. She was allowed to turn the drawing-room into a studio but was obliged to have my grandmother sitting in this room with her even when her sisters were being painted.

After my mother took the Gold Medal in the Academy Schools she stayed at our Italian village for a year.

A young, clever painter, she was misunderstood, and my Italian grandmother, although devoted to her, could not make out the independent English girl, whose views even in England were also in advance of her time. My uncle also made things difficult, but my father insisted on turning a room upstairs into a studio, putting in a stove heated by faggots, for the kitchen alone had a fire. The only other heating was charcoal in scaldini held in the hands or put between the feet, and warming pans heated the beds.

My mother became ill with the severe and hard winter life and family misunderstandings. She was forced to go to bed; she asked for broth or junket, but such things were unheard of, and again my father came to the rescue. The couple then became engaged and again my father helped smooth over difficulties by obtaining models for the picture with the peasants in groups, buying and selling in front of our house. This picture was called *The Eternal Door* because of the carved stone head of God the Father, which still surmounts it. In after years, when I went to Italy, I saw peasants standing

about buying and selling, or sitting on the same stone by this door and eating from old terracotta bowls, just as my mother had painted them in this picture which is now in the Birmingham Art Gallery and Museum.

When my mother returned to England she kept my father *au courant* with all her work and with all she was doing.

My father did everything for his sick mother, who at first did not like his engagement to an artist. She thought possibly he might be happier with a beautiful young countess of the conventional type, whose people wished him to marry, and who 'would not have painting to interfere'. When asked how he liked her, and if she was not beautiful he said, 'Not as Louisa'. 'But she has beautiful eyes?' 'Not as Louisa's, which are blue, and in comparison with Louisa, she has not an idea in her head!' he answered.[12]

When my mother's engagement was finally accepted my grandmother wrote, 'From the first, when Enrico saw Louisa he never had any other thought'. There were many discussions as to the possibility of my mother going to live in Italy, and my Italian grandmother wrote, 'What have we to offer in exchange for the honours, and so many kind and good friends?'.

My father was beginning to do well with his engineering, for my grandmother again wrote, 'If they marry, then Louisa can live in Italy where she need not depend on her work, and only paint for amusement. It would be a sacrifice for her to give up her position, but we should all live together and never be separated again'.

She also asked, 'Do not English artists marry; would it harm your position at the R.A.?' My mother sent her a 'bath full of love' and the following, although written jokingly shows she really had contemplated giving up England.

'I think you have said at different times that you needed me to

176

look after your bonnets. Well, Enrico will tell you that I have made up my mind to come. Mind I think it a very extravagant plan, for just think what it involves! Our letting this house, selling our furniture, giving up everything, and making Mamma come to Milan, all on account of your bonnets!

'Now *I* think that it would be a more economical plan if you got the most *expensive* bonnets from Paris, but Enrico seems to think that your bonnets need so sadly looking after by me that I suppose there is no help for it, and I must come!'

After living in Italy was finally given up my grandmother wrote, 'You *may* regret your position as an artist; remember there is more prose in marriage than poetry'. She also asked if the sacrifice from an independent life would not be too much, saying, 'I tell you beforehand Enrico is not very yielding, but give him his own way and he returns to yours'. She little knew how keen he was to give my mother every advantage.

My mother considered future prospects from every point of view and wrote to my father:

'My fear for you is that you have not the character which makes a man get on in the world. The man who gets on has a certain *savoir faire,* he never refuses any work that comes to his hand, until he has so much that he can choose the best, and he must have a quick eye to know where his interest lies, and a large way of looking at and judging things.

'You ask if it is possible for you to be an Alma-Tadema or a Leighton [13] – I say *Yes*. Why not? If I were a man, with a man's strength, nothing should stop me from making my way.[14] We must remember always that you are not an artist, but an engineer, but what is there to prevent you from becoming as *distinguished an engineer*, as Alma-Tadema is an artist? If you became distinguished in your profession I should have much more pride in your success than in my own.

'In all your plans you must not forget that I am an artist at

bottom, and that you cannot change it. You cannot cut out of my life what has been. Therefore think well if my artist nature will suit yours. Do not love me now for what I am, and afterwards expect me to change from that, for that I fear would bring great unhappiness to both.'

In answer to my father's objection to my mother's working so hard she wrote:

'I quite appreciate your feeling about my working, and I do not think it would be wise or right to *depend* upon what I make, but so far as it lies in my power to make a little money, you need not fear to let me do it.[15] *I* understand that you would never wish me to do too much and if *I* understand you, and have faith in your affection, we need not mind what other people think. I am sure you would not on that account wish to stop what has made the happiness (such as I have had) of all my life.

'I think most people are too *ready* to *comfort* themselves with the thought that those who are in a better position in the world than themselves only *seem* to be so.

'I must say that I think people who are well off are as a rule happier than those who are poor, and I do not think that to be poor, is to be honest. The chances are that the poor man is not more honest than the rich, only he is in all probability either less hard-working or less clever. From this point of view I think there is very little merit in being poor, as the poor man can neither help himself nor others. If honest *work* can gain wealth, I see no reason not to try to have it.

'As regards income, I thought that if, as you said you have about £500 or £600 a year, I could in one way or another add £300, or even £400, we should be *very comfortable indeed,* and then without anxiety you could seize every opportunity of getting on both in London and in Italy.'

Undine was one of the pictures of these early days and the

LOUISA STARR CANZIANI, *Sintram*, 1872

179

Observer of May 14th 1870 described it as the gem of the gallery, and added, 'One of the finest portraits in the whole Academy is *A Portrait of J.E. Pfeiffer, Esq.*, by Miss L. Starr.' When Watts saw this painting of Mr. Pfeiffer he took down his own picture replacing it by my mother's and thereby giving her a place on the line.[16] He also sent her several commissions. Mrs. Watts wrote to me describing the above incident, and saying how much he admired her work. . . .

In 1872, the picture of *Sintram* was painted, which was much admired, and it was bought by the Corporation of Liverpool. I remember my mother telling me how overjoyed and surprised she was when she received the following telegram: 'The corporation have decided to purchase your picture *Sintram* for the permanent gallery if you will accept two hundred guineas for it, reply to-day.' The stories of Undine, and also of Sintram, by De la Motte Fouqué, were amongst my mother's favourite tales told to me when I was a child.[17]

It was through George Carseldine, an Australian interested in Art and the Museums of Australia, whom I met during the War, that *Undine* and also my own picture, *The Bombardment of Rheims Cathedral*, were acquired for the Brisbane Museum. As it was still unallowable for women to work from the nude, my mother drew the models in combinations or tights.[18]

Hardly Earned was painted in 1875. This picture, like the others was hung on the line in the Academy and it attracted great attention. The artist desired to express her deep feeling for the struggles of her fellow-women. *The Times,* May 24th 1875, said:

'There is an unforced pathos in Miss Starr's tired daily governess (527) who, after her wearisome day's trudge through the muddy streets, and her more wearisome day's work of hammering 'scales' into her pupils, comes home to her shabby lodging house parlour to fall asleep from sheer exhaus-

tion by her cold fireside, where the ashes have gathered grey, and the tea-kettle stands soot-encrusted and silent on the hob.

'There is no undue insisting on the painful or pathetic side of this over-true picture of hard and ill-paid toil, though some may call the wet boots, which have been dragged off the stockinged feet, a step just over the line which separates the sad from the squalid. But this seems to us hypercritical in the presence of a picture so unpretendingly true, and which produces its effect by means so fair, and with a reserve and reticence so artistic.'

A governess whom my mother had met when away painting a portrait was the original of this picture. She told me how the profession of governess was then regarded as the only profession open to the 'young lady' obliged to earn her living in those days.[19]

At intervals my father came to England on short visits. My grandmother who announced his arrival about six a.m., to her sister in England, wrote:

'Do not tell Louisa, or she will jump out of bed and not get out quietly like a *lady*. Put on your shawl, and wait for him in the parlour otherwise you will catch cold.'

The marriage was finally arranged to take place quietly at Dover in 1882, but my mother would not have the conventional marriage service, including the words of 'promise to obey', and she said 'it was a religious ceremony and not a tea-party'. The vicar gave an address of rooms, as it was necessary for my father to take these for sixteen days and leave luggage in them before the *giorno d'orrore*. The vicar met my mother at the station with his carriage and invited her to stay at the vicarage until the ceremony. They then left for Italy. She had not been south and they went to Naples and Capri, where they sat on the roof of a house against the hillside and had lunch, and watched Vesuvius erupting. She told me how the hot lava

LOUISA STARR CANZIANI, *The Alien*.

burnt their boots. Also how when in the blue and green grottoes of Capri a wave carried their boat into the Grotto and their fisherman demanded to be paid double. My father said he was not a *forestiere* to be played tricks with, but the fisherman answered he was from north Italy, therefore a *forestiere*, and if he did not pay he would swamp the boat!

My father spent much time working in Italy, and looking after his delicate mother and crippled brother.

On the first anniversary of his wedding day, January 23rd 1883, he wrote from Rome:

'This letter will probably reach you on the morning of the 26th, that is, a year after our marriage. It is a year that has passed. We must so act that all succeeding years pass in like manner, to love each other. Now you are my dearest wife but you are ever my most rare Louisa, as at the first, and this is for all my life. I am most happy. I want to repeat now, and always, that the day of our marriage is, and will be, the fairest of my life, and I hope of yours too. I shall remember it with love, and the greatest pleasure, on every occasion. You know how much I love you, how happy and contented I am when with you, that I ask nothing better than to be beside you, and to kiss and embrace you. Now receive ever so many kisses and embraces from your Enrico who loves you, if not more, at least not less than at first. Farewell, my dearest.'

Another letter asks:

'What are you doing without me all day? Paint, paint, eat and eat. Mind, when I come to London, I shall not let you do either, the one or the other, therefore, avenge yourself while there is time; if not, "when the feast is over, the saint is derided" (Italian proverb) *Passata la festa gabbato lo santo.*'

His letters of affectionate teasing using Italian expressions continued. These *Rules for Matrimony* were enclosed in one letter:

1. The husband is always right, and more particularly, when he is wrong.
2. The husband has his own way, and the wife must obey.
3. The wife always follows her husband everywhere (when, however, the husband wishes it).
4. The husband is the master, and the wife the slave.
5. The wife must be always pleased, when the husband is contented.
6. The husband is everything; the wife is nothing.

On the return from their honeymoon my mother continued to paint and every year portraits and pictures were exhibited in the R.A. and in other galleries. The portraits of Lady Nicholson and of Lady Pelly were shown in the Grosvenor Gallery, and in 1885, Victor, son of Professor Flower, F.R.S., John Collman, Esq., Mrs. Keightley, the Hon. Lady Villiers were all painted and exhibited. Another picture greatly admired by Watts was of *Miranda When First She Beholds Ferdinand*. On the death of our old friend Mrs. Woodward, who owned it, it came home to us. There was also a little head of my grandmother, which now hangs in the drawing-room and which is one of the most attractive pictures.[20]

In the early days of their married life, my parents lived at 14 Russell Square, in a district then a centre of artists and British Museumites. The drawing-room was used as a studio, with my grandmother on guard. Then in 1886 they all moved to Palace Green, where I was born. To work alone in a real studio was a great advantage.

My mother did several designs for dress reform, which always interested her. She spoke of the hideousness of bustles and shoulder-of-mutton sleeves, white blouses, black skirts, and sailor hats, and Walter Crane did much to encourage her to write on this subject.[21]

Extracts from an article on dress in the *Strand Magazine* of February 1891:

'What constitutes fitness and womanliness in dress? Do the dresses of the period possess these qualities? I certainly think not always. To be beautiful, it should be the expression of a beautiful mind, a beautiful body, and of perfect health and ease, and of natural delight in movement. Also, it should have no association with pain. No dress can be beautiful that is disfigured by an innocent animal wantonly sacrificed to the vanity and egotism of the wearer. What womanly woman would wear real astrakhan on her jacket (if she knows *what* real astrakhan is) or the corpses of gulls, doves, humming-birds, swallows, etc., in her hair? No one with a heart could do it, or, having a heart, the brain must be wanting which would enable her to think of the unjustifiable cruelty to which she gives her sanction. If I were a man, nothing would induce me to marry a girl who would wear a bird. I should think: "Either she is selfish and cold, and through life would sacrifice everything to her own vanity or interest, or else she has so little mind and judgement that she would be ill-able to conduct the affairs of life with discretion." I should say that never was a pretty face rendered one whit the prettier by the body of a dead animal above it, but that on the contrary the attention is distracted from the living beauty beneath, and the mind is saddened and disgusted by the association of cruelty and death, and decay, with womanhood, which should rightly call forth only deepest feelings of admiration and respect.'

My mother was a keen supporter of the Royal Society for the Protection of Birds, and whether in a bus, picture-gallery, train, or walking, if she saw a woman wearing a bird in her hat or bonnet, she always spoke to her and explained the cruelty. As a sensitive child I was often made uncomfortable when she talked to and lectured a complete stranger on this subject.

There was a *Daily News* plebiscite in 1900 for the fourteen most popular Academy pictures. Louisa Canziani's pathetic

picture *News from the Front* ('But things like this, you know must be, in every famous victory') was chosen as one of the fourteen pictures, and was also described as 'One of the most touching pictures connected with the war. It represents a girl with her face hidden in her hands, who has flung herself down on the nearest doorstep in the abandonment of her misery in seeing the loved one's name in the list of the killed; her father sits beside her, helpless to comfort. It is a fine and touching picture'. My mother actually saw this incident on the steps of St. Mary Abbot's Church.[22]

To an interviewer who asked, 'Have you any hobbies?' my mother replied, 'Yes, hundreds, if hobbies they can be called. I call them convictions, or rather, interest in rational subjects. I take the right side, of course. First, I abhor cruelty to animals, including the barbarous and hideous custom of wearing corpses of birds in bonnets, and corpses of animals round the throat. Secondly, I detest wife-beating, and deplore the inadequate punishment meted out by the law.[23] Then comes cruelty to children – or, rather, this ought to come first, followed by the animals, then the wives, because the wives could protect themselves if they stuck to each other, and made fuss enough. My next hobby is the interest I take in the Society for the Regulation of Abuse of Public Advertising. Then I sympathize most deeply with the Preservation of Ancient Monuments and everything that is beautiful, down to a tumble-down cottage or a mossy old gate. After that comes the Society for Suppressing Street Noises: but I should think that would be almost enough. These are my present hobbies, besides, of course, the universal tastes that every one has, music, the drama and others.

'You ask my views upon art as a profession for a girl of talent', continued my mother. 'It seems to me that if a girl has talent enough there is always room for her at the top, and this might apply to every profession. Every profession is overfull, art, as well as everything else, yet I believe that there is, and

always will be, room for those with exceptional gifts. I, however, believe that no one is justified in taking up art as a profession who does not love it so devotedly that it is the irresistible impulse of life, apart entirely from the desire of gaining money.'

The quantity and quality of work my mother produced was amazing, and it is impossible to write about all she achieved. The long corridor at Palace Green is filled with photographs of her pictures and there are others put away in an ivory and mother o' pearl inlaid English chest which she picked up at Hastings for ten shillings! I am trying to trace all her work for a complete record and I frequently hear of fresh pictures and portraits of which I knew nothing.

My mother was elected President of the Art Section of the International Congress of Women held in London in 1889. I heard her give her speech on the Spirit of Purity in Art; she spent much time in preparing and practising it, and even went to elocution classes. I sat at the end of the large hall in Westminster, heard every word and the burst of applause at the conclusion.

Notes

1 The Society of Women Artists remains in existence today, still holding an annual exhibition at a London venue. No history of the society has been written, as its archives were destroyed during the 1939-45 war.

2 Canziani's work is widely scattered now, and much untraced, but one collection of her drawings is at Birmingham City Art Gallery, which also owns some informal pieces of work by Louisa Starr.

3 Starr was amongst the second group of female students to enter the Academy Schools, the first few having been admitted the year before, 1861. They had a difficult time there, due to male prejudice against them and to keen public scrutiny of their unprecedented and contentious situation. See, for instance, G.D. Leslie, *Inner Life of the R.A.* (1914), where the admission of women into the Academy is talked of as an 'invasion', 'artfully planned'.

4 Women in the middle and upper classes were often taught in this way, by young male artists who were on their way up the ladder or by older men whose reputations alone were not enough to live by. The incidences of such drawing *mistresses* were rare and have been scantily recorded, though it is clear that such family enterprises as the Nasmyth drawing school or the teaching taken on by John Sell Cotman but expedited by his whole family, involved women as teachers of art, and indeed, relied on their teaching.

5 Previously known as Leigh's, a private school for training students for entry to the Academy. See Christopher Neve, *Country Life*, 24 August and 31 August 1978, for a brief history of the school.

6 Canziani is confusing her mother with Laura Herford, who was the woman who first gained admission as a student, by this stratagem, the previous year. The *Art Journal*'s obituary notice of Herford suggested that all the female students at the R.A. 'probably owe their advantages to Miss Herford's bold venture' (*Art Journal*, January 1871, p.80). Henrietta Ward makes the same confusion between Starr and Herford in *Memories of Ninety Years*, chapter 4, p.59. An additional interest attaching to Herford is that she was the aunt of another later female artist of note, Helen (Paterson) Allingham.

7 This gambit was recognised by women themselves, as well as by liberal male artists and some parts of the art press, to be absolute dog-in-the-mangerism, which used the idea that there was no room for more students as a pretext for cutting the intake

of women. The female students already in the school submitted an official complaint, couched in very ingratiating language, which had the effect of amending the rejection of female students which the Academy had planned to a quota system. In 1867, a second such petition got the ban lifted altogether.

8 The whereabouts of the painting are at present unknown. The *Art Journal* described it thus, however, when it published an engraving of it in 1871: 'The composition is simple, and the artist acted wisely in not loading it with numerous figures and accessories, as under the circumstances she might well have been tempted to do. The young victor, kneeling modestly, lays his prize at the feet of the monarch, who regards him with a strange, half incredulous look, as if he could not realise the fact that such a stripling could have overthrown the terror of the Hebrew hosts. The figure of Saul is very stikingly dignified, yet easy in pose. Behind his chair is Jonathan, who already seems to feel that yearning towards David which afterwards grew into a friendship that has become a proverb.'

Such anecdotes as this cited here concerning the models for famous pictures or statues are a commonplace of artists' memoirs, often patronizing and often sentimental, and frequently failing to identify the model by name. For a critical consideration of this and other aspects of the model's relationship to the practice of art, see Frances Borzello, *The Artist's Model*, London 1982. Similar stories to this one of Canziani's occur in Butler's, Jopling's and Ward's books.

9 Sir Francis Grant (1803-78) was then President of the Royal Academy. A part of his fulsome speech on this occasion was: 'I think this is a very serious consideration for us men who call ourselves the lords of creation. We may well tremble in our shoes when we see this great 'storm wave' of female talent and enterprise rolling rapidly forward and threatening to overwhelm us.' Grant had a niece who was a professional artist, Mary Grant, whose marble bust of her famous uncle is in the National Portrait Gallery, London.

10 During the discussion of women and the R.A. which Starr's success aroused, it was often recalled – though *Punch* does not do so here – that there had been two women amongst the founders of the Academy (Mary Moser and Angelika Kauffmann). Their names were invoked by critics who supported the idea of women in the Academy as often as those of Margaret Carpenter, an early Victorian painter (1793-1872), and Henrietta Ward, once she became established, as proofs that women were owed a place in the Academy equal to men.

11 This painting, widely praised, is now untraced. It was a common subject – see, for instance, Fanny McIan's *The Pet of the Tribe* (1843), sold at Sotheby's in 1984 – which fits into the tradition of the fancy picture.

12 As an American, brought up liberally in Britain, Starr would have been highly educated compared with her Italian contemporaries: the first attempt at state schooling only occurred in 1870 in Italy.

13 Laurens Alma-Tadema (1836-1912) was a Dutch painter who settled in England in 1870 and became immensely popular for his highly decorative, sentimental, and sexist classicism. Both he and Leighton would have counted as neighbours to the Canziani household, part of the Kensington set.

14 This recognition that men had a better chance in the world than women accompanied by the refusal to be deterred by it, is in striking contrast to the sentiments of the address which Starr gave at the Chicago World's Fair in 1893 on 'Women's Work in Art', in which she removes her women's rights from the real world to one of religious reward: 'Rouse, then, o my countrywomen, to the fullness of your vocation as artists! Use all the opportunities offered you, not to win the poor fame awarded by gallery or salon, but aspire to that ideal consistent with the life of a Saint – the Christian work of a Christian woman in Christian Art.'

15 Portraiture is always one of the most obviously commercial genres for a painter (or sculptor) to practise, and, allied with the

truism that alleges women's particular feeling for people (as opposed to ideas), the female artist who wanted to earn a living from her work often ended up as a portraitist *faute de mieux*. Starr's success with private patrons can be gauged by the names which occur in her record of exhibited work, either as owners or sitters, but by the 1880s she was exhibiting almost exclusively portraits, with the odd fancy picture every now and then. The most notable instance of public patronage which she received during her lifetime, was the purchase for the new Walker Gallery in Liverpool by the local Corporation of her painting *Sintram* (1873). Aberdeen City Art Gallery owns a much later painting, *The Alien* (1906), given by Estella Canziani in 1936.

16 G.F. Watts (1817-1904), like Alma-Tadema and Leighton, was one of the artists who lived and moved in Kensington, and was at the time one of the lions on the art scene. Since his version of Victorian classicism was more painterly (less linear) than that of similar figures, praise from him would imply praise for brushwork, colour and fluency. To be hung on the line meant to have a picture placed at eye-level on the gallery wall, the most favourable place for a work to be seen.

17 See William Vaughan, *German Romanticism and English Art*, London 1979, for a discussion and appraisal of the use by British artists of such German literary themes. Undine, the most popular of De La Motte Fouqué's stories, was published in 1811. The author died in 1843, but his popularity far outlived him.

18 The picture's whereabouts are unknown, but it was engraved in the *Illustrated London News* in 1870.

19 The rise of the governess as an image in the British painter's repertoire relates to the issue of the 'redundant woman' mentioned in the Introduction. The governess was already a symbol of distress in the 1840s, appearing in Richard Redgrave's painting *The Poor Teacher* (1842), now in the Victoria and Albert Museum, and in Charlotte Bronte's 1848 novel *Jane Eyre*. Other examples in painting include a number of works by

other women artists: Emily Mary Osborn, *The Governess*
(1860) reportedly bought by Queen Victoria but not presently
in the royal collection; Rebecca Solomon, *The Governess*
(1854) now in an American private collection. Starr's image
differs from these two in presenting a single figure, and in
detailing the woman as a *music*-teacher. For present-day dis-
cussion of the governess as pictorial symbol see Rosemary
Treble, *Great Victorian Pictures*, Arts Council GB, 1978, p.71
and Susan P. Casteras, *The Substance or the Shadow: images of
Victorian womanhood*, Yale 1982, p.33.

20 None of these pictures is presently traced. *Miranda* was shown
at Liverpool in 1886 – it is a subject from Shakespeare which
was not infrequent in the galleries.

21 Walter Crane (1845-1915), decorative artist and designer, was
associated with William Morris's circle, the Arts and Crafts
movement, and dress reform. He had a sister, Lucy Crane, who
wrote art criticism and verse.

22 Canziani writes that this picture was construed as being sym-
pathetic to the Boers, who constituted the enemy to British
troops in the war which is being discussed. She says: 'During
the South African War, troops were encamped in Kensington
Gardens, and I made scribbles of their tents with them cooking
or lounging about. We spent Easter on the Isle of Wight and saw
the wounded lying on stretchers on the platform of South-
ampton Station. Mrs. Charles Hancock organized lectures and
sewing parties for comforts for the troops, and was persecuted
for her international outlook and sympathies. At my day school
I was teased, because my mother also had sympathy with the
Boers . . .' (Mrs. Charles Hancock, it will be remembered, was
the person who bought Canziani's first exhibited picture.)

23 A celebrated case in 1891, the Clitheroe case (Queen v. Jack-
son), had reminded women of the unsatisfactory state of the law
on this matter: see Albie Sachs and Joan Hoff Wilson, *Sexism
and the Law*, Oxford 1978.

INDEX

Albert, Prince Consort 116
Allingham, Helen (nee
Paterson) 78, 188
Allingham, William 22
Alma-Tadema, Laurens 127,
131, 177, 190, 191

Barrett, Elizabeth (later
Browning) 3
Bashkirtseff, Marie 13, 17
Benham, Jane (later Benham
Hay) 20, 24, 26–40
Bodichon, Barbara (nee Leigh
Smith) 20
Bonheur, Rosa 1, 77, 143
Brontë, Charlotte 13, 81, 91,
191
Brooks, Shirley 144, 159
Browning, Elizabeth Barrett –
see Barrett
Browning, Robert 55, 66
Burne-Jones, Edward 48. 154,
162
Butler, Elizabeth (nee
Thompson) 7–8, 9–18, 49,
70–112, 143, 148

Canziani, Enrico 174 ff.
Canziani, Estella Starr 9–18,
163–192
Canziani, Louisa – see Starr
Carpenter, Margaret 190

Carroll, Lewis (Charles
Dodgson) 160
Cassatt, Mary Stevenson 65
Chorlev, Henry 19
Clayton, Ellen Creathorne 8, 43
Cogniet, Leon 46
Crane, Lucy 192
Crane, Walter 184, 192
Creswick, Thomas 126, 136

De La Mare, Walter 166
Decamps, Alexandre 100, 110
Delacroix, Eugène 100, 110
Detaille, Edmond 77
Dickens, Charles 13, 84, 116,
124, 135, 158, 160
Dickens, Kate – see Perugini
Dicksee, Frank 127
Disraeli, Benjamin (Lord
Beaconsfield) 131–2, 152
Doré, Gustave 92
DuMaurier, George 149, 160

Edwards, Mary Ellen
(MEE) 140
Eliot, George (Marian Evans,
later Cross) 68
Etty, William 26

Fildes, Luke 127
Fox, Eliza (later Bridell-
Fox) 20, 43

Frith, William 116, 128, 138
Fry, Elizabeth 117, 120–1, 134

Gambart, Ernest 125–6, 136
Garibaldi, Giuseppe 79, 82, 92
Gaskell, Elizabeth 13, 19
Gérôme, Jean-Leon 100, 110
Gilbert, John 148
Gilbert, W.S. 154, 161
Gladstone, William Ewart 13
Goodall, Fred 128, 137
Grant, Francis 174, 189
Grant, Mary 189–190
Greg, William 3

Hall, Samuel Carter 116
Herford, Laura 5, 188
Hill, Octavia 43
Hood, Thomas 3
Horsley, J.C. 127, 128, 131
Hosmer, Harriet 46
Howitt, Anna Mary 8, 9–18, 19–44, 67
Howitt, Mary 19–23, 41, 44
Howitt, William 19
Hunt, Edith Holman (nee Waugh) 52
Hunt, William Holman 111, 156, 162

Jameson, Anna Brownell 2, 4, 19, 40
Jopling, Joseph 140, 159
Jopling, Louise (nee Goode, also later Rowe) 8, 9–18, 139–162

Kauffmann, Angelika 5, 9
Kaulbach, Wilhelm von 19, 20, 32–3

Knight, Laura (nee Johnson) 94

Landseer, Edwin 85
Lea, Anna – see Merritt
Legros, Alphonse 46
Leighton, Frederic (Lord) 49, 135, 148, 157, 160, 177
Lewis, J.F. 100, 110
Long, Edwin 132

McIan, Fanny 190
Manet, Edouard 67
Martineau, Harriet 111
Merritt, Anna Lea 8, 9–18, 45–69, 136
Merritt, Henry 45–8, 53–64, 65–9
Meynell, Alice (nee Thompson) 72
Millais, John Everett 22, 46, 86, 93, 135, 140, 147, 157
Miller, Florence Fenwick 142
Morisot, Berthe 67
Moser, Mary 5, 190
Müller, William 100, 110
Murillo, Bartolome Esteban 61, 69, 172
Mutrie, Martha and Annie 94, 140

Neuville, Alphonse de 77

Osborn, Emily Mary 192

Paterson, Helen – see Allingham
Patmore, Coventry 3
Perugini, Kate (nee Dickens) 149, 158, 160, 162
Prinsep, Valentine 155, 158, 162

Redgrave, Richard 191
Retzsch, Moritz 19
Rossetti, Dante Gabriel 22–3, 159, 161
Rossetti, William Michael 23
Ruskin, John 23, 65, 67, 156–7, 162

Schreiner, Olive 108, 112
Siddal, Elizabeth (Lizzie) (later Rossetti) 23
Smith, Barbara Leigh – see Bodichon
Solomon, Rebecca 192
Starr, Louisa (later Canziani) 7, 9–18, 163–192
Stephens, F.G. 22
Stone, Marcus 127
Swynnerton, Annie 49, 93

Tenniel, John 149, 160
Tennyson, Alfred (Lord) 27, 41, 82

Thackeray, William Makepeace 124
Thompson, Elizabeth – see Butler

Veronese, Paolo 53, 65
Victoria, Queen 13, 77, 116, 137, 192
Vigee-Lebrun, Elizabeth 12
Vigri, Caterina 1

Ward, Edward Matthew 113–6, 121–5, 132, 134
Ward, Henrietta (Mrs. E.M.) 9–18, 67, 94, 113–138, 140, 188, 189
Ward, James 113
Watts, Alaric Alfred 23
Watts, G.F. 48, 162, 180, 191
West, Benjamin 87, 94
Whistler, James McNeill 140, 149–50, 156–7, 159, 161
Wilde, Oscar 140, 161